Silk Stocking Mats

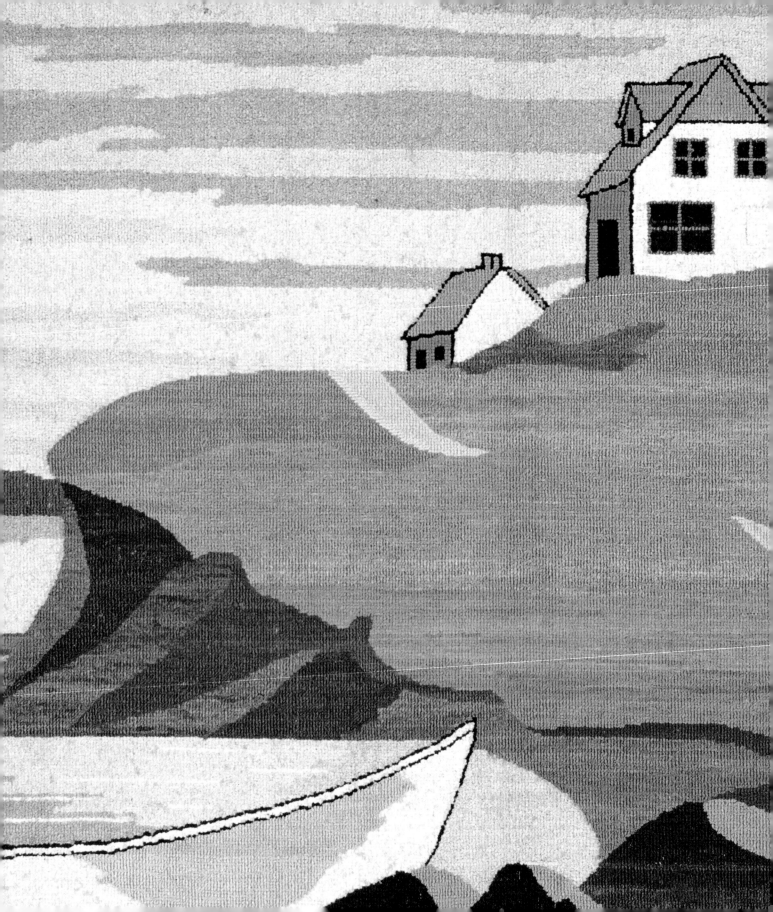

21 May 2008

For Elizabeth —
Thank you so much for your interest
and enthusiasm. It was a treat to
meet you! Enjoy!
Paula Laverty

Silk Stocking Mats

Hooked Mats of the Grenfell Mission

Paula Laverty

McGILL-QUEEN'S UNIVERSITY PRESS Montreal & Kingston • London • Ithaca

ISBN–13: 978-0-7735-2506-1
ISBN–10: 0-7735-2506-8

Legal deposit second quarter 2005
Bibliothèque nationale du Québec

Printed in Canada on acid-free paper.
Reprinted 2006

Publication of this book was made possible by financial support
from the International Grenfell Association and the Pasold
Research fund.

McGill-Queen's University Press acknowledges the support of
the Canada Council for the Arts for our publishing program.
We also acknowledge the financial support of the Government
of Canada through the Book Publishing Industry Development
Program (BPIDP) for our publishing activities.

Library and Archives Canada Cataloguing in Publication

Laverty, Paula
Silk stocking mats : hooked mats of the Grenfell Mission /
Paula Laverty.

Includes bibliographical references and index.
ISBN–13: 978-0-7735-2506-1
ISBN–10: 0-7735-2506-8

1. Rugs, Hooked–Newfoundland and Labrador–History.
2. Grenfell Labrador Medical Mission. I. Title.

NK2813.A3N47 2005 746.7'4'09718209041 C2005-900285-9

This book was designed and typeset by studio oneonone
in Electra 10/14.

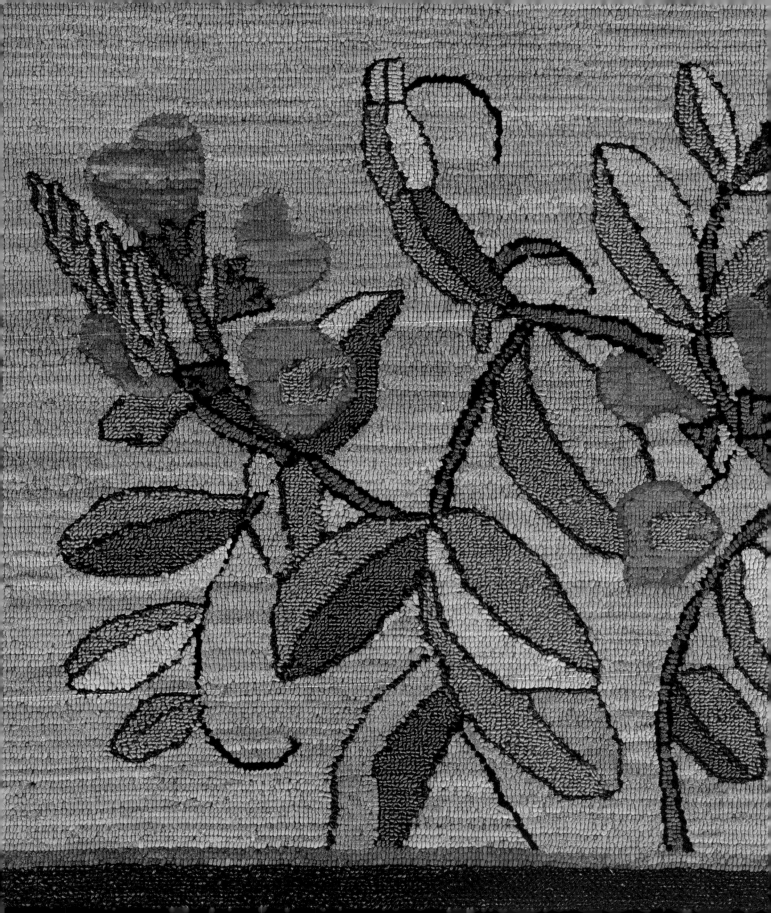

Contents

Introduction

The Grenfell Mission was a medical mission in the remote areas of Labrador and the Great Northern Peninsula of Newfoundland. While the Mission began in 1892, this book starts in 1906 with the establishment of the Industrial, a cottage industry that became an important part of the Mission by providing for the making of handicrafts as a means of supplementing the local economy. The Industrial is chronicled here with a sole emphasis on hooked mats; a significant number of other products was also produced but they are not the focus of this book, though some are mentioned in passing.

I have endeavoured to answer the many questions relating to the hooked mats: Who hooked them? Is it possible to date a mat precisely? Can a mat-hooker recognize her own work? What does a name or a number on a mat label mean? Who designed the mats? What were the sources and the inspiration for the designs? Above all, how did the mat-hookers feel about the Industrial, the Mission, and their craft?

The smallest bits of information often filled the largest gaps. I travelled by small plane and open boat, visiting nearly every community having ties to Dr Grenfell and the Industrial. Fog, tumultuous seas, and wind hampered my efforts at times and, sadly, elderly mat-hookers had passed away, leaving no memories behind. Such setbacks aside, mat-hookers gave me the gift of their time, welcoming me into their homes with generosity and enthusiasm and willingly sharing their stories. Their eyes came alive as we pored over hundreds

of photographs of mats, many evoking a comfortable nostalgia. A chance stop at a small ice cream shop led to one of my most informative interviews. The mat-hookers were eager to give me their patterns and other artifacts, and when I politely suggested that these should be kept in the communities for future historical research they shrugged and said, "It's just them old mats; who would be interested?" They expressed amazement when I explained that, in fact, a great many people were interested in their craft and their stories.

Monetary facts and figures generally – unless specifically noted – refer to the gross output of the entire Industrial. All figures quoted are backed up by at least two sources, one of them independent of figures in *Among the Deep Sea Fishers*, the Grenfell Mission's quarterly publication. "In production" dates refer to the earliest mention or archival photograph I was able to find of a specific mat design; they indicate only that a design was being hooked at that time and do not preclude a slightly earlier date for a given design. Mats are dated with "in production" dates only, since it is impossible to place an exact date on any mat. Measurements are given in inches, height followed by width. Further, unless otherwise noted, the pattern names in this book are not those given by the Industrial but, rather, descriptive names that I have arbitrarily devised.

As it became clear that a mat-hooker could not identify her own work, it became important to know the living mat-hookers, to understand their motivations and applaud their contribution to the craft. I have made every attempt to present the facts as they unfolded and have used quotes extensively so that, as much as possible, the Industrial's history is told by many who played a part in it.

What is revealed is the story of a time and place, and it is important not to colour that history by judging it by today's values, sentiments, and ways of thinking.

It bears repeating that these mats were hooked by the warm light of a kerosene lantern at a time when travel in winter was by dog team and in summer by small open boat. Electrical power was not widely available in homes on the Labrador coast until 1972. Most people had never seen money and remained indebted to traders for the supplies that their fish catch could buy. Books and magazines were scarce at best; contact with the larger community and the outside world nearly non-existent. While the division of labour was clearly defined, the role of the women in the community was quite equal to that of the men. Women worked at keeping the home and "making the fish" (the process of cleaning, splitting, salting, and drying the catch), while men fished, trapped, and hauled wood and water. All hands were integral to making ends meet. The hooked mats are an art born out of necessity, originally used for warmth and decoration and appealing to the sense of "Waste not, want not" but then becoming a real means of securing necessary clothing, food, and medicines.

Grenfell hooked mats defy boundaries. When most of the mats were being hooked, Newfoundland and Labrador were British colonies; the materials used came from all over Canada, the United States, and Great Britain; in the early years the mats were made to appeal to an American sensibility, though later they were sold only in Canada. It is not important to claim ownership of these mats – what *is* important is to hear the stories they have to tell.

My Labrador Rug

Old silk stockings, worn and grey,

 Packed in a box and sent away,

To a fisherman's home by a wintry sea,

 You have all come back again to me,

In the form of a ship and a flying gull,

 White for the sails and brown for the hull,

Blue for the sky and the sea.

Old silk stockings, tired of the town,

 Did you smell the tang of the seaweed brown?

Have you heard the lonely seabirds cry,

 While the good wife worked with hook and dye?

Black for the rocks and the fisherboy's hair,

 White for the ice and the polar bear,

Blue for the sea and sky.

MARY B. HUBER
(c. 1938)

PART ONE

The History

Wilfred Thomason Grenfell (1865–1940) was an
energetic, idealistic English physician schooled at
London Hospital Medical College and, briefly,
Oxford University. He spent his boyhood by the
sea in the tiny hamlet of Parkgate, England. His
father, Reverend Algernon Sidney Grenfell, was
the headmaster of Mostyn House School, a small
boys' school that he struggled to keep afloat. In
his later years, Reverend Grenfell was plagued by
neurosis and committed suicide. Wilf's mother,
Jane Hutchinson Grenfell, bore four sons, one of
whom died of meningitis in childhood. An affable
and athletic young man, Wilf decided on a career
in medicine early in 1882, after a visit to a local
doctor who showed him a pickled human brain
and talked about the functions of the human
body. "I was thrilled with entirely new emotions,"
Wilfred Grenfell wrote later.[1] In February 1883,
he enrolled in London Hospital Medical College.

Under Queen Victoria, the spirit of the age
was one of self-sacrifice. English gentlemen were
intent on conquering the undiscovered world and
carried with them a passion for bettering the
human condition, especially in remote areas.
After a chance stop at a revival meeting held by
the American evangelist Dwight L. Moody in
London's East End, Dr Grenfell renewed his flag-
ging religious fervour and made a pact with him-
self "to do the things Christ would do if he were
a doctor in my place."[2] Dr Grenfell liked to say
that he found his compass that night.

Almost immediately upon receiving his diploma in January 1888, he signed on with the Royal National Mission to the Deep Sea Fishermen (RNMDSF), which operated a convoy of medical ships in the North Sea ministering to the needs of the men of the fishing fleet. He spent three years cruising among the hundreds of smacks that trawled the shallow North Sea, tending to the fishermen's cuts, bruises, and broken limbs, bringing them reading materials and tobacco, and leading prayer services. Then in 1891, a co-worker returning to England from Canada told Dr Grenfell of the bleak conditions among the Labrador fishermen. There was not a physician, nurse, or druggist working on the entire isolated coast. Asked if he would be interested in crossing the Atlantic to introduce much-needed medical care to the people of Labrador, Grenfell's answer was an instantaneous "Yes."

Labrador remains one of the world's lonely lands. Its ragged coast stretches 750 miles from the northern tip of Newfoundland to the southern tip of Greenland. When Dr Grenfell arrived on its shores in 1892, Labrador, together with Newfoundland, was an isolated British colony. Some 1,700 Inuit, several hundred Innu, and 3,300 people of British origin were living in widely scattered outports (settlements) dotting a vast area of 110,000 square miles.

Situated where the Arctic Ocean turns the corner to the Atlantic, Labrador's austere coastline is broken up into hundreds of islands. Towering cliffs protect perfect natural harbours and long stretches of bronze sandy beaches. A backbone of rugged mountains and distant whaleback hills runs through the interior. The beauty of northern

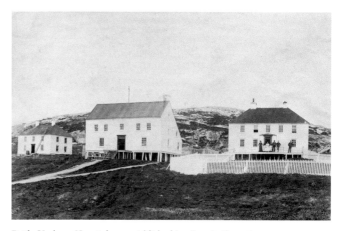

Battle Harbour Hospital was established in 1893. In the autumn of 1930, a carelessly discarded cigarette started a fire on the island. The fire spread quickly and the hospital was destroyed. Luckily, by this time the Grenfell Mission had shifted its focus and moved the staff to St Mary's River (St Mary's Harbour). However, some equipment, medicines, and furniture remained, most of which was lost. (Provincial Archives of Newfoundland [PANL] VA91-19-1)

Newfoundland and Labrador's gray rocks, islands, harbours, and fjords is intensified by icebergs that ride the ocean's swell in spring, reflecting the colours of the sea. Arctic wildlife – polar bears, walrus, and seals – travel south from the Arctic, borne by the floating ice of the Labrador Current. Winter sets in early and stays late, leaving Labrador icebound much of the year.

The twenty-seven-year-old doctor embarked in June 1892 aboard the RNMDSF hospital ketch *Albert*, with a crew of nine North Sea fisherman. After seventeen days they made landfall just north of St John's, Newfoundland, where they were delayed by the great fire raging in the city. They reached Domino Run on the Labrador coast on 4 August.

What Dr Grenfell discovered there laid the foundation for his life's work. He met a courageous people, hard-working, devoutly religious, and reserved, but always generous and hospitable. They were fighting insurmountable odds, facing rampant poverty, unrelieved sickness, poor nutrition bordering on starvation, inadequate clothing and housing. Shortages of wood and water were acute. All water had to be drawn from a hole in the ice over a spring and hauled in sacks or buckets; wood was chopped by hand and dragged home by dog teams. When Dr Grenfell arrived, travel by small, open dory was possible only from May through October. During the long winter, dogsleds and snowshoes (locally called "rackets") were the means of travel over the ice and snow. Communication with the outside world was sporadic at best in the winter and relied on irregular mail boats in the summer.

The livelihood of the people depended on the success of the cod fishing season. When the fishing was good, making the fish took up much of the summer months. When the fishing failed, as it often did, people were forced to subsist using their wits and their will. In winter, trapping replaced fishing. The fishermen were in constant debt to traders, who advanced provisions on credit against the season's fish catch at prices they set themselves. A ledger found at Battle Harbour, Labrador, for example, records that the merchants there paid three cents a pound for fresh Atlantic salmon and that a pair of rubber boots cost six dollars: a fisherman had to sell 200 pounds of fish to afford one pair of boots. Little or no aid was forthcoming from Britain for the people of its colony.[3]

Dr Grenfell quickly decided to dedicate his life to alleviating the distress he encountered. Out of his devotion grew a medical mission that, in its far-reaching aims, had a significant and lasting impact on the lives and futures of the fishing families who lived in a land of awesome beauty but who suffered from – as he later wrote – "utter lack of opportunity."[4] Dr Grenfell brought to the Labrador coast a medical degree, a skipper's experience for operating a hospital ship, and a missionary's zeal. He convinced a St John's merchant to donate a house in Battle Harbour and established his first hospital in 1893. A second, seasonal hospital began admitting patients at Indian Harbour, Labrador, the next year.

Within a few years, the RNMDSF, worried about the financial drain of Dr Grenfell's ever-expanding work, began to withdraw its support. He responded by setting out on lengthy fundraising tours throughout Canada and the United States, speaking to universities, organizations, and charitable foundations. Early on, seduced by the number of prospective donors, he began concentrating his endeavours in the United States. He was gifted with special prowess as a speaker and fundraiser, and donations began pouring in. But more than just financial support was forthcoming: legions of highly qualified medical personnel, teachers, other skilled professionals, and young people and college students known as WOPs (workers without pay), lured by Dr Grenfell's charisma and challenge, volunteered their time to his effort. Construction of a third hospital, in St Anthony, Newfoundland, began in 1901. Here, in this tiny settlement on the northeastern tip of the Great Northern Peninsula, Dr Grenfell established his headquarters.

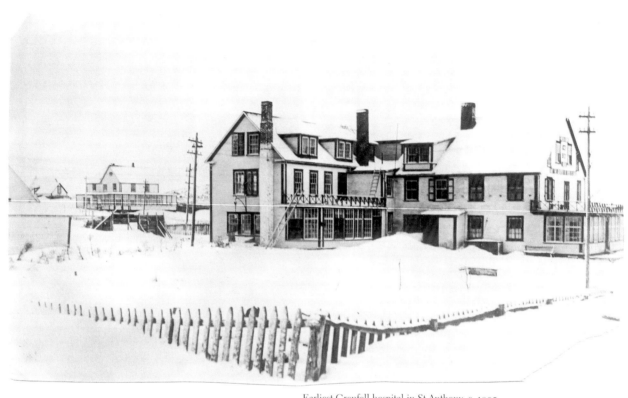

Earliest Grenfell hospital in St Anthony, c. 1905
(PANL VA118-258)

Grenfell Associations were founded in Canada, the United States, and Great Britain and Ireland to support Dr Grenfell's medical work in Newfoundland and Labrador. The International Grenfell Association (IGA) was formed in 1913 as an umbrella group for the smaller regional associations, relieving the Royal National Mission to the Deep Sea Fishermen of its involvement.

BEGINNINGS OF THE
INDUSTRIAL: WEAVING

Dr Grenfell realized early on that medical help alone was not enough for the people of the outports. His daughter, Rosamond G. Shaw, remembered her father saying, "If you hand out charity, they'll hate you."[5] Dr Grenfell firmly believed that outright gifts of money, food, and clothing would offer no long-term help to the families he was trying to reach. This belief formed the seeds for the establishment of the cottage industry known as the Industrial, which produced a number of distinctive handicrafts, including weaving, woodworking, and embroidery, as well as the now well-known hooked mats that are the subject of this book.

Dr Grenfell's vision of what the Industrial would become was immeasurably enhanced by Jessie Luther, an early pioneer of occupational therapy in the United States. While on a fundraising tour in the spring of 1905, Dr Grenfell was introduced to Luther in Marblehead, Massachusetts. Originally from Providence, Rhode Island, she was an accomplished professional artist who championed the Arts and Crafts move-

ment, which attempted to counter the rapid changes arising from industrialization by encouraging a return to domestic handicrafts. Luther was involved in setting up a small sanatorium in Marblehead, known as the Handicraft Shop, which offered such crafts as pottery, weaving, and woodworking as treatment for patients recovering from nervous collapse and similar maladies. This was an unusual form of treatment; a rest cure was most often prescribed at the time. Dr Grenfell was immediately impressed by her methods, seeing in them a way for the northern fishermen's wives to add to their families' meagre and unreliable income from fishing. With his usual enthusiasm and impetuosity, Dr Grenfell urged Luther to make the journey to the Grenfell Mission headquarters to start a weaving industry. Always tempted by a challenge, she headed north to St Anthony on 29 June 1906 for what was to be the beginning of nearly ten years of unselfish service to the people of northern Newfoundland and Labrador and the Grenfell Mission.

For a woman of nearly forty-six years of age to have attempted this journey on her own tells us something of Luther's indomitable spirit. The trip took days by train and steamer, all with uncertain connections and travelling conditions. Luther felt that the uncertainty made "it all the more interesting."[6] Several factors combined to make the outcome of this first trip frustrating for Luther. She saw Dr Grenfell only once, and in his absence there was no-one to support her efforts at the Industrial. The short duration of the trip was a major deterrent, as was the fact that it was summertime: all the women were busy making the fish and had no time to devote to crafts – a

pursuit they could not be convinced would be of any benefit to them. All things considered, Luther found establishing a viable crafts industry on a permanent basis impossible. However, she did not give up; when Dr Grenfell invited her to return the next fall and stay through the winter, she readily agreed.

Luther was trained in a host of crafts, including wood-carving, carpentry, basketry, weaving, and pottery. Now that she knew the odds she was facing and had a better understanding of the local culture, she wasted no time introducing these skills to the local people. Shortly after her return, she noted in her journal: "I talked with Dr Little[7] tonight about the industries and submitted a plan for immediate development … The men and boys are to meet me Wednesday night in the Loom-Room to talk about pottery, woodcarving and drawing, the women on Thursday to plan weaving, spinning, basketry and mat-making. Classes will be formed for the winter and the work begun after Christmas."[8]

Luther's primary aim was to establish weaving as a source of pride and profit for the local women. But many difficulties had to be overcome for the weaving project to become profitable. Luther first had to teach the local women how to weave, as no cultural precedent existed. She found the transportation of supplies extremely difficult, irregular, and expensive. The small sheep population was in continual danger because of the basic instincts of the essential husky dog, so wool had to be procured elsewhere. (The Canadian Handicrafts Guild in Montreal encouraged the project by donating wool – 200 pounds in 1907 – and samples of homespun to

the Industrial.) Because of the size of the looms, weaving could not easily be performed in the women's small homes, often making it necessary for them to travel many miles by dog team to St Anthony to work in the Loom Room. Luther trained local girls, then sent them to the outports dotting the coast to instruct a curious but suspicious group of women. Accustomed to existing on the uncertain results of the summer's fish catch, the women were often unwilling to try anything new. It took several seasons, but with Luther's uncompromising faith and careful planning, a successful weaving industry was established with centres in St Anthony, Griquet, Cook's Harbour, and Flower's Cove, Newfoundland; Harrington Harbour, Quebec; and Forteau and Red Bay, Labrador. The Mission paid the women by the yard, and the weavers frequently kept half of the cloth they wove. Weaving became a thriving business for the Industrial; in time, demand by the buying public exceeded the supply. Coverlets, table scarves, floor rugs for bathrooms, and cushion covers, as well as homespun sold by the yard or fashioned into products such as bibs, purses, and laundry bags, found an enthusiastic market at the Industrial's sales.

As early as September 1906, locally made crafts were ready for sale. Luther writes in her journal with disappointment, "The *Portia* (the coastal boat) came today in the midst of a howling gale and not one passenger came ashore … We felt deflated for the shop was in perfect order, with all the goods displayed."[9] By 1907, the Mission was actively seeking markets for the Industrial's products. The Canadian Handicrafts Guild in Montreal reported in its bulletin that

Jessie Luther in St Anthony, c. 1906
(Martha Gendron)

arrangements had been made to become a distribution centre in order to "aid Dr Grenfell in his practical mission."[10] Two years later, Luther's journal recorded that goods were being shipped to shops in St John's: "We have been busy all afternoon pricing and packing articles to be sent to St John's for sale, and the size of the box is quite impressive."[11] The next July she wrote, "We have just finished packing a box of miscellaneous products destined for exhibition and sale at Montreal and hope it is the first of many."[12] After each of Luther's trips north she returned home to the United States with a small cache of Industrial products to show and sell: ivory carvings, embroidery on doeskin, grass baskets, weaving, hooked mats, knitting, tinware, and small wooden items – toys, letters openers, window wedges, napkin holders. The crafts found an eager market in the New England states.

MATTING SEASON

Although Dr Grenfell and Jessie Luther were certainly aware of the flawlessly hooked and colourful mats that abounded in the houses of the local people, the potential of this craft was overlooked in the first few years of the Industrial. Mat-hooking in Newfoundland and Labrador did not originate with the Grenfell Mission; rather, it was a utilitarian craft whose roots lay with the earliest English and Scottish settlers and spanned decades by the time Dr Grenfell arrived in 1892. Highly skilled local women were producing technically perfect rugs simply to cover and add warmth and decoration to their cold, bare floors. Every woman

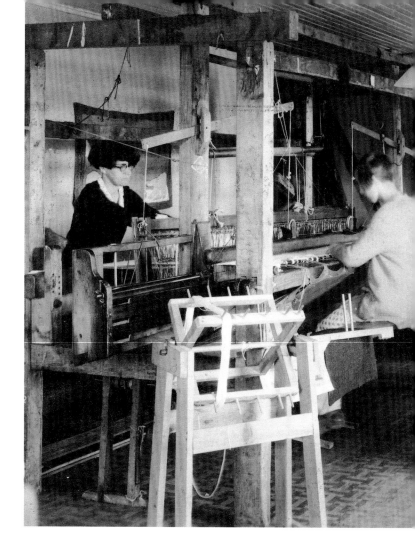

hooked, most from early childhood. "I's always bin hookin', ever since I'd be big enough to hold a hooker and sit on a stool," quipped an elderly mat-hooker in her distinctive northern lilt.[13] "There's nothin' in this world I likes better than hookin' a mat," said another[14] as a group of women recalled their mat-hooking days. Perhaps the bold colours, undisciplined designs, and stamped patterns[15] sold by the traders kept the saleability of the women's mats from being immediately apparent.

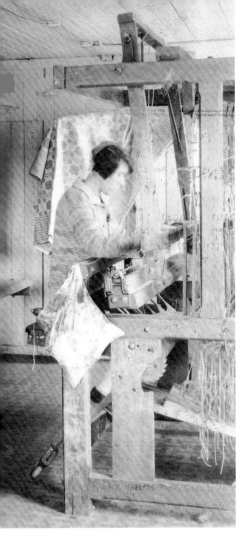

Girls weaving at the looms in the Industrial Department at St Anthony, c. 1925 (Wilfred T. Grenfell Papers, Manuscripts and Archives, Yale University Library)

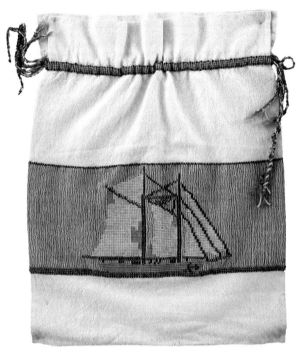

Examples of weaving.
Laundry Bag: woven linen with supplementary weft design, 21 x 16.5 inches. In production by 1923. To achieve the pattern, workers wove individual strips and used separate bobbins to insert small designs into each strip.

Bib: woven with mercerized thread, hand embroidered. 12.5 x 9.5 inches. Bibs were in production by 1930; a bib similar to the one shown here was featured in "Jane Loring's Where to Shop" guide in *Harper's* magazine in November 1930 and praised as being an "extraordinarily nice present."

The quiet months of February and March were known as the "matting season" all along the coast. It was a time of respite from the demands of making the fish. Luther termed it "an annual psychological moment"[16] when all the women began to hook mats. Even recently, one woman whose age and eyesight prevent her from hooking said, "Every spring when the time comes to go matting, my mind flashes back. I wish I was doing them now."[17]

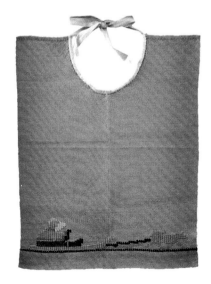

No special equipment was necessary for mat-making, and what was needed did not cost anything and could easily be made by the women's husbands. Each home had a mat frame, made from four pieces of wood lashed together. When not in use, it was stored against the wall and out of the way. The hook was merely a filed-off, bent nail pounded into a whittled stump of wood, which with constant use was polished smooth and fit snugly into the contours of a woman's hand. Mat-hookers drew their patterns on old grain, flour, or sugar sacks (potato sacks were too coarse) with the burnt end of a stick. No scrap of material had seen the end of its life until it was hooked into a mat.

The traders sold "stamped mats" as early as 1870, which the women prized for their bright colours and flowery designs. Almost completely removed from the influence of books, pictures, or art in their remote setting, the women eagerly copied the patterns from one another, believing that a manufactured pattern was superior to those they could design themselves. They made duplicates by placing a piece of paper under a stamped design and punching out its outline with a pin onto the paper. The result was a stencil that could then be inked onto a piece of sacking. In this way, mat-hookers integrated new patterns into their creative work. But Luther termed the stamped mats "ugly designs in glaring and inharmonious colours [sold] with pound packages of bright colours,"[18] and felt they were unsatisfactory and unsaleable.

Colourful and appealing "scrap mats" or "hit and miss mats" (mats of a hooker's own design, made with bits of old clothing) were also being hooked. The designs were often blocks or triangles arranged like a patchwork quilt; others were circles or simple shapes; still others showed intricate floral motifs. The women frequently offered to sell these mats to Dr Grenfell or Luther in exchange for medical services. The best of them would be accepted and would serve as an "interesting addition to our annual sales as curios."[19]

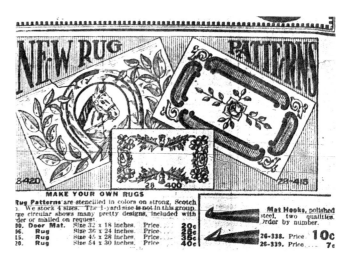

Examples of stamped rug pattern advertisements from Eaton's catalogue, Fall/Winter 1922/23

Dr John Little of the St Anthony hospital was the first to note the mats' possible usefulness in preventing the spread of disease. Men frequently used the hooked rugs, which were the only floor coverings, as targets for spitting. In November 1907, Luther wrote in her journal that Dr Little, in his zeal for combatting the prevalent tuberculosis, had "designed a rug with the device 'Don't Spit' in red letters on a white background, bordered with a pattern in red and green. Several people have used the design on door mats."[20] None of these original mats is known to exist today.

THE MATTING CLUB

Luther was familiar with the successful Abnakee hooked rug cottage industry developed by Helen Albee of Pequaket, New Hampshire,[21] and subsequently saw the same potential in Labrador and began to pattern the Industrial along similar lines. Her initial challenge was to pique the local women's interest so that they would become involved. As with the weaving, this was not easy. The first mention of organizing the matting industry occurs in Luther's journal on 29 January 1908: "This afternoon was the beginning of the matting club. Several women came but evidently with the idea of looking around before committing themselves."[22] And on 5 February 1908: "Mr Ash brought the matting frames for the class today, but none of the women appeared; 'too dirty'[23] the girls said."[24] A week later she wrote: "This afternoon was reserved for matting, and it was a blow when Mrs Pelley appeared. When I asked where the others were, she said they all

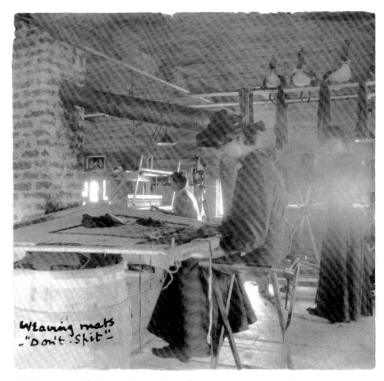

Weaving mats in the Loom Room in St Anthony, c. 1910 (PANL VA118-51-2)

went to Miss Storr[25] one afternoon a week for a bible class and thought that was enough engagement. It troubled me at first, but later I discovered a matting class met last year at the hospital and Sister Williams, the nurse, had given them a cup of tea. I suspect that in my zeal for work I have not had social function in mind, so when the girls have made several really lovely rugs, the women will be invited to see them in the solarium when it is warmer, and we will have tea there. We will see what happens."[26] It is possible that the women did not feel the need for lessons in a craft they had already mastered.

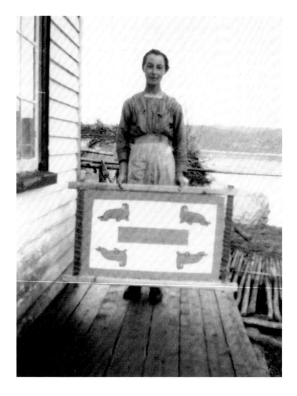

A young girl in White Bay, Newfoundland, displays
her mat, c. 1922. The mat is similar to those designed
by Jessie Luther. (Elizabeth Page Harris Papers,
Manuscripts and Archives, Yale University Library)

There is no further mention of any problems,
and Luther writes with enthusiasm on 16 February
1908 that Dr Grenfell "approves of the plan for
the women's matting class."[27] In an April 1909
article in *Among the Deep Sea Fishers*, Luther
commented that the matting work was planned
for the older women, who would meet once a
week for a social afternoon.[28] Perhaps she realized
that the key to success might just be a cup of tea!

Luther designed some simple patterns using
themes of local significance: fish, dogs, seals,
walrus, jellyfish (with four central rings), ducks,
bears, rabbits, ships, gulls, reindeer, and a Lap-
lander with herding dogs and tents. The designs
were treated as borders running around a plain
centre. The mats were to be hooked using new
wool and outing flannel,[29] some of which Luther

purchased from Helen Albee. She distributed
mat bundles, which included the pattern marked
on a brin[30] base and materials for hooking, for
the women to work on at home. Colour samples
pinned to each part of the pattern indicated where
to use each colour. Luther frequently mentioned
in her writings that mats of good workmanship
and colourings that would not "clash with average
household furniture should find a ready market."[31]
The rugs were designed as furnishings to be lived
with, not as curios, and were sold for prices rang-
ing between $6.50 and $25 depending on size,
design, colouring, and workmanship. It is certain
that only a small number of these early mats were
hooked. While a few were undoubtably included
in Luther's New England sales, most have not
survived.

Early Dyes

During the earliest days of the Industrial, Luther attempted to introduce vegetable dyes to colour wool for weaving and new cotton and wool flannelette for matting. She noted that some of the women "already appreciate the beauty of vegetable dyes and soft colouring."[32]

The dyeing was carried out in the Loom Room, in an enamelled dishpan over a little Florence oil stove. Paten bark powder,[33] a dye the fishermen used to colour their sails and nets and thereby prevent rot and mildew, produced a soft pinkish brown. When the bark powder was used as a weak dye, it produced a lovely, delicate colour that was fast and easily replicated. Spruce twigs mordanted with alum gave a pretty fawn colour. Madder and indigo were used, as was copperas (ferrous sulfate) with lime, which yielded a rust shade. Browns could be derived from lichen gathered from rocks and trees. The objective was to obtain colours that would be durable.[34] The Canadian Guild for Crafts in Montreal supplied Dr Grenfell and Luther with samples and recipes for dyes in 1909. Luther acknowledged receiving them, saying she anticipated "much pleasure experimenting according to their instructions and suggestions."[35]

Vegetable dyeing took valuable hours and demanded considerable expertise, a keen sense of colour, and proper equipment, all of which were in short supply at the Industrial. Commercial aniline dyes, coal tar dyes, and alizarines, introduced in the middle of the nineteenth century, were colourfast and much easier to manage. They still needed careful blending to acquire the perfect hues Luther required, but the process was considerably more efficient. Dyes were repeatedly mentioned in the constant appeals for donations of raw materials needed by the Industrial and acknowledged with relief when they were received: "[T]he long delayed box of dyes … has at last arrived."[36] The Mission also stressed that clean rags that did not have to be dyed would be gladly accepted.

DR GRENFELL'S CONTRIBUTIONS:
THE HOOKED MAT INDUSTRY

Dr Grenfell's recognition of the hooked mats as a viable part of the Industrial, which had originally focused on weaving and woodworking, may have been heightened while he was on a trip to Battle Harbour in 1910. Luther reported that, after disposing of important matters, Dr Grenfell sat down and began drawing designs for hooked mats to be given out to the local women.[37] He credited himself with coming up with the idea of turning the hooked mats into a beneficial industry in 1912, when he and his wife Anne[38] were visiting the home of a prosperous fisherman at the edge of Newfoundland's Hare Bay. The fisherman's wife and daughters proudly displayed their winter's mat-hooking for the doctor and his wife. Their work was beyond reproach, and the idea of standardizing and refining the mat-hooking to suit the marketplace quickly became Anne's project. Dr Grenfell wrote an article, "The Hooked Mat Industry," for *Among the Deep Sea Fishers* in May 1913, enthusiastically announcing that one result of the winter's work had been the

"development of a new industry which promises to be very helpful indeed to the poorer women of the coast."[39] In the article he made no mention of Luther or her attempts at establishing mat-hooking as an important part of the Industrial, although he echoed her sentiments that the mats being hooked by the women were "extremely unattractive … even the stamped patterns are generally impossible flowers or mottoes."[40] Two years later he returned to this theme, writing that the colours used would be unattractive to buyers: "[T]he assortment of colours in the mats designed by the women themselves, we might almost ascribe to the 'futurist school'."[41]

Dr Grenfell had a whimsical artistic talent and designed patterns of northern images that included reindeer, dog teams and komatiks (Inuit sleds), wild geese flying high over spruce trees, a snowy owl perched in a fir tree, polar bears on ice floes, as well as scenes depicting life in Newfoundland and Labrador, such as the killing of a whale, a lynx stalking crows, and foxes hunting partridges. Despite these efforts, he did not seem overly optimistic about the long-term benefits of the hooked mat industry: "Although perhaps it will never be possible to make the industry entirely self-supporting, as so many of the mats have to be given out to people who need work, but who may not combine with this the ability to make a mat well enough to be saleable, yet we feel that by making the patterns to represent local scenes, and of new and similar materials, it should be possible to find a market."[42] He was quick to point out, however, that the women loved seeing a scene unfold under their fingers and that all who had seen the new patterns "wanted to possess themselves of them as souvenirs."[43]

Another idea of Dr Grenfell's was to exhibit the mats for the purpose of getting orders. The strategy seemed to work; a sale in Boston in 1913 sold an impressive $400 worth of Industrial products. In 1914 McHugh's, a fashionable shop on Manhattan's 42nd Street, ordered a sample mat of each pattern. The mats were being sold strictly as business, not charity, proving their merit. Anne Grenfell stated in a letter to W.R. Stirling, a close friend and confidant of the Grenfells and a founding member of the International Grenfell Association (IGA), that "the death of the head of [McHugh's] would make no difference in their pushing the mats. We have sent them 50 already this spring [1916], we have sold about 50 others and have orders on hand for more. I am particularly glad that it is going ahead this year, as the fish are so scarce here in St Anthony, that the women have kept right on coming through the summer, an unheard of thing, as usually they are so busy making the fish. We give out an average of twenty a week."[44] These figures represent a significant jump in production compared with the previous year, 1914–15, when the combined St Anthony and Griquet branches of the Industrial produced 230 yards of homespun, forty knitted articles, and twelve hooked mats. The increase can be explained by the report of a poor fishing season and the women's resultant willingness to hook during the summer months

The Resignation of Jessie Luther

When Anne Grenfell endeavoured to standardize the hooked mat industry, thus becoming directly involved in the daily workings of the Industrial, Jessie Luther became increasingly dissatisfied. Anne wrote a letter to the IGA board complaining that Luther "was not willing to sell except at a very high profit ... and that she would not employ but a very few women, and never any but those who could do extra good work. Naturally ... this left out the needy ones. She implies that she ... stopped giving out her mats in large numbers ... when we [the Grenfells] came into the field ... but Miss Luther never gave out mats in any quantities."[45] Anne pronounced the mats designed by her husband "more interesting," saying that "even the people who hooked them liked them better."[46] She also declared, erroneously, that Dr Grenfell had started all the local industries on the coast "long before Miss Luther came."[47] In a breach of social decorum, the contents of this letter were repeated to Luther.

Citing differences of opinion, Luther resigned at the end of the summer of 1915. In her letter to the IGA board she made her position clear: Dr Grenfell's "aims in regards to the standards, management and development of the department are so at variance with my own and what is more important ... the lack of any regard on his part to verbal or written agreements make[s] further associations with him utterly impossible."[48] She wrote a similar letter to Dr Grenfell and, referring to a meeting between them requested by the board, stated that, "as the discussion in regard to my resignation is absolutely final, such a meeting is neither necessary nor advisable."[49] She ended her letter: "It is with extreme regret that after all these years in which I have given my utmost of time, strength, ability ... the end should come like this, but now it is inevitable."[50] Dr Grenfell's response to her letter of resignation contained a further hint of their discord: "Your fears about our little mat industry seem groundless. We have on hand now orders for 140 mats, 75 of these being for repeat market trade."[51] In her pursuit of the highest standards of workmanship, Luther had altered indigenous designs and trained her workers to produce only highly saleable crafts. She had been fighting for the establishment of a permanent Industrial fund with an endowment of $1,000, which would be used to pay the workers, purchase needed materials, and cover shipping costs. She considered this plan essential for the Industrial work to progress, and it had not been implemented.

Despite Anne Grenfell's criticism, Luther deserves the praise Dr Grenfell lavished on her many years later in referring to the important role of the Industrial in nurturing the lives of the local people: "Increasingly, as I grow older I realize the debt of gratitude I owe you. The key to the whole situation is the Industrial Department."[52] Luther built the Industrial from the barest of beginnings. By the time she resigned, after nearly ten years of faithful service, it was fully developed. She persevered though her efforts had been hampered by insufficient and expensive materials, difficulties with dyeing and transportation, and the huge task of creating markets. As a trained artisan, she encouraged and inspired superior work. She had traveled thousands of miles along the rocky coastline instilling a feeling of interest, self-reliance, and self-confidence in the workers. For them, financial benefit had followed. Luther gave the

people the "courage to attempt and the ability to do."[53] She remained loyal to the Mission, making a return visit in 1930 and calling her years of service "the most stimulating experience of my life."[54] Luther continued to lead a full and active life until she died, less than a month shy of her ninety-second birthday.

FURTHER DEVELOPMENTS IN THE HOOKED MAT INDUSTRY

The Grenfell Mission now regarded the hooked mats as an important asset to the Industrial's effort and infused new energy into its further development. "The mat industry is a bonanza to our consciences, and a solution to a difficult problem … of putting clothing and a little ready cash within reach of many needy women and children,"[55] wrote Dr Grenfell in 1916. Diverging from his early petition for donations of old clothing, he now echoed Jessie Luther's request for only new materials: Canton flannel,[56] outing flannel, and woollen flannel. Using new materials insured that the mats were absolutely clean and sanitary, and added durability to the product. Assembling kits for distribution to the mat-hookers based on the sixteen patterns designed by her husband, Anne claimed, "It takes me three and one half hours every day to get ready the necessary mats, and with them and Wilf's correspondence I can refute the statements of certain ones that I do nothing all day long! For years I have worked very hard on this mat industry and I am interested to see it go ahead."[57] To meet demand, Anne was preparing twenty-five mats a week, cutting and hemming brin, drawing and stencilling designs, and tearing the materials into strips. Each mat took twelve to eighteen yards of new material. With each mat she gave out, Anne supplied a small painted picture of what the finished article should look like. Still, the mat-hookers often added their own touches or deviated from the instructions, and not all hookers worked with the same flawless precision. In the post-Luther era, the Mission gave work to all who needed it. It was strongly suggested that mats not coming up to standard be pulled out and rehooked. (Today, when reminded of this policy, mat-hookers shuddered and avowed that they would rather take a smaller payment than struggle with the difficulties of pulling out and rehooking a mat.)

The usual selling price for a standard (26 by 40 inch) mat was $5.00. Of this, the mat-hooker would get $1.50, with the remaining $3.50 going toward the costs of the brin on which the mat was hooked, the new flannelette or wool used in the hooking, the dyes and dyeing, and marketing expenses. In a six-month period in 1916 the Industrial reported selling about 200 mats, which represented payments of $300 to the mat-hookers. Interested buyers were assured that the mats "were really very quaint, attractive, durable and useful, especially in halls, bathrooms or nurseries."[58] In 1917, 360 mats were sold at a higher price; they were made by sixty women and represented an earning of $20 for each. Considering that no family was earning as much as the equivalent of $500 per year for a household often having five or more children, and that many people had never seen money – the yearly fish catch was traded for supplies – the change wrought by the Industrial was clearly substantial.

The mat-hookers almost always took their payment in the form of clothing vouchers. There were few, if any, places to spend cash, and people were accustomed to a barter-based economy. (One mat-hooker did remember having often stayed up all night to finish a mat so that she might have twenty-five cents for the church collection plate.[59]) The families desperately needed proper clothing and supplies; to that end, the Mission offices and churches throughout Canada, the United States, and Great Britain collected bales of new and used clothing, footwear, blankets, toys and games, Christmas decorations, sweets, books and magazines, seeds, preserving jars, and all manner of other donations for shipment to St Anthony and other outports. One report cites a donation from Toronto containing "20 utility bags filled with everything needful to keep a young girl tidy and clean."[60] The Mission operated separate clothing stores, and the mat-hookers and other Industrial workers took their vouchers there after delivering their finished goods. Many of the hookers I interviewed remembered with pleasure the array of clothing earned by their handiwork. Clothing was often given out in ten-cent or fifty-cent bundles, containing six to eight pieces of clothing. Mat-hookers were unanimous in saying that it simply did not matter what was in a bundle. If a sweater was too small, it could be unraveled and reknitted into several pairs of mittens; if a coat was too big, its material provided a warm pair of trousers. The Mission enforced a strict rule that only one "baby bundle" could be taken per family per year. In this manner, whole families were clothed "inside and outside." In later years, as conditions improved, women began to take cash to use for paint, wallpa-

per, curtain fabric, oilcloth for the floor, and other small luxuries at one time undreamed of, which could be purchased through the Eaton's catalog.

A succession of supervisors followed Jessie Luther at the Industrial. Anne Grenfell remained involved with its workings, but increasingly preferred to spend time in the United States fundraising and procuring scholarships to American colleges and universities for deserving young students from Newfoundland and Labrador. Alice Blackburn[61] had worked with Luther and upon the latter's resignation took over the day-to-day operations of the Industrial until 1918. In 1917, she requested sufficiently long new pieces of black broadcloth or black woollen pieces for use in the hooked mats and reported that the hookers had completed nearly 200 mats and were scrambling to fill additional orders. Many of these mats were special orders; as each was completed it was mailed directly to its purchaser. In 1920, Laura Young[62] assumed the leadership of the Industrial through the generosity of three friends of the Grenfell Mission who pledged to support her in her position for two years. During her tenure, the Industrial continued using outing flannel and new wool and supported sixty mat-hookers, paying each an average of $22 a year. Young is credited with putting the Industrial on a sure foundation and expanding the work in areas along the Labrador coast, especially in Red Bay, a picturesque fishing village nestled beneath high reddish cliffs along the Labrador Straits. Red Bay became the Industrial centre for the Strait of Belle Isle on the southern Labrador coast.

Local girls became skilled teachers and were sent out to direct the Industrial work all along the

coast. Notable among them was Minnie Pike. Young assigned Pike to supervise the growing Industrial effort in her home village of Red Bay. Pike was a most capable worker whose talent and loyalty to the Grenfell Mission earned her several scholarships, to Berea College in Kentucky in 1920, and to other vocational schools across the United States. Full of energy, she taught weaving and mat-making and distributed the Industrial's goods, sent over from St Anthony, down the length of the Strait until "she was an old lady."[63] Dr Grenfell showed particular concern for her welfare, asking a Mission worker to make sure that Minnie was always properly fed.[64] She worked in one capacity or another for the Grenfell Mission nearly her entire life, and was a dominant factor in the success of Red Bay in the Industrial's efforts for the Mission.

More than twenty copyrighted mat patterns, including several new designs, were in production in the period from 1918 to 1923, among them two walrus on ice pans, a fleet of four schooners sailing north, a fox chasing a rabbit, three bears travelling behind one another over the snow, three dogs with traces resting in front of a cabin, and two men paddling a canoe by a bear on an ice floe. To cover rising costs, the price of a standard sized mat rose to between $6.50 and $8. Sorely in need of flannelette to meet demands from the mat-hookers, the Mission felt obliged to make the increase, despite feeling it would present a real handicap to sales.[65] However, sales remained strong, and by the end of the summer of 1921 a record number of 410 mats had been hooked, bringing the cumulative total from 1912 to 1921 to slightly more than 1,300 mats.

White Bay, Newfoundland

Few of the Industrial's records survive, but accounts cataloguing its efforts in the White Bay area on the eastern coast of Newfoundland are extant at Yale University. They provide important information about the matting industry, and we can assume that similar activity was happening in the St Anthony area and on the Labrador coast.

In 1921, Elizabeth Page,[66] a tall, pretty Vassar graduate, journeyed to an outport in White Bay to teach nutrition classes to the local women. On her arrival she found that all the people had relocated, so she continued on to Brown's Cove, a tiny, isolated fishing community at the bottom of White Bay. Page eloquently described the scene she found: "[T]he shores were wonderful, densely wooded mountains, often breaking off at the sea in red-brown cliffs. I have never before seen anything more beautiful."[67] Grenfell soon visited the area and urged Page to survey the local women in order to identify those who could contribute to the Industrial effort. Reporting a fair degree of interest, Page went to St Anthony for training at the Industrial so that she might establish a strong base of capable workers in White Bay the next summer. She returned and for the next two summers made a weekly circuit by motorboat supervising the more than ninety workers in the outports of the Bay: Englee, Hooping Harbour, Williamsport, Harbour Deep, Jackson's Arm, Sop's Arm, Westport, Purbeck's Cove, Pembley and Granby Islands, Fleur de Lys, Bear Cove, to name but a few. She offered encouragement and instruction, dispensed materials for mats, picked up finished pieces, and sent those accepted to St Anthony for

Minnie Pike and assistants, c. 1932 (PANL VA118-20-240)

distribution and sale. Her journal lists the contents, valued at $107, of one trunk bound for St Anthony:[68]

1 floral (brin) mat
1 floral (flannelette) mat
4 dog team mats
2 bear and seal mats
3 flying geese mats
2 mother bear and cubs mats
2 bear on ice pans mats
1 reindeer team mat
2 fox and rabbits mats
2 goose marsh mats
2 scrap mats
4 woven bedspreads
13 woven runners

Page firmly supported the Mission's belief that work for the Industrial should be kept supplementary to the local industries of fishing, lumber, and trapping, but she also recognized the beneficial results of the women's being able to share in providing for their families. She delegated the most skilled workers to supervise the winter work in their communities so that it could continue in her absence.

Interestingly, in the White Bay records for July, August, and September 1924, of the 113 mats shipped to St Anthony, one was a special order and forty-nine were "native pattern scrap mats." Scrap mats were subject to the same careful scrutiny for competent hooking. According to the few records available, prices paid for them equalled or exceeded those for Mission picture

mats. The scrap mats were important for keeping alive traditional ideas and encouraging women to retain their own identity in their craft.

Mission staff kept careful account of the Industrial work. To improve the system of record-keeping, specially designed cards were introduced in 1923 to track whether a worker's family was in need, the kind and grade of work she did, the amount of work she had been given and had returned, and how much she had been compensated. A girl earned the right to her own card at the age of sixteen. The records for the White Bay area at this time provide the following data: Of eighty-nine mats given out in 1922–23, twenty-seven were not returned; of the sixty-two returned, half were pronounced "excellent work" and averaged a payment of $2.50 per mat, sixteen were "good" and brought about $2.30, eleven were "fair" and brought $1.75, and five were "poor" and either were not paid for or received a small token payment. The staff made telling comments beside many names, such as "needs work, mother has TB, father old." The emphasis was on well-made, clean, carefully standardized work. While Mission policy was to accept only work that met its criteria, cases were certainly dealt with on an individual, by-need basis. Some substandard mats were accepted and used as sample mats, or sold locally or at staff sales as seconds.

Page kept a notebook with extensive lists of things to do. One page itemized orders she had to fill for respected department stores in the United States: W & J Sloane on Fifth Avenue in New York City had ordered 200 scrap mats; wool flower mats were needed for H. Garrett on 10th Street in Manhattan; and Carson, Pirie, Scott in Chicago had requested Mission picture mats.[69] Page worked tirelessly to organize the matting industry in the White Bay district until 1924, when she returned to the United States. She maintained a continual correspondence with her Industrial workers and remained an ardent supporter of the Grenfell Mission.

St Anthony

During the same period, work progressed with nearly assembly-line discipline at the Industrial in St Anthony, now under the able direction of Catherine Eloise Cleveland of Kensington, Maryland. Cleveland joined the Mission's staff in 1922 as a teacher travelling with the nutritional unit in Labrador. In September 1923, she replaced Alice Blackburn (who was briefly back in charge after Laura Young's tenure) as the Industrial supervisor in St Anthony. Cleveland, trained at the University of Wisconsin, had a highly specialized industrial arts and economics education. For three years, she devoted all her energies to the Industrial work. Like Laura Young's, her position was supported by friends of the Mission. Endeavouring to unify, simplify, and broaden the reach of the Industrial, Cleveland travelled the entire coast acquainting herself with the difficulties and possibilities at each Mission station. Another Industrial worker wrote, "Words fail me to note the advance in the Industrial work. The early work of Miss Luther, the Misses Schwalls, Miss Young, Miss Pollard,[70] Mrs Blackburn … has blossomed out under Miss Cleveland. We could not believe that such

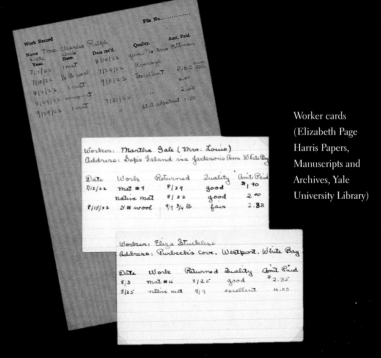

Elizabeth Page, "Taking Sample Mats Ashore," Coachman's Cove, Newfoundland, 1925 (Elizabeth Page Harris Papers, Manuscripts and Archives, Yale University Library)

Worker cards (Elizabeth Page Harris Papers, Manuscripts and Archives, Yale University Library)

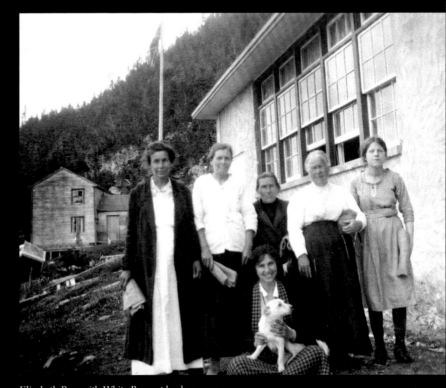

Elizabeth Page with White Bay mat-hookers, 1925
(Elizabeth Page Harris Papers, Manuscripts and Archives, Yale University Library)

beautiful mats … could be done by our people."[71] The quality of the mats was better than ever.

Although solicitations for an endowment for the Industrial effort never ceased, funds were now available to effect desired changes at St Anthony, which included moving into larger quarters, specifically, ten rooms in the old orphanage building. The Mat Room in the new quarters bustled with workers preparing bundles for distribution to the mat-hookers. Bins containing parcels of different-coloured flannelette and other fabrics lined the room. The use of a spectrum of colours made each mat distinctive. Cupboards contained shelves where mats were stored in an organized manner. In the Loom Room, girls tore the flannelette into three-yard lengths. (The mat-hookers would cut their own quarter-inch strips from this yardage.) They used this measure because it took three yards to hook a border on a standard-sized mat, and gauging yardage for other sections on the same basis worked well. Women came on Tuesdays and Fridays to deliver finished work and pick up new work. A summer worker remembered wrapping and giving out ninety-six mat bundles in one day. Workers weighed new work before distributing it to the mat-hookers. When the finished mats were returned, the weighing process was repeated to make sure that all the material that had gone out came back. The women were scrupulous about returning all the hooking flannelette they had been given, even sweeping up the cut-off scraps (and dust!) and stuffing them into the toe of an old stocking.[72] Many mat-hookers came by dog team or rowboat; often several days of travel were required to complete the round-trip journey to pick up or deliver their work. During the winter months, an Industrial worker toured the remote harbours of the district by dog team, visiting the local women. Her komatik was loaded with mat bundles and other supplies, as well as small luxuries such as cocoa and beans. The trip could take from a week to a month and provided welcome social contact and encouragement for the mat-hookers.

New designs were constantly adopted in an effort to keep abreast of current trends and fashions. While many retained a northern motif, new patterns often reflected an artist's whim or were designed for the intended market. Colonial nostalgia was sweeping the United States and Canada, and the interest in hooked rugs was keen. The craftswomen eagerly hooked the new floral patterns that the Industrial's staff designed and distributed to satisfy requests from customers.

Elena (Nina) Hepburn is credited with designing large and small mats of this type, which were hooked using cotton, wool, brin, and silk. From Freehold, New Jersey, Hepburn volunteered for the Industrial in Indian Harbour and North West River, Labrador in 1924. She also worked in Muddy Bay, Labrador in 1925–26. Besides designing mat patterns, she taught workers at the Industrial to make whimsical walking sticks with carved handles, delightful toys, and dickies with embroidered pockets and bands around the sleeves and hood.

Jean Wishart of Toronto spent the summer of 1925 in St Anthony also designing floral mats. She added nursery mats to the growing list of patterns as well, including "Mary and Her Little Lamb," "The Fat Pig that Went to Market," "Humpty Dumpty Who Sat on the Wall," and "Goosie,

Goosie Gander." In a letter to her parents she wrote, "I am designing rugs – I did a nursery theme today."[73] A relative remembers Wishart saying that she designed floral mats that would appeal to the American taste at the time and adapted early American cross-stitch designs into hooked mat patterns. Wishart, who trained at the Ontario College of Art in Toronto and Cooper Union and the Art Student's League in New York City, was an example of the type of talented artisans Dr Grenfell was able to lure northward. Because of ill health, Wishart spent only one summer with the Mission, but she remained active in the Toronto branch of the Grenfell Association, assisting at fundraisers and taking charge of mat sales.

One of Catherine Cleveland's aims was to develop a well-regulated organization for marketing the Industrial's goods. With Anne Grenfell, she worked assiduously to secure the Mission's involvement in the British Empire Exhibition of 1924. The exhibition, which took place on the grounds of Wembley Stadium and encapsulated the entire resources of the British Empire, featured a booth of Grenfell Industrial products. Grace Hamilton Parker, one of the volunteers working at the booth, provided a lively account of the display: "[T]he enthusiasm and delight over the beautiful work is never-ending. Many people try and insist that the hooked mats are woven. They have never seen such fine hooking. Of special interest are the four floral mats in the glass case – one of flannelette, one of jute thread, one of wool and one of silk. Then the familiar dog teams and polar bears are ever admired and enjoyed."[74] As a result of this exposure, orders

Invitation to the Annual Christmas Bazaar, held at Prince Arthur House, Toronto on 17 October 1956
(Private collection)

for the Industrial's products poured in from all over the world. The Mission continued participating in the Empire Exhibition for many years.

Cleveland also arranged for the Boston office of the New England Grenfell Association to act as a distribution centre shipping mats and other products to sixteen cities where interested friends of the Mission held sales. Carson, Pirie, Scott in Chicago, the Wool Shop in Highland Park, Illinois, and the Indian Curio Shop in Boston, among others, stocked an inventory of mats and sold standard-sized picture mats for fourteen dollars. From 1924 until the early 1940s, Jay's, a specialty shop on Temple Place in Boston, held an annual Christmas sale of mats and other

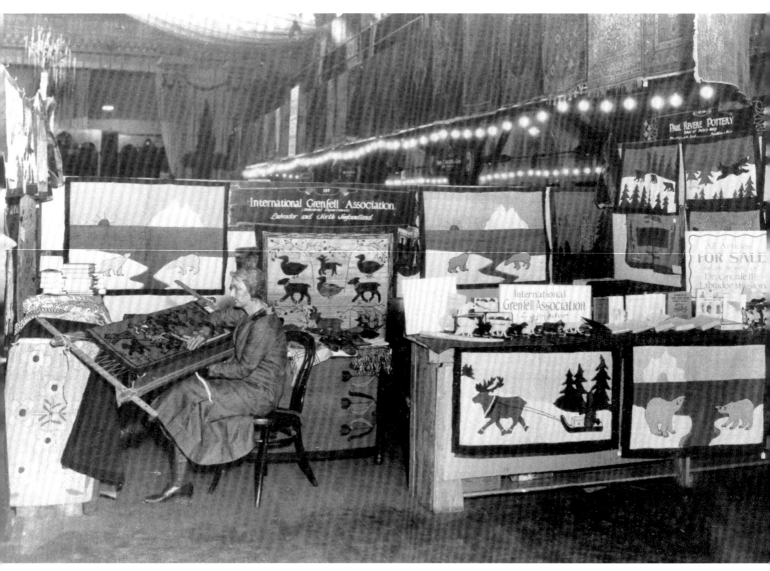

Minnie Pike hooking a mat at the Third Annual Craftsman Show in
Boston, 1927 (Point Amour Lighthouse Museum, Point Amour, Labrador)

Industrial products, providing space and advertising at no charge. Its front-page newspaper advertising stated, "Every Cent Spent for Their Work Goes to Them" and added "Hooked mats are an especial feature."[75] Selfridge & Co. in London, England, also promoted the Mission's work by donating window display and selling space for pre-Christmas sales. Mission volunteers and supporters actively hosted annual Christmas sales as well, in private homes, church guild halls, college alumni clubs, and fine hotels across Canada and the United States. A published schedule of sales lists ten such events from 3 November to 17 December 1927 in New England alone.

WHEN YOUR STOCKINGS RUN ...

Catherine Cleveland contributed more than three years of dedicated service. As a result of her untiring enthusiasm and resourcefulness, the Industrial was flourishing by the mid-1920s. In December 1926, Mae Alice Pressley-Smith (known as "Pressley") succeeded Cleveland.[76] Pressley, a "short, sturdy, gallant creature,"[77] arrived from her native Scotland with special training in handicrafts. Before joining the Grenfell Mission staff she had worked for the Newfoundland Outport Nursing and Industrial Association (NONIA).[78] Her arrival was heralded: "Miss Pressley-Smith seems a very fine person. She has some pet ideas like all new people but her ability and training are splendid. She is after the most careful work and that always pays," wrote Alice Blackburn to Elizabeth Page.[79]

Pressley's arrival launched the most significant period of the Industrial. Her new ideas, the most important of which was her realization of the potential of using silk stockings for mat-hooking, revitalized the Industrial. Jean Wishart's lecture notes from 1925 mentioned cupboards in the Mat Room full of brin, flannelette, wool, and old silk stockings, indicating that some use was already being made of them. "Old clean stockings"[80] had been cited for use in mat borders as early as 1916, but it is probable that this reference was to cotton stockings. At Pressley's request, urgent pleas went out from the Grenfell Mission in 1928 and 1929 through *Among the Deep Sea Fishers* and to a mailing list of donors in the United States, Canada, and Great Britain. "Save your old silk stockings!"[81] "When your stockings run, let them run to Labrador! We need silk stockings and underwear in Unlimited Quantities! Please send your silk stockings and underwear no matter how old or worn! We need such silk and artificial silk for the making of hooked rugs of a beautiful type!"[82]

The Mission encouraged donors to cut off the cotton tops and worn feet and heels of the stockings before mailing them, to save postage – and also to save labour when the hosiery reached its northern destination. Donors were asked not to mail parcels during the winter, because of the limits on the amount of parcel post that dog teams could carry. Sunday school teachers urged children to participate in the collecting. Rosamond G. Shaw, the youngest of the Grenfells' three children, remembered handing out pamphlets requesting contributions of silk and rayon stockings during summer sales and after her father's lectures. Dr Grenfell, characteristically,

was amazed that ladies were actually throwing away or burning something so potentially useful as their tattered stockings. He quipped that for a silk stocking "to be thrown aside as useless [must be] eternal torment. No real silk stocking would want to be wasted."[83] In a letter of July 1929 thanking the Episcopal Academy in Philadelphia for some books donated to the children of Labrador, Dr Grenfell wrote: "I am going to … ask for 'more'. Do you think you could possibly collect … for us some old silk stockings, or artificial silk stockings? We use any quantity of these in our Industrial Department, and we are always trying to interest our friends, both young and old, in collecting them … If you could collect from your family, or you could tell any of your friends to collect from their families, and perhaps tell the whole form in the Episcopal Academy to collect from their families, we would have a splendid lot, I am sure. They can be any colour or any size, no matter how holey they are or how worn, it does not matter, because they are all hooked up anyhow, and are used in the making of perfectly lovely mats which give work to poor people who otherwise would not have the chance of earning a penny for themselves. … If you and your friends can help us this way you would really be giving a 'leg-up' to Labrador."[84] (Dr Grenfell never missed a fundraising opportunity; a Toronto newspaper reported in November 1931 that, when addressing a club of *Folies Bèrgere* dancers in Paris, he suggested to them that they help mankind by sending their old silk stockings to Labrador so they could be made into mats. According to the newspaper, the suggestion was well received.) Canadian and American women happily recycled their worn and laddered stockings, knowing that their usefulness would continue and intrigued that such pathetic-looking items could be transformed into such beautiful rugs.

The silk and rayon stockings were first used for flowers and the more delicate inserts, then for the finest-grade mats. But it quickly became apparent, as literally tons of stockings were donated – one year the Industrial received over nine tons of stockings and undergarments! – that the mats made from silk stockings were the Industrial's most important type of this product. From this point onward, they became the focus of the Industrial's mat-making effort. On a return visit to St Anthony in 1930, Jessie Luther marvelled that the amount of material "fairly took my breath away in contrasting it with the conditions of my early years of service with their continual struggle to make ends meet … I know of no work of the kind found anywhere to compare with the excellence of these mats, many of which resemble tapestry. It is difficult to make purchasers believe they are hooked, the work is so fine and even. This is especially true of the latest product, small mats in which old silk stockings, dyed in attractive colours are used. They are very lovely."[85]

The unimaginable had happened: The Industrial had progressed from "it will never amount to anything" to fairly bursting at the seams with success. Dr Grenfell stated enthusiastically that he felt the "hooked mats [were] as great an adjunct to public health as the hospitals."[86] Space to accommodate the work and workers was at a premium. During her 1930 visit, Luther called the Industrial "a veritable workshop or factory."[87] The stockroom, once the large

The International Grenfell Association
INCORPORATED

SUPERINTENDENT: SIR WILFRED GRENFELL, K.C.M.G., M.D., F.R.C.S.

ST. ANTHONY, NEWFOUNDLAND

July 19, 1929

W. Biddle Tamburro, Esq.,
Episcopal Academy,
Philadelphia, Pennsylvania

Dear Biddle:

On my return to St. Anthony last week I found in the library some books which you had very kindly sent up to the children of Labrador. I expect our office has thanked you already, but I wanted to add a word personally and say how much I appreciated your help.

I am going to be like Tiny Tim and ask for "more". Do you think you could possibly collect and have sent up here by Parcel Post for us some old silk stockings, or artificial silk stockings? We use any quantity of these in our Industrial Department, and we are always trying to interest our friends, both young and old, in collecting them and sending them up here. If you could collect from your family, or you could tell any of your friends to collect from their families, and perhaps tell the whole form in the Episcopal Academy to collect from their families, we would have a splendid lot, I am sure. They can be any colour or any size, no matter how holey they are or how worn, it does not matter, because they are all hooked up anyhow, and used in the making of perfectly lovely mats which give work to poor people who otherwise would not have the chance of earning a penny for themselves.

It is so much better to give the people the work, and pay them cash for that than it is to give them money out-right and make them feel that they are charity cases, if if you and your friends can help us this way you would really be giving a "leg up" to Labrador. The stockings should be sent by Parcel Pose direct to Miss M.A. Pressley-Smith, International Grenfell Association, St. Anthony, Newfoundland. Duty Free. Again many thanks for your help, past and future,

Sincerely yours,

Wilfred Grenfell

Letter to W. Biddle
Tamburro from Wilfred
Grenfell, 19 July 1929,
asking for a donation
of silk stockings from
the entire form of the
Episcopal Academy
in Philadelphia
(Private collection)

orphanage playroom, held huge quantities of material awaiting preparation. Shelves were full of great bobbins of jute thread in a soft array of colours donated by a manufacturer to the Industrial cause. Completed mats of all shapes, sizes, and colours were stacked to the ceiling on deep shelves awaiting the next steamer south. In another room, groups of workers sat tearing outing flannel into strips, winding balls of unravelled brin, sorting silk stockings by shade, snipping their tops and toes off, and cutting their legs round and round on the bias into narrow strips. Next door, workers were cutting stencils and marking the brin base with the pattern to be hooked. Rows of people sat drawing in the Design Room. In the Dye Room, specially trained workers bleached and then dyed stockings in three huge wooden steam vats fired by coal and a little wood, to obtain fast colours. (One vat was reserved for black dye only.) On a vacation visit home, Pressley had "splendid training"[88] at the Dye Works in Edinburgh; she learned a simple method of producing really fast shades. "Triumph!!" she wrote, "This really does help us along."[89] After being dyed, the fabrics were rinsed in a bathtub and sink; faulty, inadequate plumbing caused frequent overflows.

Meanwhile, output and profits had increased dramatically. In the summer of 1927, White Bay reported that mat-hooking was the sole Industrial work being pursued and that women were "making mats for all they are worth"[90] in an effort to meet the demand. Some 3,000 mats were hooked in the winter of 1929, and revenues from sales rose from $27,000 in 1926 to $63,000 in 1929. In 1930, payments to mat-hookers amounted to

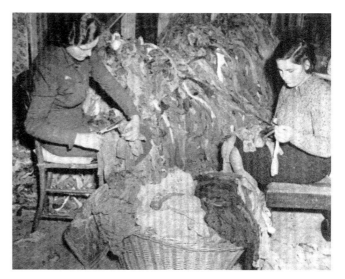

Industrial workers preparing stockings for hooking, St Anthony, c. 1930 (Private collection)

$10,847.68, which, at an average of three dollars per mat paid to each worker, indicated 3,615 mats hooked.[91] The mat-hookers were not universally pleased with their compensation, however. One worker laughed when she remembered her payments: "We weren't overpaid! I can't remember what we was paid, but I know now to think back on it, it was nothing." "But," she added, "the more you did, the more you made and we was really glad to get the clothing or money."[92] Another said, "Yes, my dear, 'twas a laugh. Sit down for two weeks and hook a mat and gets paid $3.50 … we gave up hookin' 'cause it was too hard and too much work for nothin'. But, I hooked lots, my love. All different ones. Do 'em as fast as you can hook 'em, we did. We had to. The place was different. You had youngsters and you had to work for 'em."[93] Mats not meeting the Mission's rigid

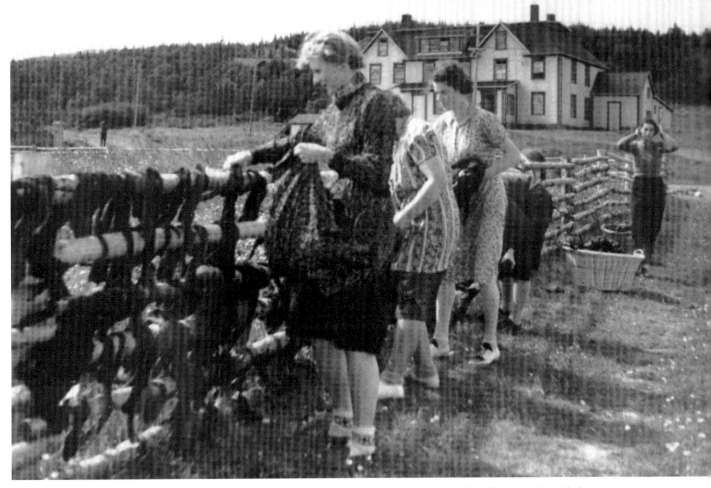

Industrial workers hanging dyed stockings out to dry, with the
orphanage building in the background, c. 1929 (Sir Wilfred Thomason
Grenfell Historical Society [WTGHS])

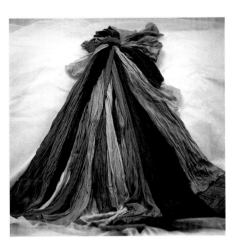

Silk stockings were received by the ton from Canada,
Great Britain, and the United States. These have
been dyed for hooking. (Private collection)

Sir Wilfred with the Industrial truck, "Freddy," which transported Industrial products to the resort sales in the United States, c. 1931 (Wilfred T. Grenfell Papers, Manuscripts and Archives, Yale University Library)

Below: Interior of the Philadelphia shop, c. 1930, showing a large pile of standard-sized mats on the table to the left of the salesperson (PANL VA118-212)

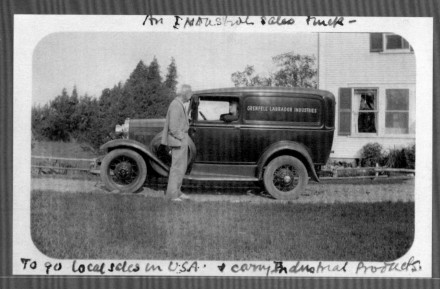

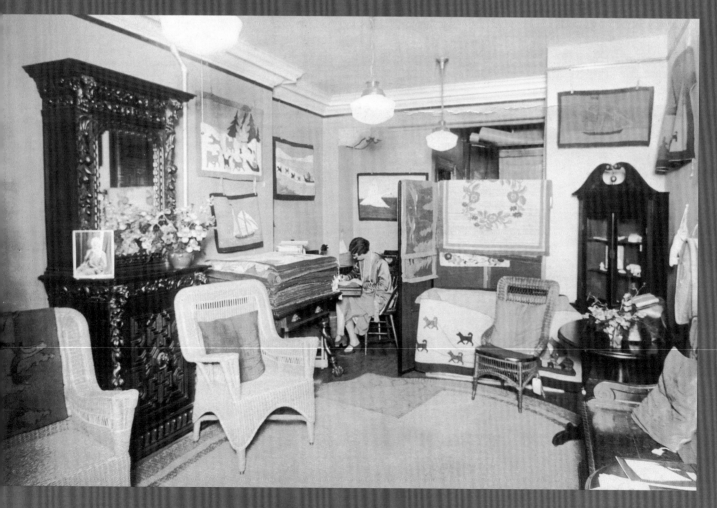

standard would be paid for at a lower price, as noted earlier. One elderly mat-hooker showed dismay when reminded of this practice and said, "If you was hookin' for the Mission, it had to be right. Sometimes the mat might be cut down in price because it wasn't perfect … [but after all that work] you wouldn't take the mat out and do it again. If you had to take a cut in price, well, you just took it."[94] The Mission justified its payments, citing the materials needed, the labour-intensive job of preparing the mat bundles, the task of taking in and assessing thousands of completed articles for the Industrial – coming from as far south as Coachman's Cove in White Bay on the east coast of Newfoundland, as far west as Flower's Cove, and as far north as Nain, Labrador – the packing and shipping of the goods, and the very real problems of finding markets and offering a mat at a price that would cover materials, labour, shipping charges, and custom duties but would still be attractive to buyers. The mat-hookers were asked to consider the real purpose of the work: to help Dr Grenfell in his inspired efforts to help others.

Production was at an all-time high, and creating and supporting new markets was critical. In 1929, after the usual winter and spring sales in the United States, Canada, and Great Britain, a considerable surplus remained. To dispose of the goods, two enthusiastic summer volunteers toured the resort areas of New England and New York State. Lake Placid and Woodstock, New York; Bar Harbor and Camden, Maine; Squam Lake, New Hampshire; Newport, Rhode Island; Gloucester, Lenox, Cape Cod, and Nantucket, Massachusetts were among the places hosting sales events. The

venture was successful, with sales totaling $7,000, and it was deemed advisable to repeat it on a larger scale over succeeding summers.

In October 1929, a store devoted to the full line of Grenfell Industrial products opened in Philadelphia at 1621 Locust Street. The next month, another store opened in New York City at 425 Madison Avenue. In its first ten months, the New York shop counted receipts of just over $14,000 (which included $8,000 at an outside sale at the Women's University Club); Philadelphia's likewise reported a financially successful first year. These outlets – with the New York shop moving from its original address to several different locations – remained open until 1938. A third shop, In the Garden, opened for the summer months of 1935 at 12 Mount Desert Street in Bar Harbor, Maine, in an effort to lure the tourist trade and the many Grenfell Association members and friends who frequented the affluent resort town. It did not reopen the following summer.

The Industrial was filling a more and more important place in the economic life of the northern communities. Vouchers from mat-hooking provided families with the necessities of adequate clothing, medicines, and food. As the Industrial flourished, wallpaper, paint, and linoleum purchased with "mat money" began to inspire a new pride. Mat-hookers became scrupulous about keeping their homes clean – an often difficult chore considering the local living and working conditions – and carefully kept their mats covered with a clean white towel when they were not working on them. Women could earn their own livelihood, allowing them to put off early marriages. The men looked at the women with new

33

respect and proudly spoke of their own contributions to the art, sometimes offering technical advice on a mat design. Scores of people found it unnecessary to accept government relief because of the opportunities afforded by the Industrial. Anne, now Lady Grenfell,[95] procured scholarships that enabled promising students to attend Berea College, the Pratt Institute, the Rhode Island School of Design, and other art and vocational schools. On graduating they returned home to teach and enrich the lives of others.

Careful planning and supervision had created highly saleable products and loyal customers. There was a correspondingly great demand for work from the mat-hookers and other workers. The Industrial's building was in dire need of repair and expansion or replacement; the old orphanage had reached its capacity. Still, creating new markets was crucial and funding the Industrial effort was a problem. While the supply of donated stockings eased costs for materials, the Industrial continued to pay workers on receipt for their work even though it could be months or years before an article was sold. Overhead expenses mounted. A catalog had to be printed; shipping and duty costs continually increased. Benefactors took up special causes. Two anonymous gifts of $5,000 were donated to the Industrial by admirers of Lady Grenfell, at which Dr Grenfell wrote, "[T]here is need of ten more such investors."[96] Another generous patron offered to pay one-third of the rent at the New York shop. The Ward Belmont School, a small private girl's school in Nashville, Tennessee, stepped forward with a continuing pledge to support the salary and expenses of the Industrial's supervisor.

The Vision and Vitality of Rhoda Dawson

In December 1930, Rhoda Dawson arrived to work with M.A. Pressley-Smith. Dawson's feisty spirit is evident from her initial impression of Pressley, whom Dawson described as "a small, round, bushy-tailed woman who was to be my future mentor, friend and exceedingly difficult superior for several years."[97] Although Dawson's position as general assistant was unsalaried, the Mission paid her travelling and living expenses. Dawson was a talented painter from Chiswick, England. The daughter of successful artists, her life had been steeped in art from early childhood. After the death of her mother, her father had secretly remarried, causing strained family relations. A friend suggested that Dawson go to work for the Grenfell Mission. Buoyed by her passionate interest in the sea, she promptly agreed. On her trip north aboard the *Prospero*, a government mail boat, she was struck by the "extraordinary charm" of Newfoundland: "the wooden stages and sheds, the little wharves, the gray or painted houses – always with white curtains in the windows – the pulled up boats and schooners, the small twisted trees near the water and the glimpses of the black fir woods behind the rocky coast line."[98] For Dawson, it was the start of a life's adventure.

Dawson's papers, donated to the Centre for Newfoundland Studies Archives, Memorial University, St John's, Newfoundland, provide a colourful behind-the-scenes glimpse into the inner workings of the Industrial at the time. Pressley, hoping that Dawson would turn out to be the "right person"[99] and not a disappointment,

impressed the regulations upon her: Women working for the Mission did not wear trousers, as the local women would take offence; there was no smoking in public and no alcohol. Dawson began to infuse her spirit and vision into the Industrial at once. The skill of the workers impressed her at once. However, she was none too pleased with the hooked rugs and other Industrial products, feeling they had a "slick" made-for-the-tourist-trade look. The challenge of making do with very little energized her: "I enjoy it because there are no drawing paper, boards or pins or charcoal, we have to wangle everything. I have laid in a stock of wallpaper to use on the wrong side … I hope [to make] home made charcoal if I can do it."[100] Dawson spent her time making up kits for the mat-hookers and copying, adapting, or developing her own designs. She concentrated on designing mats that went beyond the standard scenes of dog teams, geese, and polar bears by depicting aspects of daily life and work, as well as landscapes. Unfamiliar with the constraints of producing work for commercial gain, she found it difficult to accept that product sales were more important than aesthetics. In a letter to her father she wrote, "I have learnt a lot about colour here, working on the mats … I'm afraid the regular customers won't like my new mats, they're too sophisticated."[101] A letter to a friend in England the next month (April 1931) hints at her dissatisfaction and portends the changes in store for the success of the Industrial: "This is such a funny country. I can't say I know it because being stuck here in St Anthony one might be in an English or American country community. I am not looking forward to summer. Business being

Miss Pressley-Smith and Miss Rhoda Dawson, c. 1930
(New York Public Library)

so bad we shall be rather slack and I shall have to run the shop we have for tourists, and I would so much rather be a WOP and cook on one of the Mission boats. I'd like to send you one of my rugs. I shall have to guess at colour and I can't send you one of the best on account of price, but perhaps you'd like a cushion cover or something. I have been experimenting with colours … [It] makes me want to paint again. I suppose you don't know anyone who'd like to order a set of chair seats or an altar frontal. I'm anxious to do both. We can do beautiful things in silk or cotton or jute. Silk is more expensive on account of the duty."[102]

As Rhoda Dawson's April 1931 letter indicated, the prosperity of the Industrial was being challenged. The stock market crash of October 1929 in New York fuelled a worldwide depression and the long arm of its shadow had reached northward. Although not publicly reported, over the previous several years the Industrial's sales in the United States had been steadily declining. By 1930, as a result of a scarcity of funds, the accumulation of goods, and a lack of new markets, the IGA was deliberating on the future of the Industrial and had severely curtailed production. Pressley found herself on the defensive. In an effort to counter an increasingly prevalent attitude among some of the directors of the IGA – whom she quoted as saying, "What a lot of trouble and worry all this industrial is … why not just give $20,000 in charity and be done with it?"[103] – she wrote a twenty-three-page report justifying the continued existence of the Industrial. In it she reiterated the three original purposes of the department. First, it provided a wholesome method of meeting the needs of the people by supplying remunerative labour, which in turn allowed them to barter for or purchase necessities such as food and clothing. Second, as a result of the work given out, the standard of life had dramatically improved among the workers. "Mat money" was largely responsible for better food and proper clothing; the workers were able to afford linoleum rather than bare, chilly floors; walls were papered with wax-cloth rather than newspaper. Third, the Industrial provided sound moral training by requiring improved cleanliness,

order, and honesty and by building a strong sense of independence. Women commanded a new respect with their earning power. Pressley also noted that the Industrial was supporting nearly 2,000 mat-hookers who together received about $9,000 per year, and suggested that the output could easily be doubled by creating new markets and increasing the amount of money at the Industrial's disposal for buying raw materials and paying for work. She further cited the real need for better facilities, specifically noting that "for the development of our most important product – silk mats – the dyeing process of the stockings is a great consideration."[104]

The decline came at a time when people needed work the most. The summer of 1931 saw a significant decrease in the price of fish that produced exceptionally severe conditions. It was rumoured that nearly 20,000 people were on government relief, receiving six cents a day and living on inadequate government rations of flour, tea, and molasses. Women crowded into the Industrial hoping for work. Pressley painted a bleak picture: "All the table mats had gone like smoke and the bags, on which we were still working, were snapped up as each was finished. We turned away about twenty St Anthony people on Tuesday to come back on Friday, and they were all there, and another seventy-five besides. It is simply heartbreaking to have everyone on the coast clamoring for two or three mats … [W]e feel we ought to give everyone something if possible and not concentrate by giving as much as they want to the comparatively few, but they are so disappointed and we are so heartsick … We had to make the rule that we could only give to those who came

… We are making up the last bags to be given out this Tuesday. Then we are through – everything will have been given out. March and April are going to be terrible months on the coast."[105] It was only December; a long winter lay ahead. Stocking inventory at the Industrial had been completely depleted, and *Among the Deep Sea Fishers* continually pleaded for desperately needed donations of silk stockings and bolts of "cheap grade" flannelette and clothing. Special sale prices were offered on hooked mats at the Grenfell outlets in Boston, New York, Philadelphia, and London. "It would almost be better that no Industrial work had ever been started than it should fail them now … We can not fail them now … please buy at least one thing,"[106] wrote Pressley. The Industrial never returned to the happy days of overcrowding and standing-room-only production.

The mat-hookers were acutely aware of the changes, and a group of women from Sapo Island in White Bay wrote to Elizabeth Page complaining that Pressley didn't pay as much for scrap mats or mission mats as Page had; although the "mats are hooked better and are larger" they were being paid "$2.50 and $3 for a very scattered one.[107] $3.50 is the right price but now a very scattered one gets that."[108] "They didn't give out any mats to be hooked last fall, it has all stopped," lamented another woman.[109] "The best price is $3.50 for the largest, a lot of hard work and a lot of bending over a mat frame each day, then when we send it to get exchanged for clothing we doesn't get very much."[110]

But while sales abroad had been falling at an alarming rate, business was holding its own in St Anthony. The advent of the Clarke Steamship pleasure cruises proved to be a summer windfall for the Industrial, bringing thousands of tourists to the region for the first time. Originating in Montreal, the S.S. *New Northland* and the S.S. *North Star* carried passengers "to the scenic splendor of the lands of the untrammeled North … to see the majestic panorama of land and sea and sky, where they gain an insight into the lives of the quaint and hardy folk who wrest their living from these lands of brooding mystery," promising visits to "the fishing villages, the fur trading posts and the havens of the famous Grenfell Mission."[111]

With the promise of summer in the air and the very welcome onslaught of loaded tourist boats, the pace of production in St Anthony began to pick up. Despite the fear of being "slack" expressed in her letter of April 1931, Dawson's diary entry for the same month mentioned an increase in activity: "Too busy to write this. Designing mats, carving ivory, house painting, staff parties, carving toys."[112] In June she wrote to her father: "I have been working late tonight on some special designs … so now must stop … The Old Man [Grenfell] has arrived bringing lovely warm weather."[113] On one visit of the *New Northland* a reported $1,200 worth of goods was sold in one afternoon, "which cheered us up quite a lot,"[114] Pressley noted. By the end of the summer the Industrial was actually running nearly $2,000 over the previous year.

Tourists boats were clearly a valuable source of income for the Mission, especially given the slow sales of its products in other markets. No opportunity for making a sale could be ignored. Whenever a tourist boat steamed into St Anthony, the Industrial's workers were expected to leap out

Clarke Steamship Company Brochure, 1935, advertising cruises
on the S.S. *New Northland* and S.S. *North Voyager*
(Mohonk Mountain House, New Paltz, NY)

of bed and rush down to the shop and open up,
no matter whether the hour was 3:00 a.m. or
11 p.m. In August, Dawson told her father: "I've
had a fearful row with Pressley and gave up [run-
ning] the shop as I should have done when our
first very efficient summer worker arrived. I've
been working nearly every night this week. The
Kyle [a government coastal steamer] came in on
Saturday at 5:30 a.m. and we never heard her so I
never opened the shop and Pressley did it herself
and she was in a fine rage … I also had three days
to design, draw and make up material for a 10′
square mat (the lady artist[115] came and helped
me, or it would never have got done) with a bas-
ket of flowers in each corner and four small
threshold mats to match each with its basket, so
that's eight baskets in one room – not bad … But
the warmth you feel about Sir Wilf makes a lot
of muddle excusable, the same as Pressley's spirit
makes her tempers bearable."[116]

Relieved of her duties as shop manager and
unencumbered by commitments to the Mission,
Dawson embarked on a long-yearned-for trip
along the Labrador coast. There is scant docu-
mentation of her travels until 17 September 1931,
when she wrote to a friend from St Anthony:
"Pressley has taken me in … You know how
vixenish she was last summer, but now she is so
even tempered. We were all overworked, now
we are all underworked."[117]

In 1933, Dawson returned to England aboard
the *Blue Peter*. She carried hooked mats, sou-
venirs, and paintings she had done while on her
trip in Labrador. With her usual flair, she related
her arrival in England: "I did not leave the ship
too easily. I had a tussle with a nice young

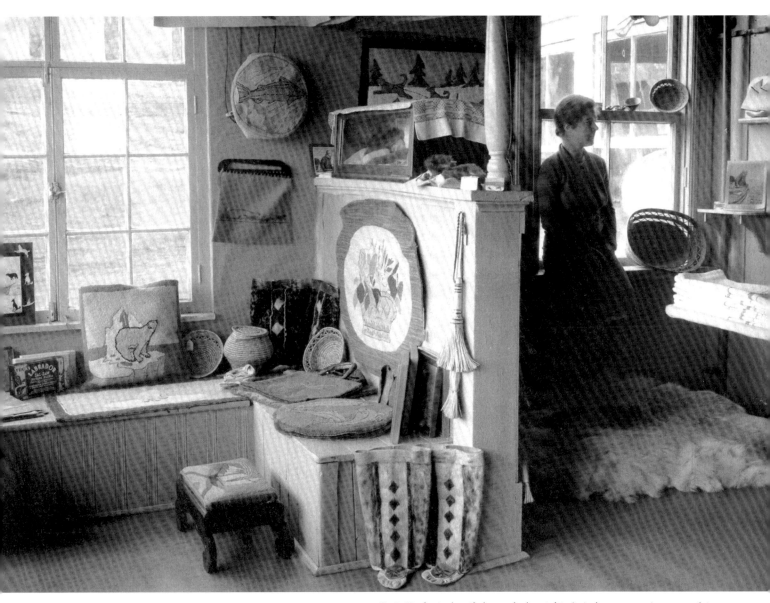

Dosia Hawley in the gift shop at the hospital in St Anthony, c. 1932 (PANL VA92-81)

Customs Officer. I tried to convey to this dunder-head that while some of my hooked rugs might be made of silk, it was second-hand silk, sent from all over the world in the form of silk stockings and reused. He proved to me, which was quite unnec-essary, that it was silk by applying a flame to a tiny loop. But this was the beginning of the end as far as English sales were concerned; Customs insist-ed on most Grenfell handicrafts paying duty so the office gave up selling them."[118] (Orders from the Grenfell Association of Great Britain and Ireland often specified "no silk" because Customs charged a full duty of more than 33 per cent, making the selling price of a silk mat prohibitive. The Industrial continued to supply Great Britain with cotton and brin mats and a few silk mats, often made to order, well into the 1940s.)

Dr Grenfell, continually seeking to promote the Mission's work, wrote a letter of recommenda-tion for Dawson to the Imperial Institute in London: "Bearer, Miss Rhoda Dawson, has been helping us out in Labrador to the best of her abili-ty, and being a bit of an artist she has been doing some pictures which … may help to give others an idea of our work here and … as we need every bit of publicity nowadays to help us carry on, I am asking her to see you, thinking perhaps you might have some way of showing her pictures in the Imperial Institute."[119] The resulting exhibition, "Down North," exhibited nearly a hundred of Dawson's watercolours, mats, carvings, and "other odds and ends." Her mats were praised as showing a "natural talent for design."[120]

Despite small profits being made in St Anthony, it remained crucial to foster new marketing schemes for the Industrial's products abroad. In the summer of 1931, two energetic volunteers, Lebe Craig and Anne Fitzpatrick, set out in the Industrial's Ford deluxe delivery truck – affection-ally known as "Freddy" – piled to the roof with hooked mats and other goods destined for sales at major resorts in New England and New York. Customers expressed amazement at the excel-lence of the workmanship and found it difficult to believe that the mats were actually hooked by hand. Over twenty sales were held before Labour Day, but the strains of the Depression were evi-dent in the final receipts.

The Dog Team Tavern was opened in 1932 in response to the pressing need for new markets. Located on the Champlain Highway in Fer-risburg, Vermont, it was close to the Grenfells' summer home in Charlotte, Vermont. A spacious historic New England farmhouse, the Dog Team Tavern promised to provide a "veritable haven for the hostesses of the neighborhood whose cook did not appear." The establishment served meals and picnics and provided a lovely setting for the display and sale of the Mission's handicrafts. Two years later, the Connecticut Dog Team Tea House, sponsored by the New Haven Grenfell committee, opened in Oxford, Connecticut. Both ventures were so successful that updated facilities were soon needed. A new Dog Team Tavern built by the bend of the river three miles north of Middlebury, Vermont, was specially designed

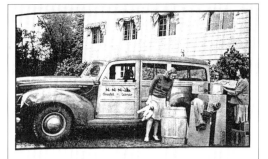

We Hope —

You will wish to have us finish loading our Labrador Station Wagon and bring the Home Industries to your home for a sale. Please do not wait for a personal letter but write us if you will sponsor an exhibit and thus help us give more work to our Northern Neighbors. Our loaded wagon will come anywhere — whenever you want to present Labrador products to your friends.

⚓ ⚓ ⚓

Grenfell Labrador Industries

156 FIFTH AVENUE NEW YORK, N. Y.

Summer volunteers packing hooked mats and other Industrial goods into the Grenfell Industrial's Ford Deluxe station wagon for the summer resort sales, 1940 (*ADSF*)

with a large front room for displaying and selling handicrafts. The Dog Team Tea House was reopened on the main road in Cheshire, Connecticut; beset with personnel problems, it was referred to as "dead on its feet" and "a drag around our necks,"[121] and closed shortly thereafter. The Dog Team Tavern remained open until 1943, when the war made it too difficult to bring in goods from the north and to hire help.

All potential sales venues were explored. Volunteers staffed booths at trade shows and exhibitions in an effort to promote the Industrial's work. In 1933, handicrafts were displayed at the Combined Sales for Missions Overseas in Westminster, England, the Save the Children

Fund in Manchester, England, and the Century for Progress Exposition in Chicago. In 1934, the Sportsman Show in Boston, the New York Flower Show, and the Women's Art Association in Toronto were added.

Despite the concerted quest for new markets and sales, a letter to "Dear Dawson" from Pressley in December 1933 called the situation at the Industrial in St Anthony "futile." Pressley complained that she was "so tired and so bored"[122] and mentioned that she was considering a position with the University of Pennsylvania. To complicate matters, it was reported that $20,000 had been lost in American business alone and Pressley had heard rumours that a new head of the Industrial,

Grenfell sales poster, c. 1934 (Private collection)

Interior of the first Dog Team
Tavern, North Ferrisburg, Vermont,
c. 1932 (Wilfred T. Grenfell Papers,
Manuscripts and Archives, Yale
University Library)

NONIA and Grenfell Labrador
Industries booths at Dorland Hall,
Piccadilly Circus, London,
December 1931 (PANL VA93-174)

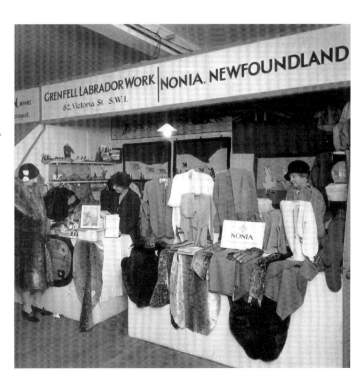

Industrial, Janet Stewart,[123] had been appointed over her and was to tour the coast in place of her. In spring 1934, Dawson sent a telegram to Pressley inquiring about coming back to St Anthony and offering to take her position. Pressley replied, urging Dawson to return in the winter on the last boat, which she too was hoping to catch after a brief return to Scotland in the fall. The letter indicated that the financial situation was so bad that the Mission wouldn't pay Dawson's expenses for the summer, when they could get "volunteer girls to run about for nothing," but that in the winter it would be different.[124]

By July 1934, Dawson was back on Newfoundland soil, having accepted an offer from the IGA to teach school in Payne's Cove on the Strait of Belle Isle. When her teaching position ended she travelled to various communities helping with the Industrial work.

HARRINGTON HARBOUR

Pressley dispatched Dawson to Harrington Harbour, a rocky, treeless outcropping located at the mouth of the Gulf of St Lawrence, in a part of Quebec then known as the Canadian Labrador. Harrington Harbour was the largest English settlement on the Canadian Labrador. Built on four of the countless islands surrounding the small, snug harbour, its foundation is a great mass of heaved-up rock; there is not a level square foot anywhere. The village is huddled to one side, leaving the back side wild and desolate. Yet it isn't drab or grim, but beautiful in a stark but vivid way: the spring brings a riot of colour in the low-growing flowers, softly coloured lichens, and velvety mosses.

"I'm going to do some Industrial work," wrote Dawson in November 1934. "Harrington is a little hospital with a staff of middle-aged Canadians, so it will be quiet and respectable."[125] Begun in 1906, the hospital was supported entirely by the Canadian branches of the Grenfell Mission. The location, one of the least accessible parts of the Quebec coast, hampered early efforts to start a branch of the Industrial (which here became known as Canadian Shore Industries). But by the time Dawson arrived, the women of Harrington Harbour were quietly turning out hooking said to be the "finest of its kind anywhere in Canada and peculiar to Harrington … The women hook so fast their hands become a blur."[126] Dawson was amazed at the finish and fineness of the work compared to that at other stations along the coast and felt that the women were also more creative. Their creativity may be accounted for by their location in Quebec; they were closer to cities and so had readier access to people, ideas, and materials. Several of the women had a regular clientele in the towns and did not need work from Canadian Shore Industries.

The Mission had not vigorously pursued the Industrial effort at Harrington Harbour, trusting the limited output to the head nurse at the hospital or the community worker at Mutton Bay, a small fishing community thirty miles to the east. The local women themselves had gradually worked up a business, which had grown with the increase in tourist boats. Gladys Mitchell Chislett recalled the steamer arriving in Harrington

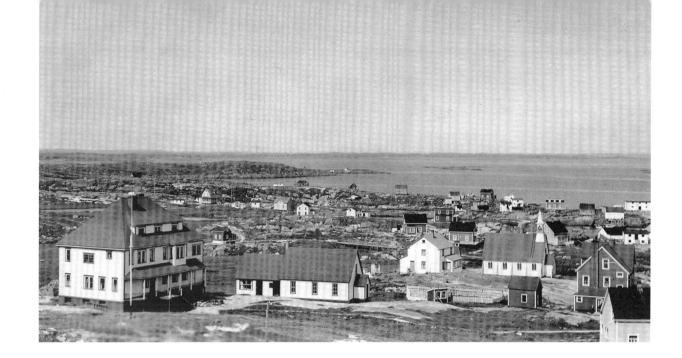

Harbour every two weeks. Tourists coming ashore in small boats were met by a host of local people displaying quantities of handmade articles for sale on tables set up along the wharf. The young girls each carried a special box filled with hooked mats, purses, small carvings, and knitted items. The community felt great disappointment when severe weather or heavy seas kept the steamer from making port. The Mission eventually took notice of these efforts.

In Canada, several outlets stocked the Industrial's handicrafts: the Canadian Handicrafts Guilds at Toronto, Montreal, and Windsor; the Odd Crafts Shop in Banff; Eaton's department store; and a small selection of other specialty shops. The work was also shown at the Canadian National Exhibition. Much of Harrington's Industrial output was therefore ordered specially for sales organized by the Grenfell committees in Ottawa, Montreal, Toronto, and the many smaller

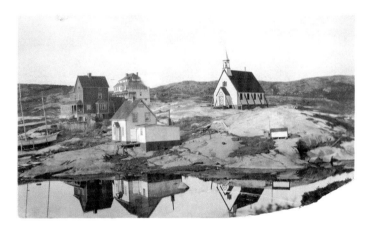

Top: Harrington Harbour, showing the old Grenfell Mission hospital, which was replaced in 1950, the Industrial building, the vicarage, and the Anglican Church, c. 1949 (Dr Claire Neville)

Above: Harrington Harbour, with the Anglican Church and the Grenfell Mission hospital in the background, c. 1910 (PANL VA118-149-6)

branch associations. Upon her arrival, Dawson reported: "[W]e have 350 mats to make, nearly all small."[127] Harrington also received Industrial orders from St Anthony, and many of the local women hooked the mat patterns popular there. Once finished, the mats were shipped back to St Anthony for sale and distribution. But the mat-makers of the tiny Quebec settlement contributed their own distinctive style and designs as well. Graphic scenics depicting Harrington Harbour's buildings and islands, puffins, a smaller version of the Mallards Flying over Reeds design, a rabbit family, kayaks, deer nibbling tree leaves, and deer at sunset were only a few of the patterns that origi-nated in the area. Dawson lent her own creativity to the patterns. The manager of the Philadelphia shop wrote an effusive letter to Dawson praising her work: "[T]he pièce de resistance was the Harrington hooking … each piece is a work of art. We want to congratulate you on the results of your winter at Harrington. The colors are very artistic. We shall not have it in stock very long at the rate it is being bought. We do hope you can make some more floral designs such as the little round gentian mat. We should like to have a set of Labrador flowers. We have the Twinflower, Crackerberry and Sweet Pea but not in the small mats … This letter is just to tell you we are all delighted with your work and thank you for it."[128] A few months later, Dawson was again con-gratulated for providing the best mats of the summer sales.

Dawson's fervour for the Mission's work was palling, however. In June 1935, a telegram arrived from St Anthony requesting her urgent return to take charge of the summer sales, which she

The *New Northland* off Harrington Harbour, c. 1933
(Wilfred T. Grenfell Papers, Manuscripts and Archives, Yale University Library)

termed "such a bother."[129] Unexpectedly, amidst a flurry of unexplained "unpleasantness,"[130] Pressley had returned to Edinburgh leaving the Industrial affairs in, she said, "apple pie order."[131] But with Pressley thousands of miles away and the uniniti-ated trying to take charge, the Industrial was slipping into disarray. After Dawson's return to St Anthony, it was Harrington Harbour's turn to experience difficulties. Dawson received word from Laura Thompson, the nurse in charge there, that the summer sales "had not been so hot. The first (boat) tour … we sold about $16 worth. The next about $14 and the last one never did stop here."[132] In November, Dawson wrote a letter from Battle Harbour to a friend: "I'm stuck on the south shore of the Straits of Belle Isle … I just write letters and sew and make up a few mats and send telegrams … I can't imagine why I stayed here. I'm homesick and it's the height of desola-tion and I am *so* tired of mats and this stupid old mission."[133] In a letter the following month she

confided, "I think I may cut and run because the news does not sound good and I do not much want to be stuck here till June unable to get out. This job is not sufficiently vital enough [*sic*] for the Industrial to suffer if I go."[134] A year and a half after her return to Labrador, while working in Red Bay and being "more or less in charge of the Industrial,"[135] Dawson broke her contract with the Mission and without notice "bolted."[136]

Although she intended to go home, an unexpected stop in Twillingate on New World Island in Newfoundland introduced her to the work of the American visionary and medical pioneer Dr John Olds, whose stature among the people of that part of Newfoundland equalled or surpassed that of Grenfell. Dawson remained in Twillingate and later spent time in St John's before returning to England in the late summer of 1936. In an article written for *Among the Deep Sea Fishers* after her return home, she cautioned that the Industrial was now the "public trustee for the folk art of the Labrador" and that it "ha[d] a moral responsibility" to keep to a simple standard by which it could survive. She continued that "the artistic tradition [in Newfoundland and Labrador] is, in fact, like the flora, sparse and minute, but vigorous and exquisite upon close examination, true to the character of a country of pioneers and hunters, wind-blown and water-worn, and consistently developed from the materials at hand."[137] Dawson remained a vigorous supporter of the Grenfell Mission. In 1957 the Anglican congregation at Cartwright, Labrador commissioned her to design two stained glass windows for their new church. Dawson had married the sculptor John Bickerdike in 1955; she died in London, in March 1992, at the age of ninety-four. She bequeathed her noteworthy collection of Labrador mats, both Grenfell designs and local patterns, to the Victoria and Albert Museum.

ROLLER COASTER RIDE AT THE INDUSTRIAL

Despite having devoted nearly ten years of unwavering creative vision and persistent effort to the Industrial, M.A. Pressley-Smith did not return after the summer of 1935. Her father died and she suffered a bout of ill health. Later, Rhoda Dawson called Pressley's contribution "enormous, varied and complicated."[138] Back home in Scotland, Pressley began weaving again, making tweeds and fine silk tartan scarves; she remained active in the Scottish Women's Art Society until her death in 1972. Her obituary noted that she had driven the Grenfell workers "pretty unmercifully as she herself was untiring in her work" and that she played chess "well enough to entertain Dr Grenfell – no mean feat."[139]

Janet Stewart, the Canadian who had been appointed to tour the coast as Industrial supervisor in 1934, assumed the leadership position along with an American, Dorothy Francis (Limouze). Stewart's time with the Grenfell Mission had begun in 1927 at the nursing station in Mutton Bay. During one of Pressley's leaves in 1929–30, Stewart had worked as acting supervisor at the Industrial, so she was well acquainted with the challenges facing her. But she was an exacting personality and several assistants found her "terrifically tough"[140] to work with. Stewart expected

Janet Stewart in winter dress (PANL VA118-208)

people, even those in dual roles such as orphanage volunteers or nurses as well as Industrial workers, to put in hours of overtime regularly at the Industrial in order to return it to its former order and profitability. An air of discouragement pervaded the Industrial.

The increase in tourist cruises stopping at the Grenfell Mission stations continued to boost profits significantly. "We've had a terrific summer – crowded in every way, patients, workers, tourists, boats etc."[141] wrote Harriet Curtis, wife of Dr Charles Curtis.[142] She enthusiastically continued, "Our tourist sales have been record breaking – the top being $1,500, and every one of them over the record last year, at least for the *Northland* sales."[143] The capacity of the ships had been greatly increased for the summer of 1936 and, thanks to

Stewart's efforts, there were more Industrial products to sell. Accounts show that sales for that summer totaled $10,000.[144]

The local women were busy hooking again. For the first time, Stewart had the luxury of two expertly trained assistants; she was able to have the work better supervised and more widely distributed. She succeeded in getting hundreds of mat bundles prepared and given out to the eager workers. A thousand pounds of dyed stockings had been exhausted, and Stewart scrambled for donations to keep up production. "We need cratefuls,"[145] she wrote to Lady Grenfell. Stewart also discovered that velvet was well-suited for hooking flowers and squares; it was easy to work with and looked very rich. (Velveteen, however, was not suitable as it was too thick and heavy.) She added in the same letter that "any donations of velvet would be received with open arms."[146] An assistant commented on the pace of production in a letter to Rhoda Dawson: "Our shelves are bare so the new ma'am has her work cut out for her to get them filled for next year … This is mat day and the place is mobbed even though it's close to 4 pm."[147] She also alluded to the potential for the following summer: "I hear the Clarke steamship line [is] putting on a new boat with a passenger accommodation of 500. May be a rumor but we have got to be ready."[148] A year later, a reported $17,000 worth of goods had been sold to the passengers of the tourist boats, and it was noted that "these people are a very material help to the Industrial department in St Anthony, Harrington Harbour and Forteau."[149] Mrs Curtis wrote to Lady Grenfell that "our Industrial sales continue to boom and already after seven visits we have

more in hand than we had after nine last summer."[150] (Receipts for the first stop of the *Northland* in 1938 totalled $1,046; for the *North Star*, $2,377.)[151] The government coastal steamers, the *Kyle* and the *Northern Ranger*, also brought passengers keen for handmade souvenirs.

Booming sales to the tourist ships and the gross figures seemed encouraging, but the Industrial's roller coaster ride was not over. Profits were being realized on the coast, but sales abroad continued to suffer. After careful scrutiny of the state of the Industrial in 1937, the IGA decided that the department should produce all that it possibly could for sale to the summer tourist trade along the coast – for the simple reason that a larger net return was possible – and should send to the United States only what was needed for publicity purposes.[152] Bringing goods into the States incurred heavy shipping costs, along with prohibitive customs duties ranging from 33 to 90 per cent. When added to the cost of the products themselves, these factors brought prices so high that avenues for sales were considerably limited.

The overriding problem became the fact that, despite the high retail prices for their handicrafts, the workers themselves were not seeing enough benefit. For the season ending September 1937, approximately $7,400 worth of goods – 25 per cent of the Industrial's total output – was shipped to the United States. This was the figure established on the coast, based on the cost of materials and labour and an overhead of 25 per cent. However, with transportation, customs duties ranging from 25 to 90 per cent, and an average overhead of 50 per cent factored in when they reached the States, the goods had a retail value of

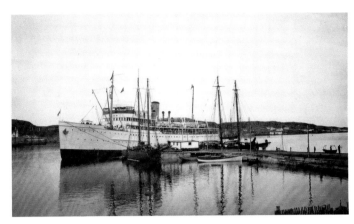

The *New Northland* at St Anthony, c. 1933
(Wilfred T. Grenfell Papers, Manuscripts and Archives, Yale University Library)

roughly $17,500. Of this total, only some $4,000 was paid to nearly 2,000 mat-hookers and other Industrial workers: just two to three dollars each. And while the goods were a convincing advertisement for the Mission's work, the IGA feared that customers felt that purchasing goods, rather than making an outright cash donation, would do the same amount of ultimate good in Newfoundland and Labrador. This, of course, was not the case.

In 1938, it was disclosed that only $150 made its way into the pockets of the handicraft workers of the $26,389 total summer sales on the coast. Of that total, $5,400 was profit, yet the manufacturing account based on the same figure showed a $2,600 deficit.[153] Dr Curtis suggested making changes in the Industrial's policy so that the workers would receive more benefit. The following year approximately $25,000 was received for the sale of Industrial goods, of which $16,000 went

into cash payments and clothing for the local people. The Industrial appropriated $3,000 as working capital, to make sure that its efforts would not come to an abrupt halt.

Janet Stewart undertook a complete review of the Industrial in 1938. Her report echoed the sentiments of the IGA board and recommended that the shops in Philadelphia and New York City be closed. Philadelphia's had been operating at a consistent loss, and the New York shop's location at 376 Fourth Avenue was deemed undesirable for the type of clientele it was catering to. With the decision that the Industrial would concentrate its efforts on the tourist trade on the coast, there was simply not enough financial gain in keeping the two outlets open.

When the shops closed, the focus shifted to private sales held in volunteers' homes and to the summer, fall, and pre-Christmas sales trips. In Canada, Eaton's department store maintained a booth where the Industrial's products were sold year-round. Considerable inventory remained in the United States; to dispose of it, volunteers visited boys' and girls' summer camps as an extension to the continuing summer resort sales, and organized additional sales at New England boarding schools during the fall. A letter of July 1938 from Lady Grenfell indicated frustration with the slowing sales: "I am greatly disappointed that the summer sales don't begin until the end of July. Of course, this means that all the other charities … get in ahead of us. Also I am disappointed that there aren't any new places … [although] your plans for the Cape Cod sales sound very good, as it is all new or newish territory."[154] Subsequently, volunteers embarked on several successful trips

through Georgia, Florida, and the western states. Eben Joy, a future owner of the Dog Team Tavern,[155] accompanied Dr Grenfell on one of them. He remembered rushing to the train station each morning to pick up new shipments of Industrial merchandise sent from the New York office and being amazed at the long lines of customers eager to buy mats at each sale.[156] The Mission pursued this method of raising revenue until gasoline shortages caused by the war made it impossible for the road trips to continue.

THE WORLD WAR II YEARS

The advent of World War II proved to have a lasting effect on the Industrial. The coastal steamers and tourist boats were requisitioned for the war effort, ending tourist cruises as a source of revenue. Once again, the future of the Industrial was in doubt. The world conflict created a sudden further loss of markets, transportation difficulties became insurmountable, and materials shortages and rising costs exacerbated the situation.

Economic and political instability were not the only factors in the Industrial's problems. Dr Grenfell had not been on the coast since the summer of 1934. His health had begun a slow, steady decline owing to frequent minor heart attacks, and his involvement and leadership had started to fade. By the summer of 1938 he was no longer able to lecture for the cause he loved so dearly. Anne Grenfell died in December 1938 after a long bout with cancer, and Dr Grenfell made his last trip north the next summer to bury her on the crest of the hill overlooking

St Anthony's harbour. The doctor himself passed away suddenly on 9 October 1940 while resting after a game of croquet. His legacy to the barren coast devoid of public services that he had found on his arrival in 1892 was five hospitals, four nursing stations, an orphanage, two large boarding schools, two hospital ships, several smaller boats, and numerous cooperatives, clothing stores, and Industrial centres.

Amidst rumours that the Industrial was practically closed, the Mission announced that its goods would no longer be shipped into the United States as of 1940. Still, a sufficient surplus of handicrafts existed to satisfy any scheduled sales or needs. In September 1943, however, notice came that sales of all Grenfell Industrial products would be suspended in the United States for the duration of the war. In fact, they never resumed. Only the Dog Team Tavern continued to carry a small inventory after it reopened in 1946 under Catherine Vaughn's independent management.

This time, however, help arrived from an unexpected place: home. The air above Newfoundland and Labrador throbbed with bombers and the sea lanes were clogged with naval vessels. The establishment of bases on the island and in Labrador promised a steady steam of potential customers. Janet Stewart, in her fourth year as Industrial supervisor, recognized the need of the thousands of ever-changing military personnel – who had plenty of money and nothing to buy – for proper clothing, as well as for attractive gifts and souvenirs. Renewed vigour filled the Industrial. Stewart developed a strong market in St John's and at the military bases, and soon the Industrial was expecting a brighter future than

anyone would have thought possible. Indeed, it was juggling more orders for handicrafts than it could fill, owing to the difficulty of procuring supplies and finding adequate staff to oversee the work. From a loss in 1941, the Industrial posted a $10,000 profit in 1942.[157]

Canadian Shore Industries Weathers the War

The Industrial at Harrington Harbour quietly continued its steady growth. Its remote location in Quebec allowed it to operate somewhat independently of St Anthony. By 1940 it was operating on a scale large enough to warrant a full-time Industrial supervisor. Stewart appointed Veronica Wood, a Canadian from Quebec, to oversee Canadian Shore Industries. Construction began on a new work room/sales shop just a short walk up the wooden boardwalk from the wharf. The presence of a full-time supervisor considerably improved both the quality and the quantity of the handicrafts. With American sales suspended, the focus shifted to the strong Canadian branches of the Grenfell Mission community. Mat production surged nearly tenfold, and Wood avoided prohibitive customs duties by shipping mats and other products directly from Harrington Harbour to Ottawa for distribution. (Goods from Newfoundland and Labrador, still a British colony, were assessed duty in Canada.) Wood also introduced hook point, a technique similar to needlepoint, which used a graphed design as a pattern. It was exacting and tedious, since it required counting every stitch; mat-hookers were therefore paid more for pieces using the new

Gladys Mitchell Chislett and Kay Reedman in Harrington Harbour, 1954. Chislett was one of Harrington's finest mat-hookers. She is holding a piece of brin onto which she has hooked two Tea Rose coin purses. (New York Public Library)

method. Tea Rose evening bags and coin purses and Husky Head mats were two designs made by means of this type of hooking. In another Harrington innovation, mat-hookers appliquéd animal furs – usually whitecoat seal[158] but occasionally polar bear – directly onto brin to portray a realistic puffin breast or a furry polar bear.[159] It was the mat-hookers at Harrington Harbour and Mutton Bay who produced the floor and table mats, footstool and seat covers, the bulk of the knitting bags and handbags, as well as the hook point mats that carried the Mission's Canadian Labrador label. Wood received a congratulatory note: "Your little mats from Harrington are the nicest possible and I am awfully happy that you are making such a success out of them."[160] An account from a successful sale in Montreal in 1937 noted that the "mats were particularly beautiful this year, both in design and in colouring, especially the round and oval ones."[161]

Muriel Lutes of Lutes Mountain, New Brunswick supervised the efforts in Harrington in 1942–45. Her interest in handicrafts took an academic perspective, but she found meeting the workers' demands and filling the orders from Ottawa exciting. In 1944, the Canadian Handicrafts Guild organized an open competition for Victory Banners, which were to incorporate Canada's coat of arms. The Guild suggested weaving, embroidery, or appliqué, assuming that the design would be too complicated for hooking. Lutes's ingenuity was challenged; she designed a banner, which the women at Harrington Harbour hooked and entered. She remarked on the finished piece, "I don't know what the Guild will think of it, but that such a piece of work could be made from old rayon, with a filed board nail, is something, I think!"[162] In fact, the Harrington banner won first place. Lutes added new mat designs and incorporated handicrafts into community projects and study clubs. Ill health forced her to leave the job she loved in 1945 and prevented her from returning to the coast.

THE POST-WAR ERA

Janet Stewart resigned from her position as Industrial supervisor in 1946. Under her leadership the department had weathered the difficult war years; indeed, thanks to her perseverance and ingenuity, it had prospered. She and her co-worker Effie Lee[163] had performed the work of four people using "every ounce of energy and ability."[164] Stewart felt that to get the Industrial "back to the old days" would take a full two years

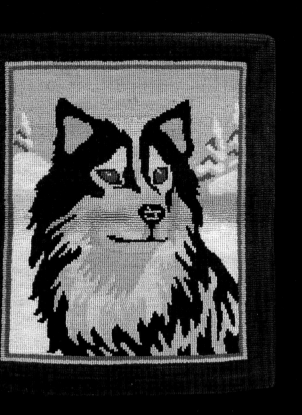

Gladys Mitchell Chislett and her husband Dave at their home in Chevery, Quebec, in 1998. Gladys is holding an Uncle Elt's Husky mat, which she had hooked years earlier; the same mat is also shown at left. Because it has been kept in the Chislett family, this is one of the very few mats that can be linked with a specific mat-hooker. (Private collection)

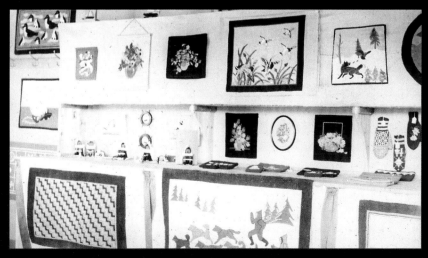

Harrington Industrial shop, c. 1952 (PANL IGA 12-28)

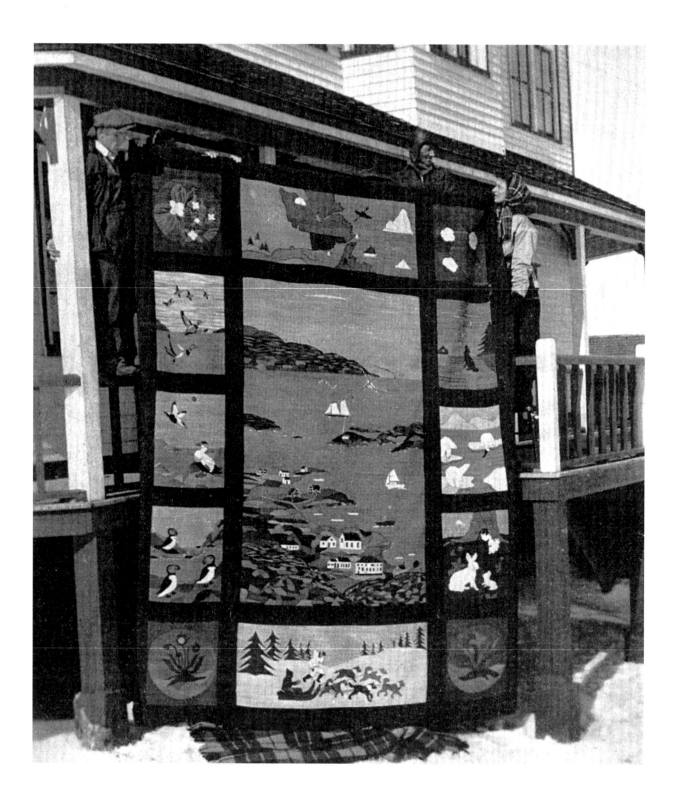

– if it could be done at all. Moreover, it had been six years since she had seen the outside world. She admitted that "one gets weary in well doing."[165] Stewart summed up her experience at the Industrial: "I have come through all the phases in this business, from the high days when we had ten summer helpers from the outside, about 40 workers within the building, 3000 mats into White Bay, and a supervisor over every department; the next was down to the depths of despair, everything shut tight with only Effie and I on the job; it gradually came back … and it finally reached high sales again within Newfoundland, the opening of the Air Port in Labrador, and in all an outlet for all we could produce under high pressure and short staff … I have not had time to do any new production of mats – I have improved some of the old ones and that is about all."[166]

After a few short-term supervisors had come and gone,[167] Dorothy Plant of Niagara Falls, Ontario stepped into the top position in 1949 and continued to provide strong and able initiative for the next five years. The Industrial in St Anthony finally moved into comfortable new quarters where sunlight streamed through the windows and efficiently arranged space provided a warm, welcoming atmosphere to workers and customers alike. The market for the handicrafts "continued at a terrific pace"[168] after the war ended because

Opposite: A Harrington Harbour masterpiece, c. 1945. This amazing sampler mat shows some of the designs originating in Harrington. A special order, it was prepared for hooking by Muriel Lutes. At one time it decorated the floor of the members' lounge of the Montreal Museum of Fine Arts. Its present whereabouts are unknown. (ADSF)

of vastly increased air traffic, with stopovers in Newfoundland bringing a myriad of new customers eager to buy souvenirs. A fish plant opened in St Anthony in August 1945, bringing good wages to husbands, sons, and brothers and creating strong local sales.

But the end of the war brought an unexpected challenge for the continuance of the mat industry. Nylon stockings were first sold in 1939. Despite costing nearly twice what silk stockings did, they were strong and sheer and women were happy to pay the price. Nylon was considered so essential to the war effort that its use was restricted to the military after the United States entered the conflict in 1941, and nylon stockings were available only through military post exchanges. After the war, the reintroduction of nylons caused a sensation; in one instance in 1945, a crowd of 10,000 people jammed a San Francisco department store, causing a sale on the stockings to be called off![169] However, nylon stockings did not have the elasticity that the mat-hookers required, while the dyers complained that they would take only blue dyes: the beautiful tints attained by dyeing silk and rayon could no longer be achieved. Appeals continued for acutely needed supplies of silk and rayon, stressing that only these materials should be sent, since nylon was of "no use in the hooking of picture mats,"[170] though it could be used for certain braided rugs made at Harrington Harbour. As donations dwindled and supplies of silk and rayon were exhausted, the Industrial began buying bolts of rayon from a manufacturer in Montreal, much of which was used as it was received with no further dyeing. Times had changed; the distinctive subtleties of shading

and the artistic palettes prized in earlier mats became only a memory.

However, the scarcity of raw materials was not the only factor contributing to a downturn in production. Newfoundland and Labrador joined Canada in March 1949. With Confederation came needed and welcome government relief – and a change in attitudes. The increased financial help in the form of family allowances, disability and old age pensions, and unemployment insurance meant that the women no longer felt they needed to hook mats. Unfortunately, a stigma became attached to the craft work. Mothers, believing that only poor women hooked, did not encourage their daughters to continue the tradition. Already in 1945 Janet Stewart had written, "[I]f the people do not want the work you just can not go out into the highways and byways and gather them in against their wishes."[171] Confederation opened new opportunities for travel, and the influx of service personnel created an awareness beyond the island and the coast. Young people, yearning to experience life "away," lost interest in crafts. It seemed the Industrial had come full circle: an eager market for its products existed, but the women no longer needed the benefits provided by the work and their interest in it waned.

In 1955, the Industrial changed its name to Grenfell Handicrafts and shifted its emphasis from furnishing supplementary work to people in their homes to providing occupational therapy in the hospitals. Dorothy Plant was succeeded by Mary Andrews in 1955. Andrews was important to Grenfell Handicrafts for the next six years. Women continued to hook mats, but on a much smaller scale and often only for their own use. In 1959, Handicrafts gave out fewer than 150 mats to be hooked and was operating at a substantial loss.

A survey published as *The Muff Report* was undertaken in 1962. Dorothy Plant, now secretary of the Grenfell Labrador Medical Mission in Ottawa, enlisted Mary Eileen Muff to join her in spending five weeks travelling along the coast to ascertain whether Grenfell Handicrafts could be resuscitated. They visited fifteen communities and interviewed 121 people, most of whom felt that the work of craft development should be continued, albeit with different objectives and modes of operation. One notable exception was Mary Andrews, newly resigned from her supervisory position of the past six years, who felt that handicrafts were no longer of such vital importance in supplementing the family income as they had been before Confederation. Andrews cited a letter describing the situation at Harrington in 1959: "The hookers here have become used to doing certain designs, and just *will not* undertake any new designs, so that when we try to concentrate on a limited number of these we cannot get more done than usual as only the hookers who work those designs will handle them, while the others prefer to remain idle. No amount of talking or coaxing will budge them. They either hook what they like or go without."[172] (The paternalistic tone of this letter is consistent with the relationship between the Mission workers and the local crafts people. Mat-hookers did enjoy hooking familiar patterns again and again; by doing so they made sure that the work was always well done and quickly finished, earning them more money.) Andrews noted further that in White Bay, where over the previous forty years the women had

usually hooked more than a hundred mats per winter, hooking had stopped altogether in 1957. The women said simply that they were tired of hooking and did not wish to do it any more. St Anthony was employing a single full-time assistant to supervise all the crafts, and two women worked afternoons to assemble the mat bundles. Only Red Bay continued to produce quality mats in quantity: 124 from October 1960 to June 1961, hooked by thirteen women. Most of the mats hooked were the Newfoundland Map design, which remained in great demand.

The Muff Report stated that most of the hooking was now coming from Harrington Harbour, where production had shown a steady increase over the previous three years. In 1960, Harrington shipped 460 articles to St Anthony for distribution; in 1961, the figure had more than doubled to 987 articles. Twenty-six women were actively engaged in hooking and were doing superior work. The report recommended that hooking be vigorously pursued in Harrington Harbour under the continuing able leadership of Eileen Wedd.

In Harrington, a local woman, Aunt Esther Cox,[173] was in charge of all the dyeing; the mat-hookers said with pride that she could get *any* colour and had no equal on all the coast. The Industrial and, later, Grenfell Handicrafts supplied the dye and bleach packets that Aunt Esther used in the two batches of material she dyed nearly every day for close to thirty years. Her record books for the early 1950s show that in a month she bleached as many as 146 pounds of silk and rayon and dyed nearly 180 pounds of material and over 70 pounds of stocking tops – all for a payment of $53.35 (which included a 10 per cent

bonus). By the end of the decade, with the switch to the bulk purchase of pre-dyed materials, Aunt Esther was dyeing only small amounts; she recorded just four pounds in August 1958, for a payment of $1.10. Not all stockings and undergarments needed to be dyed: whites were required for snow scenes, puffin breasts, and sails; mat borders were mostly black; and many shades of beige were hooked into rock outcroppings. The cotton tops of the stockings were cut off and dyed separately, as their heavier texture dictated that they would be used differently. Aunt Esther's daughter, Barbara Harding, remembered being sent out to gather snow, which was melted to fill the "great big dye pot" that was always simmering on the woodstove. She also recalled her mother throwing handfuls of coarse salt or stirring vinegar into the pot to complete the dying process. Harding smiled at the memory of lines strung everywhere, inside and out, draped with drying dyed stockings and undergarments.[174] Aunt Esther was justifiably proud of her reputation and once quipped to an Industrial supervisor, "I bin dying for 50 years and I isn't dead yet!"[175]

The Muff Report gave a negative account of the work at St Anthony; no new designs had been created there in the previous ten years. Moreover, the workers were in a state of uncertainty as to the future of Grenfell Handicrafts because Mary Andrews was preparing to leave, indicating that she was doing so because "crafts were finished on the coast."[176]

The report made a number of recommendations. First, the policy of Grenfell Handicrafts needed to be redefined. The location of the headquarters should be moved from St Anthony to

North West River to take advantage of the huge military presence there. (This recommendation was never followed.) Also, Eileen Wedd was to be appointed director, responsible for administering the new policy and expected to continue her work of designing new articles as well as new mat patterns.

In 1968, a Canadian from Toronto, Marilyn Dunford, was appointed director of Grenfell Handicrafts. She recalled being acutely aware that it was floundering. Dunford concentrated her efforts on the embroidered parkas and dickies, feeling that the mats were too old-fashioned for the time. No emphasis was placed on their production, but Dunford did introduce long wall hangings, which she had Eileen Wedd design. These banners were hooked in three designs, two of Newfoundland flowers and one of puffins sitting on pilings. Mat-hookers hooked only the design, leaving the rest of the brin exposed. The wall hangings could be hooked in no time, and their popularity with both the mat-hookers and consumers surprised Dunford. New mat designs were no longer being introduced, and most of the items being hooked were square floral coasters and a series of small picture mats of young children, called Eskimo Babies. The women hooked these mats with wool yarn,[177] which had been introduced for hooking around 1961.

Today, only a handful of women continue hooking, producing about a hundred mats per year in St Anthony under the reorganized and independent Grenfell Handicrafts label.[178] The mats are the original Grenfell patterns worked in wool yarn. In some cases, they are hooked by the remaining aged mat-hookers, who still work with the same flawless precision; however, their colourings lack the subtleties so cherished in the old mats.

From a craft born of necessity these distinctive, timeworn mats have become an avidly sought-after form of artwork. The lives of the thousands of women who made them were touched by their making but, sadly, we know few names. The mats carry but one name, that of Grenfell, and while his vision deserves much credit, great numbers of people were responsible for the making of each mat. None was more essential than the mat-hooker herself, who spent countless hours bending over her mat frame by the soft glow of a kerosene lamp, quietly hooking the story of her homeland, dedicating herself to a craft she loved with the goal of helping to feed and clothe her family. The craft that once helped people make a better living now keeps alive a disappearing way of life and the spirit of the coast.

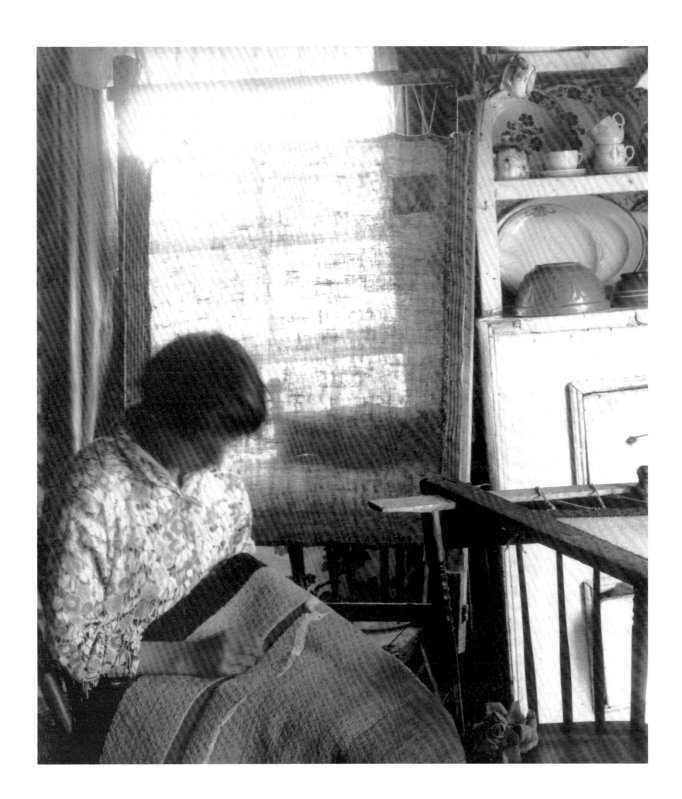

The International Grenfell Association

PRESENTS: GRENFELL HANDICRAFTS—HAND-HOOKED MATS

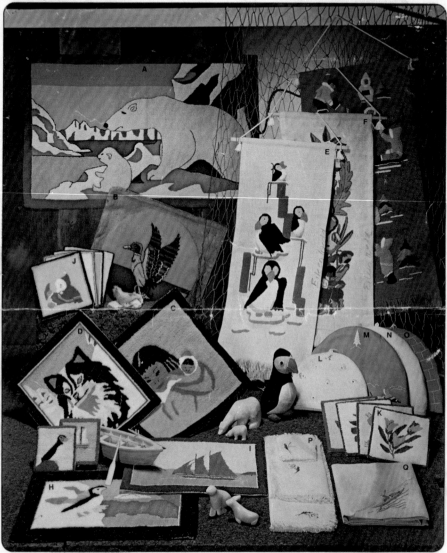

International Grenfell Association
Handicrafts Catalog, c. 1974,
showing the selection of mats
being hooked at this time
(Marilyn Dunford)

All mats are hand-hooked on the Labrador coast.

A. Standard Mats: Mother and Cub in Ice Field, size 26″ x 40″.
B. Mallard design Foot Stool Mat. This is a very old design,
recently renewed. Polar Bear design also available. **C.** Eskimo
Mother and Child, two sizes 14″ x 14″ and 18″ x 18″. **D.** Original
Husky Head design. **E.F.G.** Wall Hangings in various designs:
Puffin, Floral, Children at play. **H.** Puffin designs, size 10″ x 14″.
I. Schooner design, size 10″ x 14″, also available 17″ x 25″. **J.** Set
of three depicting Children at Play, size 10″ x 12″. **K.** Set of Floral

and Berry design Hot Plate Mats, size 6″ x 6″. **L.** Small Tea Cosy
of Grenfell Cloth with hand-embroidered design on both sides.
M.N.O. Large Tea Cosy of Grenfell Cloth with hand-
embroidery on both sides. **P.** Set of hand-embroidered Place
Mats, Centre Runner and Serviettes, in Wash and Wear cotton.
Q. Hand-embroidered linen Table Cloth.
*Not shown are Dog Team designs in assorted sizes up to 48″ x 34″.
Flying Geese sizes 12″ x 16″ and 26″ x 40″.*

Time Line

1892 Wilfred Thomason Grenfell first voyages to Newfoundland from England, under the auspices of the Royal National Mission to the Deep Sea Fishermen (RNMDSF), a medical and religious organization ministering to the needs of fishermen at sea.

1893 Return voyage aboard the *Albert*; Dr Grenfell establishes a hospital at Battle Harbour. He decides to devote his life to alleviating the sickness, poverty, and exploitation prevalent on the Labrador coast, and begins fundraising to further this work.

1894 A seasonal hospital is established at Indian Harbour, Labrador.

1901 Work begins on a hospital in St Anthony, Newfoundland. Dr Grenfell chooses St Anthony as the headquarters of the Grenfell Mission.

1905 Dr Grenfell meets Jessie Luther in Marblehead, Massachusetts while on a lecture tour. Intrigued by her unusual treatment of "nervous collapse" with occupational therapy, he urges her to come north.

1906 Jessie Luther travels to St Anthony with the aim of establishing a weaving industry to assist local women in augmenting the unreliable income from the fish catch. The Harrington Harbour hospital is built with contributions from the Canadian Grenfell Mission branches.

1907 Dr John Little designs the first Grenfell mat, with the words "Don't Spit" in red letters on a white background bordered with a pattern in red and green. The Grenfell Mission starts actively seeking markets for the products of its Industrial department.

1908 First mention of a "matting club" in Jessie Luther's diary.

1909 Grenfell marries Anne McClanahan of Lake Forest, Illinois. Jessie Luther introduces mat patterns with designs of local significance, including walrus, a dog team, an arctic hare, ducks, reindeer, rabbits, and reindeer herders treated as borders around a plain centre. The Canadian Guild for Crafts in Montreal gives Luther recipes for vegetable dyes.

1910 Luther's journal notes that "he [Dr Grenfell] became interested in making designs for hooked mats that are being prepared for distribution among the local women who work for the Industrial department."

1912 Anne Grenfell becomes involved in standardizing the mat industry with respect to designs, materials, and workmanship.

1913 Founding of the International Grenfell Association (IGA). Dr Grenfell appeals through *Among the Deep Sea Fishers*, its quarterly publication, for clean used clothing and scraps of flannelette and cotton.

1914 McHugh's, a fashionable shop in New York City, orders samples of each mat pattern.

1915 Jessie Luther resigns, citing differences of opinion regarding the running of the Industrial.

1916 Sixteen mat patterns representing local scenes are in production. Designed by Dr Grenfell, they include dog-driving, reindeer-driving, reindeer on an ice floe, bears in snow, bears on an iceberg, a white owl, a flight of geese, a lynx stalking crows, foxes hunting partridge, and a whale hunt. Each design covers the entire mat.

1916–18 Alice Blackburn is supervisor at the Industrial.

1917 About 360 mats made by sixty women have been sold. The sales represent the equivalent of about twenty dollars of income per mat-hooker.

1920 Laura Young becomes supervisor at the Industrial. Over twenty copyrighted patterns are in production. New designs include a fleet of schooners, two walrus on ice floes, three bears, a dog team in front of a cabin, and two men in a canoe paddling by a bear toward an ice floe. This year, 410 mats are made. It becomes difficult to get coloured flannelette. Only new materials are now used in the mats.

1921 Elizabeth Page is placed in charge of the Industrial work in the White Bay area of Newfoundland.

1923 Catherine Cleveland becomes supervisor at St Anthony. Special record-keeping cards are introduced for Industrial workers.

1925 Emphasis is placed on floral designs to meet the demand for mats of the "Colonial type." Mats are worked in cotton, wool, brin, and silk.

1926 Mae Alice Pressley-Smith is appointed supervisor at the Industrial.

1927 Dr Grenfell is knighted by King George V.

1928 "Save Your Old Silk Stockings!" plea goes out in *Among the Deep Sea Fishers*. Rayon stockings and undergarments are also requested.

1929 *Among the Deep Sea Fishers* continues to urge its subscribers to donate "silk and artificial silk stockings in unlimited quantity." Nine tons of silk and rayon stockings and undergarments are received. Grenfell Mission volunteers tour the resort areas of New England and New York State holding sales; retail shops selling the Industrial's goods exclusively are opened in New York and Philadelphia.

1930 Rhoda Dawson arrives in St Anthony to work at the Industrial. This year, 3,615 mats are hooked. At an average of about three dollars per mat the result is payments of $10,847.68 to the mat-hookers. First mention of woven fabric labels being ordered to identify the mats as a Grenfell product.

1932 The Dog Team Tavern is opened in Ferrisburg, Vermont. Accumulation of goods, scarcity of funds, and lack of new markets severely cut back mat production.

1933 Rhoda Dawson returns to England; business continues to be poor and morale at the Industrial is low.

1934 Rhoda Dawson returns to Newfoundland to teach in Payne's Cove and to supervise the Industrial effort in Harrington Harbour.

1935 M.A. Pressley-Smith returns to Scotland; Dawson "more or less takes charge."

1936 Rhoda Dawson leaves the Industrial and again returns to England; Janet Stewart is appointed supervisor. Summer tourist boats cruising the Labrador coast significantly boost sales, with St Anthony reporting record sales of $1,514 for one stopover by the S.S. *New Northland*.

1937 The IGA decides that the Industrial should produce all that it possibly can for the summer tourist trade and limit shipments to the United States.

1938 Anne Grenfell dies. The Grenfell Mission shops in New York City and Philadelphia close. The focus shifts to sales in private homes and tours by volunteers. Payments to the Industrial's craft workers fall to $150. Renewed appeals for discarded silk stockings appear in *Among the Deep Sea Fishers*.

1940 Sir Wilfred Grenfell dies. Goods from the Industrial are no longer shipped outside Newfoundland because of the closed markets, transportation difficulties, material shortages, and rising costs associated with World War II. Harrington Harbour and Mutton Bay become a major factor in the Industrial effort known as Canadian Shore Industries. Mats hooked here carry the "Handmade in Canadian Labrador" label. Veronica Wood is appointed supervisor at Harrington Harbour.

1942 Servicemen stationed in Newfoundland and Labrador provide a stable economic base; $31,000 worth of Industrial products is sold locally. American outlets continue to sell stock on hand through private sources.

1946 Janet Stewart resigns; several short-term supervisors take over.

1948 This year, 1,547 mats are sold.

1949 Dorothy Plant assumes the role of Industrial supervisor. Newfoundland and Labrador joins Canada.

1950 Appeals go out for silk and rayon, stating that only these materials will do; "nylon is of no use in hooking picture mats."

1955 Grenfell Labrador Industries changes its name to Grenfell Handicrafts, and shifts its emphasis from supplementing income to providing occupational therapy in the hospitals. Mary Andrews replaces Dorothy Plant as Industrial supervisor.

1959 Fewer than 150 mats are given out for hooking.

1968 Marilyn Dunford assumes the supervisory role in St Anthony but focuses on the clothing line. From this point on very few mats are hooked.

1981 *Among the Deep Sea Fishers* ceases publication.

1984–Present
Grenfell Handicrafts becomes a private enterprise in 1984. Today, it carries on the mat-hooking tradition, each year producing about a hundred of the same flawlessly hooked mats (made with wool yarns, which began to be used in the 1960s) from the original patterns.

Mat-hooking was centralized around St Anthony in northern Newfoundland, Battle Harbour and Red Bay in southern Labrador, and Harrington Harbour in the part of Quebec known as the Canadian Labrador. Mat bundles were prepared at the Industrial's buildings in St Anthony and Harrington Harbour and other outlying areas.

PREPARING THE MAT BUNDLES

Putting together the mat bundles for the hookers' use was the work of many hands. Designers drew original mat patterns and decided on the colours. Other Industrial workers cut stencils from the patterns by slashing through heavy card stock or, later, used x-ray film. The stencils were painted with shellac for durability. Using the stencils, the patterns were transferred onto brin with an indelible purple pencil that dyed the hands and stencils but didn't seem to harm the mats. Still other workers measured out the fabrics for hooking, commonly pinning dyed swatches to the pattern to indicate where each colour was to be used. Each mat bundle came complete with typed instructions and a small coloured drawing or sample mat to illustrate what the finished product should look like. While every effort was made to make the instructions clear and easy to follow, drawings and sample mats inevitably got lost and materials became mixed up. The resulting creative colour schemes serve to illustrate the assertion that no two mats were ever exactly alike. After the bundles were weighed, they were ready for distribution.

PART TWO

The Mats

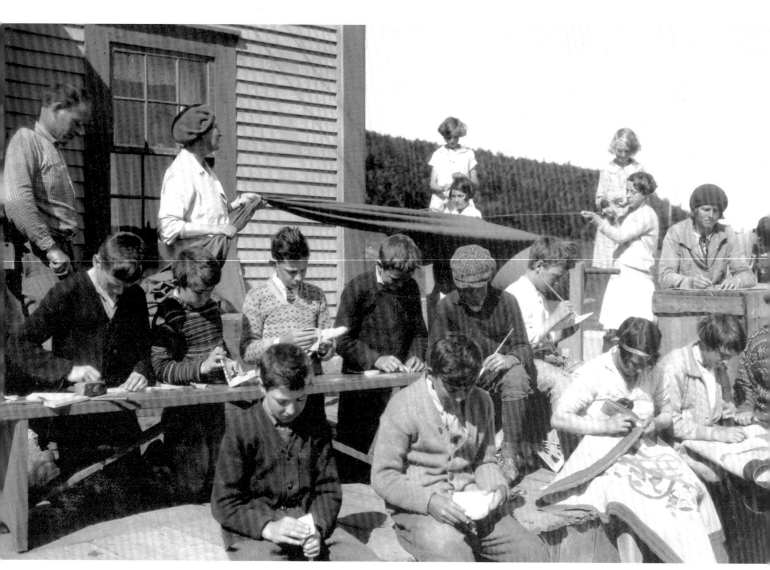

"Congestion at the Industrial," c. 1932 (PANL VA110-47-1)

Women hooked in their homes by the light of a kerosene lamp using a mat frame made of four pieces of wood, usually birch, lashed together. The top and bottom pieces were wrapped in canvas, to which the patterned brin was sewn. These two pieces had slots at each end through which the side slats could be slipped. The latter had holes along their entire length for adjusting the size of the frame, so that the backing material could be laced tight. For larger mats and rugs, the brin would be rolled onto one of the side pieces. Most mat frames were portable and could be turned as necessary to make the job of hooking easier. Every mat-hooker owned several mat frames of various sizes.

As mentioned previously, different materials were used for different purposes. Floor rugs were hooked with flannelette or unravelled brin; for the finer wall mats, old silk or rayon stockings and undergarments were required. The materials were washed, bleached, and dyed to a veritable rainbow of colours, although sufficient quantities of black, brown, tan, white, and grey stockings were used in their own tones. Every bit of stocking was used. At the Industrial, workers cut off the tops and feet, which were sold in packages costing twenty-five cents to the mat-hookers for their own use. The rest of the stocking was then cut 'round and 'round on the bias. Other fabrics were torn into strips, which measured about a quarter inch by ten inches; the size varied somewhat according to individual preference.

Silk stockings, sold in several weights (sheer, service, and heavy service) were readily available and widely advertised in the 1920s. Prices ranged from $1.55 to $2.75 per pair. The stockings were made with lisle tops and feet in all "the wanted colours: black, sunbeam, meadow-lark, bran, cinnamon, nude, toad, deer, hazel, champagne, gun-metal, and ecstasy to name a few." Silk underwear – "step-ins, dance sets, bloomers, chemise and panties" sold for two dollars. At the same time, rayon, the artificial silk made from cellulose, was gaining popularity. Real silk had to be imported, whereas rayon could be produced in local factories, keeping the cost down considerably. By 1943, in the United States, the Office of Price Administration had placed ceilings on sheer silk hosiery (which cost more to produce than service weight hose). Some felt this move was aimed toward the elimination of fine hosiery. One newspaper, the *Boston Traveler*, reported, "That leaves rayon, and what that will do to the feminine morale will be awful." On 27 October 1938 the chemical giant Dupont introduced its new synthetic yarn, "nylon" – an invention that would significantly affect the future of Grenfell hooked mats.

Mat-hookers who prepared their own materials recalled the stockings having random cuts in the legs so that they could not be worn or used for another purpose besides hooking. Stella Fowler, an active eighty-three-year-old from Labrador, shyly related this memory: "At that time there wasn't much around and lots of people, well, they used to wear 'em. The feet was cut off [at the Industrial] but people would just pull the legs up over they own legs and then they'd wore those jazz stockings, we calls them, with the pattern tops turned down. Beautiful. Some people never

had enough to finish their mats' cause they weared them. Then they started cutting through the stockings so's you couldn't wear them. That's why they [the Industrial] had to weigh them."[1] In the later years the workers prepared their own strips from bolt fabric supplied by the Industrial. Another Labrador mat-hooker, Violet Pye, recalled that it was necessary to spend an entire evening preparing the hooking materials before she could begin her mat the next day.[2] Once cut, the strips were pulled taut to draw the raw edges inward, giving the fabric a corded effect.

Each mat required a prodigious amount of material. A floor mat measuring 18 by 30 inches took between nine and twelve yards of new flannelette; a knitting bag called for about one to one-and-a-half pounds of silk or rayon.[3] To make a standard-sized picture mat (26 by 40 inches), a mat-hooker used between fifty and sixty pairs of stockings.[4]

Early on, mats were hooked through the hem, so that no visible hem was left on the reverse. Although it was difficult to do well, the mat-hookers were used to the technique, since they made their own mats reversible so they could use one side one week and the other side the next week before washing the rug. Mats could be used this way only if no hem could be seen.[5] Gladys Chislett, a mat-hooker from Harrington Harbour, recalled the technique: "Oh, yes, we hooked the hem and all for the floor mats. It was harder to do but it kept the mats firmer and so's you could use them on both sides. We didn't do it for the [smaller] picture mats, though."[6] Hooking through the hem was tedious, as Stella Fowler clearly remembered: "It would take you two days to do

the hem around, my dear, that was really hard to do ... through two or three folds of brin."[7] The technique, typical of large, early mats, produced a nicely finished piece. In later years, workers at the Industrial would stitch a visible hem around each finished mat after it was hooked.

With her mat laced to the frame, a hooker usually worked from left to right on a horizontal mat or from bottom to top on a vertical design, holding the hook in her right hand on top of the brin. Two fingers of her left hand held the material under the brin. When the hook was pushed down through the brin, a rolling motion brought the loop of the material up to the mat's surface. A great deal of practice was needed to produce an even texture. Mat-hookers still remember Pressley softly running her hand over the tops of the finished mats making certain that the hooking was smooth and even, then carefully folding each mat corner to corner to verify that it was "fair" and not "squish."[8] Grenfell mats are famed for their almost universal use of clearly defined horizontal straight line hooking – following the same row of meshes across the entire work – and for the working of fabric into every hole of the brin, which creates a texture resembling needlepoint. (Some of Rhoda Dawson's designs are notable exceptions to the straight-line hooking rule.) Una Roberts, a spry eighty-nine-year-old hooker from St Anthony who continues to make mats, stated in her matter-of-fact way: "I hooks so many I could do it with my eyes shut and still do the lines straight, they'd come out fine."[9] Woolly bears and furry dogs could be created by "tufting" – hooking higher than the rest of the work, then clipping the loops to create a fuzzy texture.

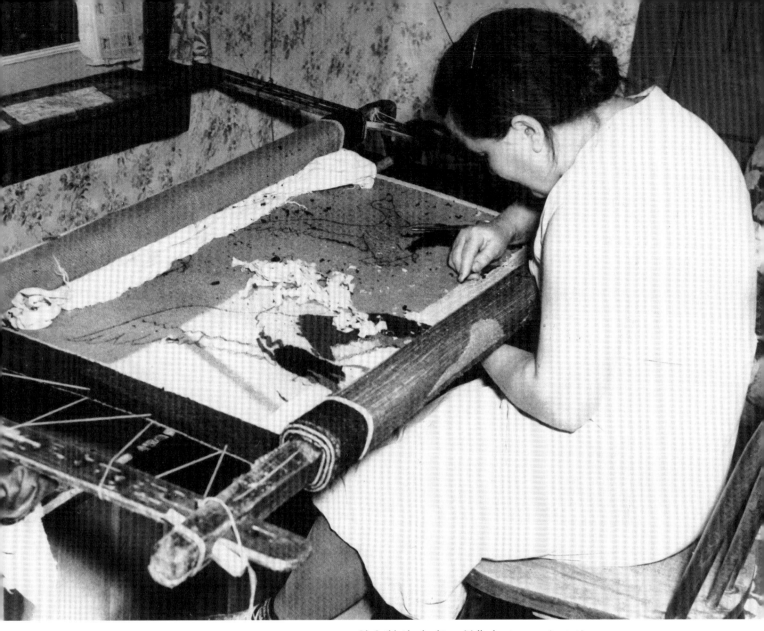

Ida Lethbridge hooking a Mallard mat, c. 1931 (WTGHS)

The mat-hookers pulled all raw ends to the top, thereby making a more durable mat, because ends were apt to catch and pull out. The women always hooked their own mats this way; their mats covered wooden floors, and stray splinters posed a significant problem. However, when they were hooking with flannelette, pulling the cut ends to the surface produced a spotty effect that was not pleasing, so they were urged to leave them underneath. When the hookers were using mixed materials or a variety of colours, as in many of the mats, the spotty effect was not as pronounced and the ends could be left on top. "If you lick your fingers you'll get the raw edges out of sight, all right!" wrote Pressley.[10] With silk, she said, "You must have the ends on top because silk strands catch so easily with fatal effects."[11]

Hookers took care to keep the mat straight on the frame or it would be "squish" when taken off. Keeping them straight was always a problem with the round mats; as a result, the small round coaster designs were eventually replaced with square ones. Oftentimes four to six small mats would be stencilled onto one piece of brin; when they finished the hooking, the mat-hookers would return the entire piece to the Industrial, where other workers hemmed each individual mat. Generally, the women were happy to hook whatever designs were available. Violet Pye of Lodge Bay, Labrador was hooking mats for the Industrial in the mid-1930s: "If you was gonna hook a mat, you jus' ask for it and they gives you what they had … Different years they'd be different patterns, one you might like one year, the next year it wouldn't be there at all."[12] (One woman in St Anthony spoke of patterns and records

being thrown out by the boxful.[13]) It has already been noted that some mat-hookers chose to make the most popular designs over and over in order to complete more mats and earn more money or clothing. Eliza Yetman, a tall, stately woman from Red Bay, smiled and nodded her head as she recalled hooking "so many mats the pile would be taller than me."[14] While most of the designs were inspired by local life, some were derived from calendars, brochures, photographs, and catalogs.

The Industrial encouraged special orders for mats, and received a host of them. On occasion a group of mat-hookers would work together on a large rug, so large it would be set up in a special frame in a community building where the women could come to hook as they found time. The Industrial paid them on an hourly basis or with one payment split among the group.

CLEANING TIPS

As mentioned earlier, to clean their mats, especially floor rugs, the mat-hookers simply washed them. The mats made for sale came with directions for their care and cleaning supplied by the Industrial:

Instructions for Cleaning Hooked Mats

• Shake mat thoroughly and remove loose dust.
• Lay mat on flat surface and scrub with very stiff brush until clean, wetting the brush with lukewarm soapy water as required.
• To remove suds, wipe surface with damp cloth

once or twice and when finished turn mat face down on clean flat surface to dry.

• Use mild soap and as little water as possible.[15]

These instructions are definitely not recommended today for cleaning Grenfell mats! Burlap has a life of only about fifty years, and wetting and scrubbing with a stiff brush will have dire consequences. To clean antique hooked mats, it is best to use the services of a textile conservator.

IDENTIFYING GRENFELL MATS

Over the years, the Industrial used at least seven labels (plus variations) to identify mats. Here, a "Grenfell mat" is defined as a mat of a documented Grenfell pattern or a mat hooked for and/or accepted by and sold through the Grenfell Mission. The earliest label to be used had "Made in Labrador" stamped in black ink on a small strip of muslin. The first mention of having a proper fabric label on the mats to identify them as Grenfell products occurs in a letter dated 11 February 1930. Pressley wrote to Margaret Pierce in Philadelphia asking, "Do you think the moment has come when we should consider having a registered trademark attached to all our industrial products? As you are no doubt aware the United States customs authorities have recently ruled that a fabric label must be sewn to all mats which we import. My suggestion would be to have the word Grenfell as a trademark and have it woven on fabric labels of varying sizes suitable to be sewn on our mats." She went on to express concern for Anne Grenfell's support of the words "Made in Labrador," adding: "I have heard quite an amount of unfavorable criticism of our using the words "Made in Labrador" when by far the greater part of our products are made in Newfoundland. It always gives me rather an uncomfortable feeling, as of not being honest, when the question is brought up by purchasers … On the other hand, I believe that Lady Grenfell feels that the words "Made in Labrador" should be retained because of their publicity value, the name Dr. Grenfell having always been associated in the minds of the public with Labrador, rather than Newfoundland."[16] The committee compromised with "Grenfell Labrador Industries / Handmade in Newfoundland and Labrador." A lawyer, a Mr Champney, recommended making the label distinctive by means of a "square 'round it or some similar thing."[17] Correspondence about the labels continued, and in August Pressley wrote to the London office: "Many thanks for ordering the Cash's labels. We are most anxious to receive them."[18] These letters make a strong case for the assertion that the hooked mats did not carry woven fabric labels until late 1930. However, some mats hooked earlier may carry a fabric label if they were still in inventory when the labels arrived. The Cash's records, held in the Coventry Archives in Coventry, England, do not go back far enough for further verification.

The most common label is "Grenfell Labrador Industries / Handmade in Newfoundland and Labrador." It was produced in two sizes, appropriate for larger and smaller mats. To identify crafts made in the Harrington Harbour and Mutton Bay region, a label reading "Grenfell Labrador Industries / Handmade in Canadian Labrador"

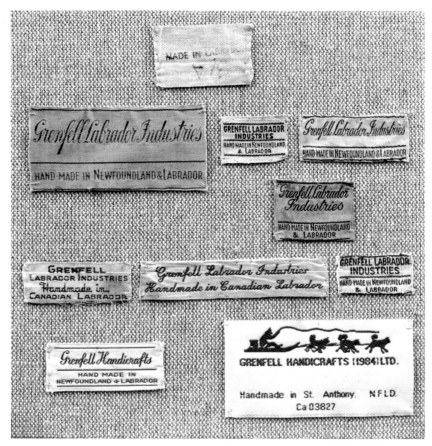

Labels used to identify Grenfell mats
(Private collection)

was used. By 1940, this branch of the Industrial was flourishing, and it is likely that it started to use its own label around this time. The label also identified these mats as Canadian goods, which were not subject to heavy customs charges.

In 1955, a new label, "Grenfell Handicrafts," was produced to reflect the Industrial's new name. Today, the hooked mats carry an updated "Grenfell Handicrafts" label that identifies them as products of the reorganized and independent Grenfell Handicrafts in St Anthony, Newfoundland.

It is unreliable to date a mat by its label – it is common to see two mats of the same design with different labels – or to use the label to identify a mat as a Grenfell product. Labels were easily removed and could be resewn onto another mat, with no regard for authenticity or design. More-over, mats may have left the Industrial without

the Grenfell label, thanks to the often hectic pace of production and the necessity for a shipment to make the next boat south. Mat-hookers in St Anthony recalled delivering a finished product to the Industrial that included a label sewn on the lower left-hand corner of the reverse of the mat. However, in Harrington Harbour, the Industrial's own workers did this job. There was no consensus among the mat-hookers in the Strait; some felt sure they had been responsible for sewing on labels, while others were certain they had not.

A handwritten number or name is occasionally seen on a label. The mat patterns were numbered; a number usually indicates a specific design. A name on a label may either indicate a mat-hooker's name or correspond to a special order purchaser. Some hookers in remote areas returned their mats by mail or boat, and the Industrial's workers needed each woman's name in order to make proper payment. The Mission discouraged customers from contacting the crafts-people directly by closely guarding their identity, so any name on a label is likely to consist only of a name and an initial for the surname.

wonderful and amazing. They are but a few of the many designs hooked by the women of northern Newfoundland and Labrador for the Grenfell Industrial. Some are unique; others are variations on popular patterns; still others follow the instructions that accompanied the mat bundles nearly to the letter. Many are among the finest hooked mats that can be found. Each, however, is a tribute to and a celebration of all the mat-hookers of the Industrial.

As noted in the Introduction, the sizes of the mats are given in inches, with height followed by width, except for round mats, where the diameter is given. The prices quoted are the base prices at the Industrial shop in St Anthony, unless otherwise stated, and do not reflect the significantly marked-up retail prices in the Canadian, American, and British markets.

A PICTURE GALLERY OF MATS

The mats pictured on the pages that follow are all authenticated Grenfell mats, with the possible exception of IGA 1931 on page 137. The mat-hookers placed a strong emphasis on the construction rather than the aesthetics of a mat. A "good" mat was one that was well-made, one whose back was as pleasing as its front. The mats featured in this section are "good." They are also

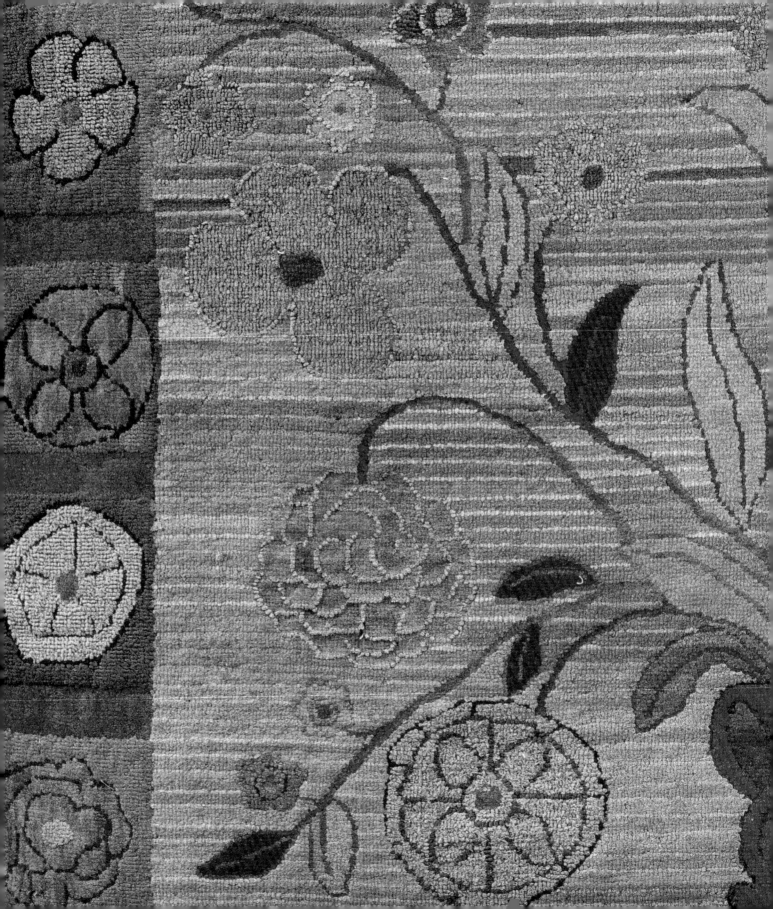

A Gallery of Mats

Map of Newfoundland Showing Hospitals and Nursing Stations of the Grenfell Mission

Silk and rayon, dyed
Design in production by 1936
42 x 31.5 inches

The design of this mat was adapted from a hand-drawn map, signed L.H.H., which showed the Grenfell Mission hospitals and nursing stations and was published in the 1935 *British Annual Report* of the International Grenfell Association. The design was hooked in large numbers in four sizes, the largest of which appears here. St Anthony, the headquarters of the Grenfell Mission, is marked by a small white house to the left of the spouting whale. Flower's Cove is shown southwest of St Anthony, and St John's is indicated by a small building on the lower right of the map on Newfoundland's Avalon Peninsula. Going north along the Labrador coast, the four teepees roughly represent the area from Harrington Harbour to Mutton Bay. Next is the Forteau to Red Bay region along the Strait of Belle Isle; the shining lighthouse identifies the port of Battle Harbour. The four igloos mark North West River, and Indian Harbour is just above at the top edge of the mat. The actual distances between settlements are vast, and much of this area, where the Grenfell Mission concentrated its efforts, remains sparsely populated today.

The Sir Wilfred Thomason Grenfell Historical Society (WTGHS) has several patterns for this design, one bearing the name of Rose White (1900–77), supervisor at the Industrial in Sandy Cove, Newfoundland. White coordinated the effort in the area; she did all the stencilling, dyed the materials, distributed the mat bundles, and collected the finished work to send to St Anthony. The Industrial supplied her with brin, bleach, and dyes. Her daughter, Stella Hoddinott, recalls from oral tradition that White hooked the first map and was given the design by a nurse at Flower's Cove, Jean Eggbert, in 1936. This design was refined from the original. Hoddinott recounted that her mother received four dollars for a large map mat; smaller versions were also hooked, for a payment of ten cents for the smallest (7 x 4 inches). Hoddinott also recollected "pounds and pounds of stockings all over the house" and a special area for doing the stencilling.[19]

In October 1936, "The Homemaker," a column in a Toronto newspaper, reported: "Beautiful rugs, incredibly fine and firm, hooked from discarded stockings … were on display and for sale at the Exhibition of Labrador Handicrafts at Eaton's–College Street. We fell into conversation with the nurse on furlough, Miss W. Murdoch, a rosy cheeked Scotch girl, and with her studied the fascinating map Sir Wilfred has made dotting it all over with wigwams, hospitals, nursing stations, schools, ships, great heaving walruses upsetting kayaks, wolves, moose, dog trains, igloos and a score of other objects that tell the story of the work among the people of the bleak Northland."[20]

Rose White, Green Island Cove, Newfoundland (Stella Hoddinott)

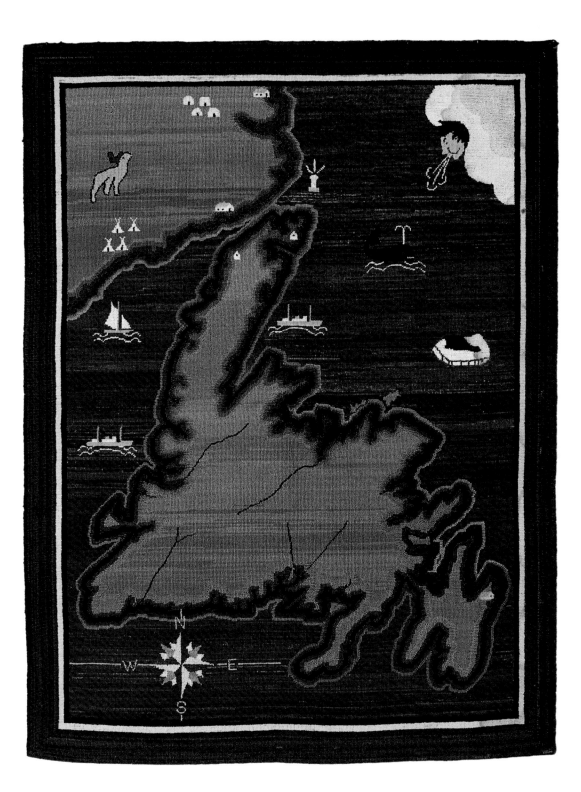

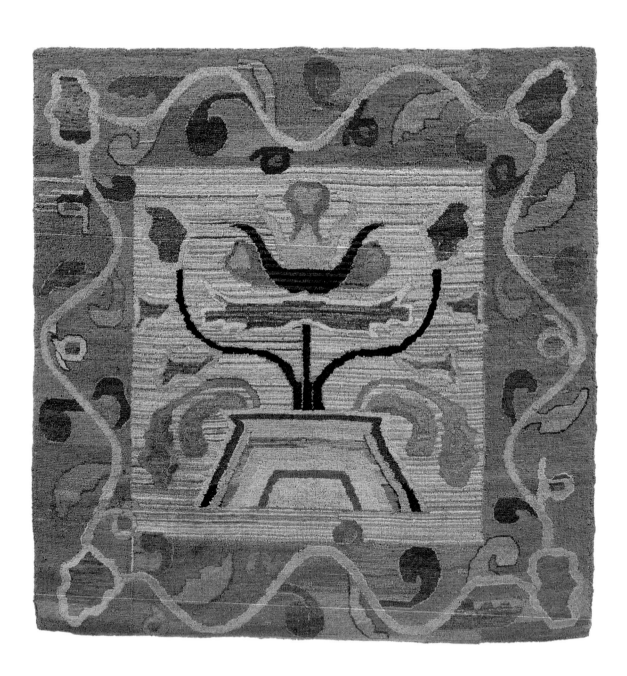

Prayer Rug

Silk and rayon, dyed
Design adapted by M.A. Pressley-Smith; in production by 1930
39 x 39 inches

A letter from Pressley to Rhoda Dawson dated
26 April 1937 states, "The 'prayer rug' pattern was
so named by us because of its vague resemblance
to Turkish prayer rug designs – especially in its
original form with the frame like this ⬚ leaving
the entrance open. I think this was forgotten in
the later copies. The design itself I took from an
old book on hooked rug patterns where the design
was described as one of the oldest hooked rug pat-
terns existing. Obviously I should say someone
before had copied it from an Oriental rug."[21] A
colour photograph of a rug hooked in this pattern
appears as the frontispiece of *Collecting Hooked
Rugs* by Elizabeth Waugh and Edith Foley, along
with the caption, "One of the earliest hooked rugs
known. The design recalls motifs seen on ancient
jewelry."[22] A mat of this same design is in the
collection of the Victoria and Albert Museum
in London, England; Dawson donated it to the
museum as part of her estate. In the notes accom-
panying the collection she wrote, "This large and
beautiful mat hung over my fireplace for years,
we never knew its origin or where the design
came from. I bought it from the annual staff sale.
It is called 'Prayer Rug' and has an Oriental
flavor."[23] The pattern number 89 is handwritten
on the label.

Sealskin Drying

Silk, rayon, and brin, dyed
Designed by Rhoda Dawson; in production by 1930–35
25 x 20 inches

Sealskins drying (Wilfred T. Grenfell Papers, Manuscripts and Archives, Yale University Library)

This mat is bolder and more experimental in design than the typical Grenfell picture mats. Rhoda Dawson wrote to her father in March 1931: "I have learnt a lot about colour here, working on the mats … I'm afraid the regular customers won't like my new mats, they're too sophisticated. I'm sure Grenfell won't, but the old original charm was already lost and they were just getting so bad one had to do something."[24]

The mat depicts the pelt of a ringed seal (*Phoca hispida*), prized because it is thinner and more pliable than that of the more common harp seal. In the early years of the Mission, people depended on the seal hunt for the necessities: food, clothing, dog harnesses, and a vast array of household goods. Seals were traditionally hunted between mid-March and mid-April, before the men embarked on their summer fishing voyage to Labrador.

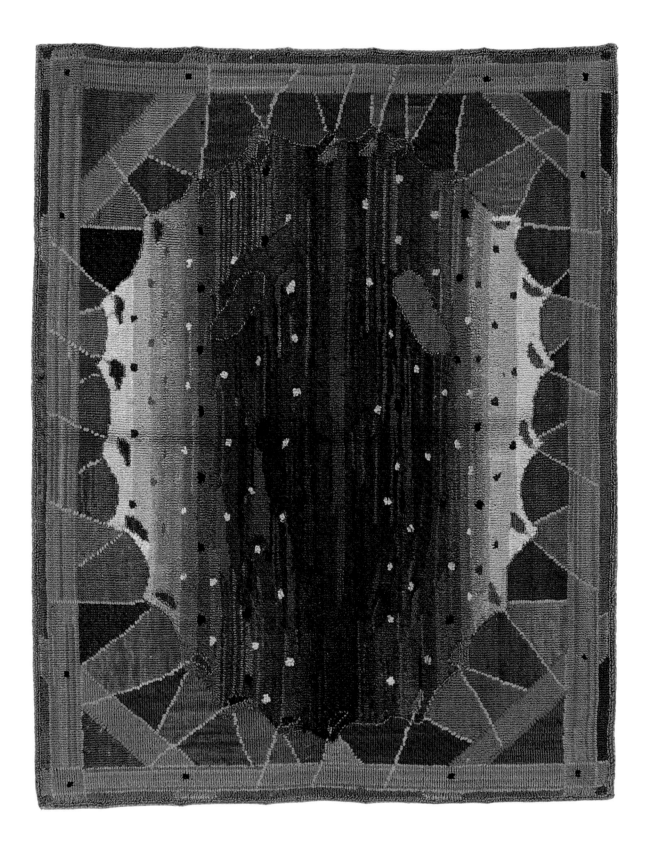

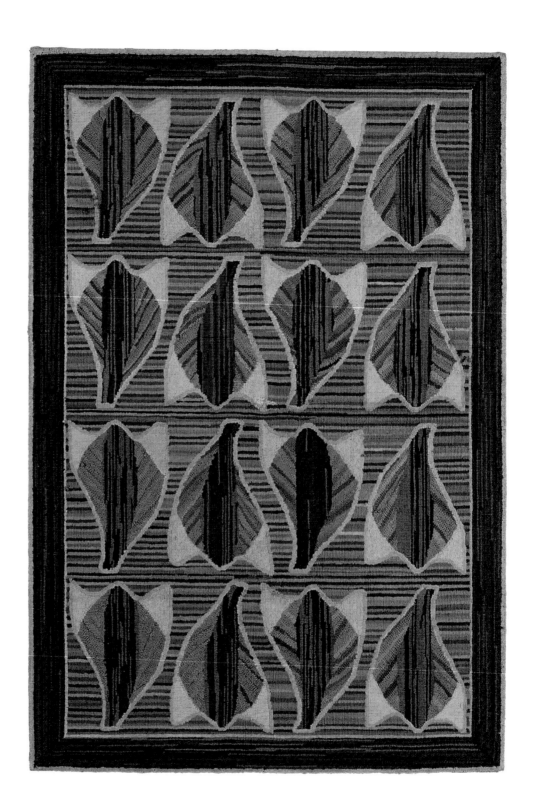

Fish on Flake

Silk and rayon, undyed
Designed by Rhoda Dawson; in production by 1933
39 x 26 inches

This mat – another bold, almost abstract, design – interprets split cod drying on a flake, a wooden drying platform atop a high staging. Dawson designed this pattern to be hooked entirely from undyed stocking material. She wrote, "I tried to keep my designs as appropriate as possible, but I had been out there nearly three years before achieving the best of mine, that showing codfish drying."[25] To Dawson, this particular mat stood out for how the women who executed the design "took it off" and for how the design got more interesting as it became more simplified. When one of the feisty local mat-hookers saw this mat recently she exclaimed, "I never see'd a fish look like that, they's supposed to be all white in the inside, them's wrong side out and whoever'd spread 'em only had a little bit of fish that day, they should be right up together."[26] Later mats of this design are seen with plain white insides and occasionally, in a creative departure, with brown insides.

Dawson's sophisticated designs did not suit the average taste, and many mat-hookers, who preferred bright colours, found her colour schemes too subdued. Dawson found it difficult to produce work for commercial gain and to accept the fact that sales were more important than aesthetics.

An invoice from the Industrial department shows this as pattern number 22, selling for a base price of $5.68.[27]

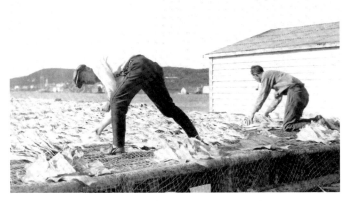

Salt cod on flake (Wilfred T. Grenfell Papers, Manuscripts and Archives, Yale University Library)

Mallard Ducks

Silk and rayon, dyed
Design in production by 1930
53 x 39 inches

Sir Wilfred Grenfell on his seventy-fifth birthday, with Mallard Duck mat (ADSF)

This design is distinctive for its realistic rendering of mallards. Seagulls, a great variety of ducks, and some species of geese were commonly seen on the Labrador coast during the 1930s. Mallards, however, were rare in northern Newfoundland and Labrador at the time, yet this was one of the most popular mats. The design closely resembles a 1929 calendar cover designed by Lynn Bogue Hunt for the Peters Cartridge Company of Cincinnati, Ohio, showing five mallards in flight. Calendar art was one of the sources for patterns in the early days of the Industrial. Today many of the mat-hookers, including Minnie Compton of St Anthony, remember this as one of their favourites: "I liked the ducks and the shadin' of the sky was all like rainbow colours."[28] Another woman said, "Took me two weeks to do a Mallard duck, got ten dollars for it. Hard work for nothin', but oh, I liked doin' it."[29]

A mat of this design was exhibited at the Canadian National Exhibition in 1951. "'I didn't realize they did such exquisite work,' said a woman as she gazed longingly at the booth's most expensive item, a hooked mat of ducks flying southward over marsh grasses. It sold for $45 which Torontonians considered unusually reasonable for such fine work."[30]

The same design was used as the cover of a 1944 engagement calendar produced for the Grenfell Mission. A June 1939 invoice lists this pattern as stock number 4, selling for a base price of $12.09.[31] A smaller mat (22 x 18 inches) depicting six mallards in breeding plumage taking flight was hooked at Harrington Harbour. A similar design, depicting three geese, was made in a square (39 x 39 inch) format.

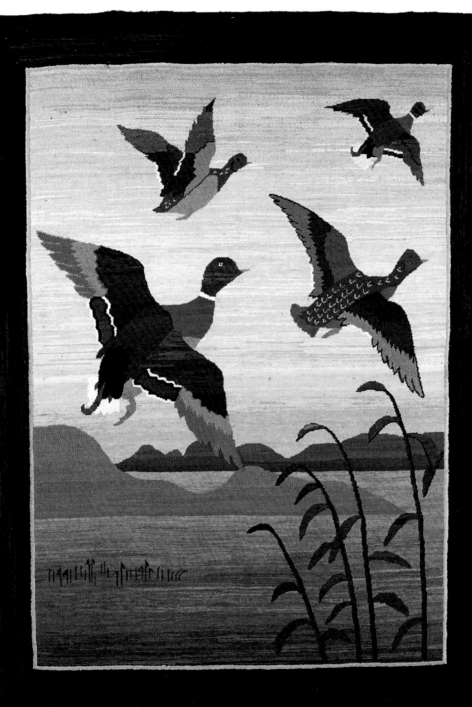

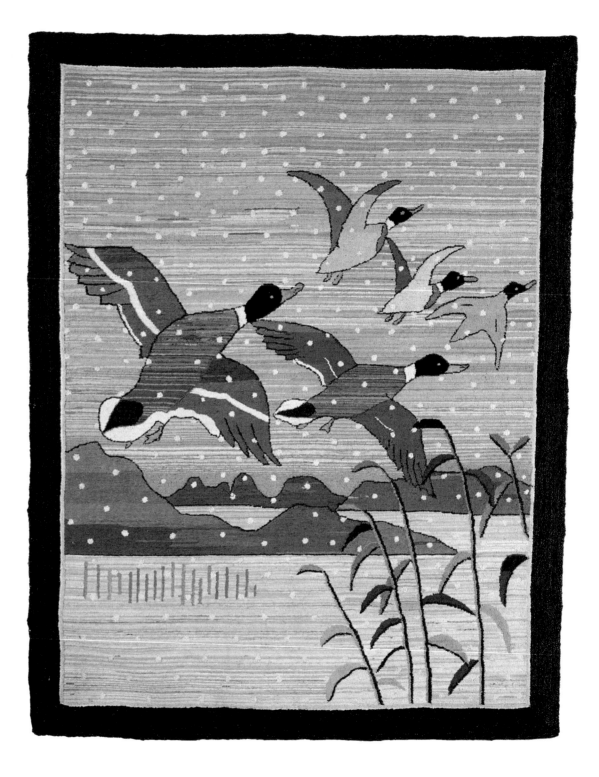

Mallards with Snowflakes

Silk or rayon, cotton, and brin, dyed
Design in production by 1929
51 x 39.5 inches

Less common than Mallard Ducks, this pattern
uses interesting textural effects. The cotton strips
used for the snow create a slightly raised texture;
brin is used in the tail feathers, heads, and out-
lines. In a letter of 2 August 1980 Rhoda Dawson
Bickerdike recalled, "What the tourists liked was
dear Wilf's Flying Geese [*sic*], with snowflakes."[32]

Meadow Mat

Brin, silk, rayon, and velvet, dyed
Design in production by 1937
37.5 x 26 inches

The design of this exquisite mat is remarkably similar to that of a rug pictured in *Hooked Rug Design* by William Winthrop Kent, called "Hindu Harmony."[33] However, the inclusion of flowers indigenous to Labrador and northern Newfoundland places this mat in a class by itself. Many of the native flowers can be identified: plum boy, bottlebrush, buttercup, blue flag, bakeapple, blueberry, crackerberry, twinflower, squashberry, and dandelion. Lavinia Mitchelmore, a mat-hooker from Green Island Cove, Newfoundland, remembered the name of the design, "Meadow Mat." The pattern was stock number 14; it sold for $5.80 in 1939.[34]

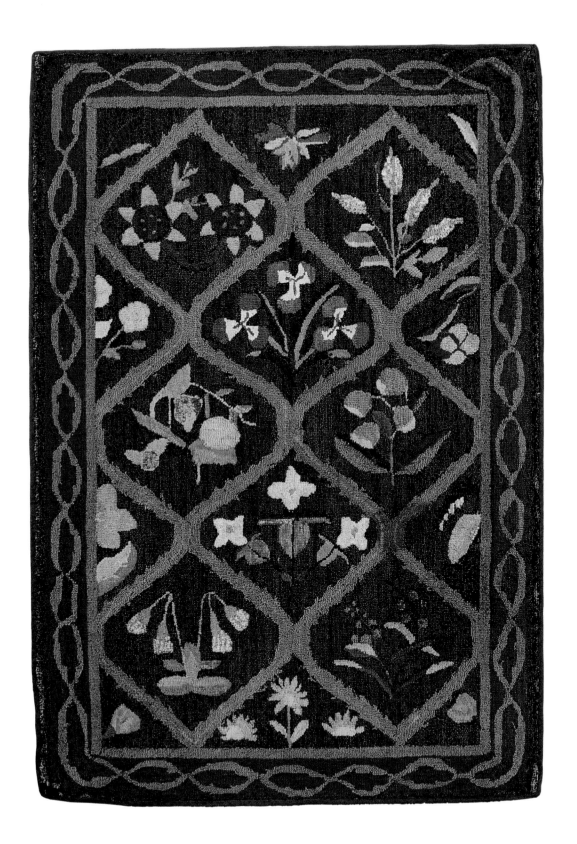

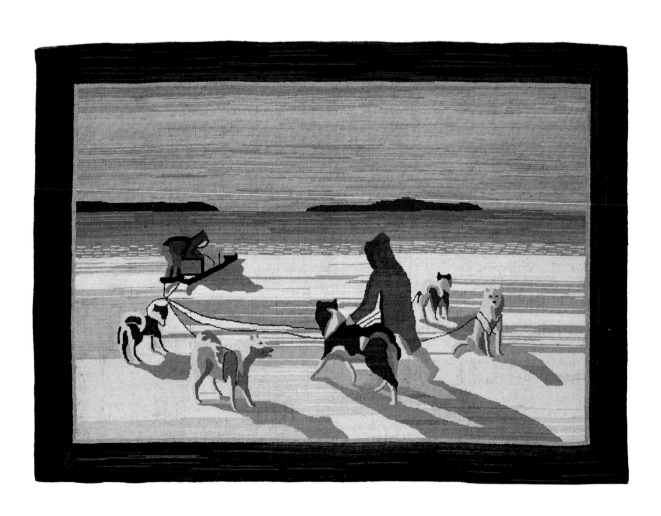

Dog Team with Shadows

Silk and rayon, dyed
Designed by Stephen Hamilton in 1942
34 x 44.5 inches

Stephen Hamilton (1908–93), an American from Amherst, Massachusetts, spent several winters working with the Grenfell Mission in North West River, Labrador. In a letter nearly fifty years later, he recalled the scene that inspired this design in 1942: "On a trip to hunt caribou, we took five dogs and a loaded komatik. On the first day crossing the bay we encountered a crevasse. The bay ice had split open and there was open water about eight feet wide. We unhitched the dogs, set the komatik at the edge of the ice and let it form a bridge. As we did this the 'alpine glow' came on casting a light so beautiful one hesitated to speak out loud to disturb the beauty of that magnificent landscape."[35] Many examples of this popular design exist, but very few include the broken ice that Hamilton described, seen clearly here just above the komatik. According to Hamilton, this is the only mat he designed.

To make sure that the sky was perfectly shaded, workers at the Industrial laid out the stockings and numbered them so the mat-hookers would know the sequence in which the colours were to be used.

Rocking Horses

Brin, undyed
Design attributed to Jean Wishart, c. 1925
26 x 39 inches

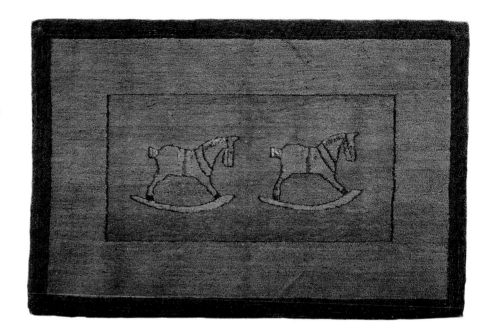

In the continual quest to expand the market for the Industrial's goods, a line of mats was designed to complement the decoration of a child's room. Jean Wishart (1902–91) of Toronto was a designer for the Industrial in St Anthony during the summer of 1925 who designed "many new and interesting patterns. There were floral patterns and designs for nursery mats, including 'Mary and Her Little Lamb', 'The Fat Pig That Went to Market', 'Humpty Dumpty Who Sat on the Wall' and 'Goosie Goosie Gander'."[36]

In 1932, a Toronto newspaper article noted, "The bold simplicity of design and color of the hand hooked rugs from Labrador made me visualize them at once in a room for a modern youngster, and the thick, firm weave guarantees its resistance to small scuffing feet … the various coloring provides for almost any decorative scheme … The rugs are also appropriate for bedrooms and bathrooms."[37] Other written accounts mention such mats as these as being particularly suitable as "nursery dados."

The use of brin as a hooking medium in this mat indicates that it was meant to be used as a floor rug. The raised, fuzzy texture on the horses' manes and tails was created by pulling the hooked loops higher on the rug's surface, then clipping the loops with scissors.

Vase of Flowers

Silk, rayon, and velvet or chenille, dyed
Design in production by 1933
25.5 x 39.5 inches

When the new floral designs were introduced, Catherine Cleveland wrote in *Among the Deep Sea Fishers* that the "workers were keenly interested in hooking the new patterns and the mats have proved to be good sellers."[38] In a 1933 photograph in that publication illustrating some household uses for the Industrial's products, a mat similar to this one can be seen as a wall-hanging in a bedroom.

Floral patterns for rugs other than Grenfells were extensively available in catalogs and department stores at the time across Canada and the United States. Two similar designs are pictured in William Winthrop Kent's book *The Hooked Rug*.[39]

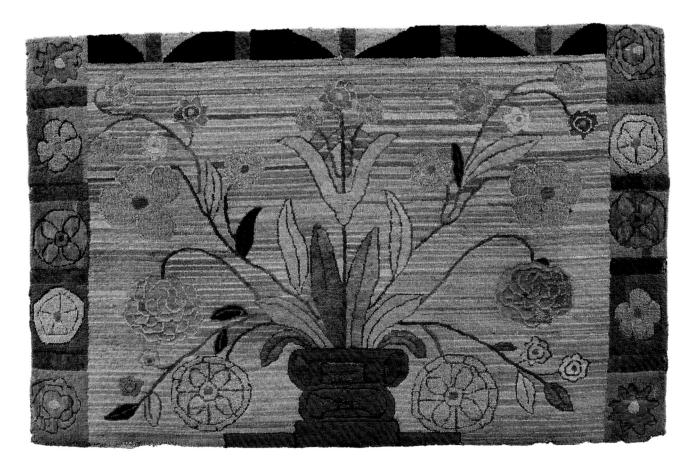

Purple Dog

Brin, dyed
Similar designs in production c. 1916
26 x 40 inches

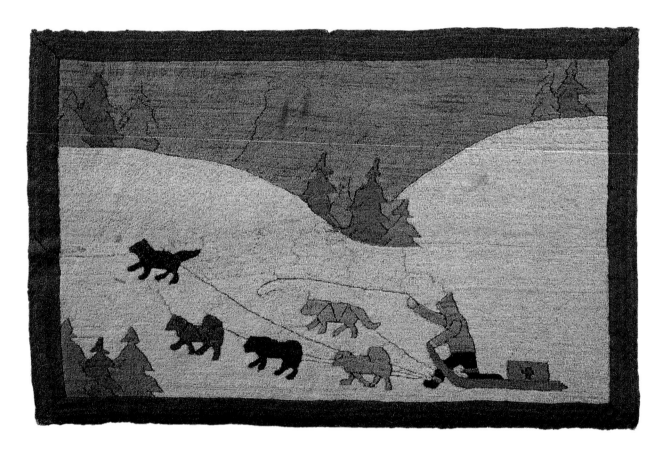

Images of dog teams pulling komatiks are
commonly associated with Grenfell mats. This
charming early design hooked entirely with brin
is an example of a standard-sized mat.

Dog Team with Curled Whip

Silk, rayon, and wool, dyed
Design in production by 1920
26.5 x 40 inches

To create a realistic raised, furry texture, the mat-hooker hooked the dogs in this mat in wool, bringing the loops slightly higher and then clipping them. The curling whip used by the team driver required extra patience to hook and is a desirable element in the design. The red cross on the "lend-a-hand" box indicates that this is a Mission dog team prepared for a medical emergency.

Dog teams were essential in the winter months for hauling wood and water and served as the only means of travel through the deep snow. The team shown here is harnessed using a "fan hitch," where each dog is attached to its own trace coming directly from the sled. This kind of harness was used for travel over open terrain. In winter, the Industrial supervisor would load a komatik with supplies and mat bundles and deliver them to the women living in the remote settlements of the district. Such visits provided encouragement and welcome social contact for the mat-hookers and their families.

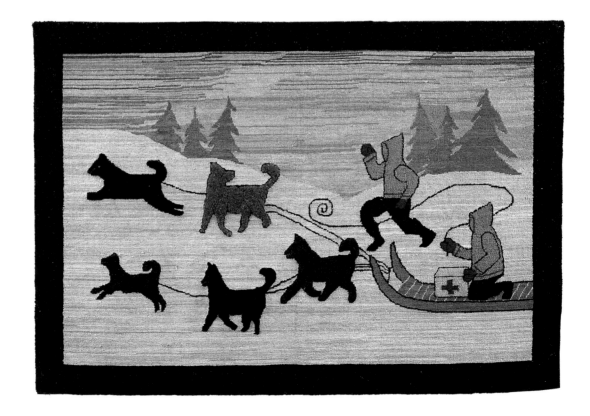

Labrador Bouquet

Silk and rayon, dyed
Design attributed to Rhoda Dawson
39.75 x 40 inches

Mat-hookers often used the striping technique
that appears here in their own mats. The plants
making up the central design can be identified as
crackerberry (bunchberry), dandelion, lily of the
valley, blue flag (wild iris), pitcher plant, and fern.
Handwritten on the Grenfell label is "Goose
Cove, St Anthony, August 1939." Goose Cove,
which supported an active hooking community,
is a fishing village a few miles to the southeast of
St Anthony at the northern entrance to Hare Bay.

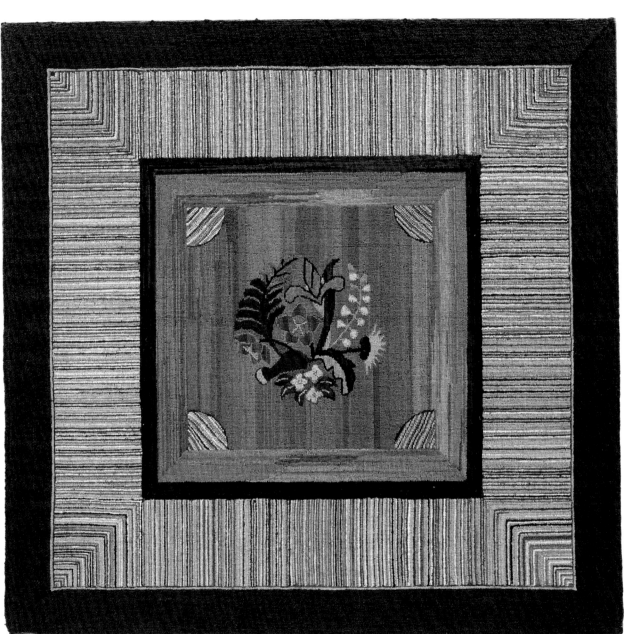

Three Geese with Half Moon

Cotton, dyed
Design in production by 1920
25.75 x 39 inches

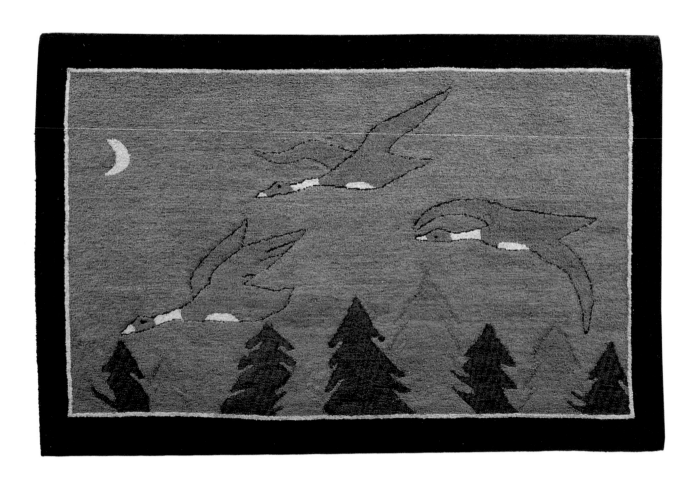

Canada Geese over Spruce Trees

Silk and rayon, dyed
Design in production by c. 1935
27 x 40 inches

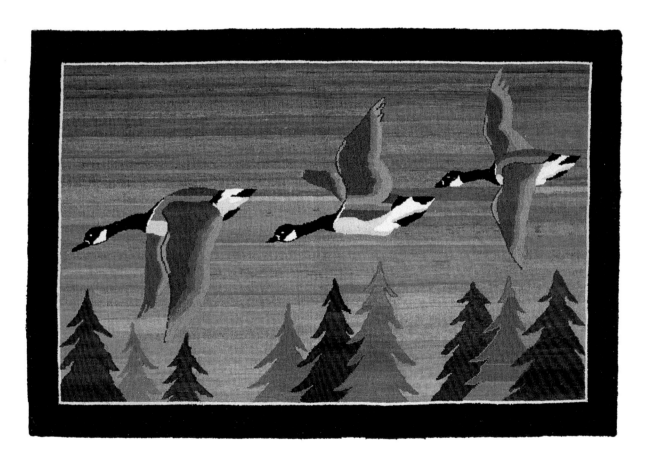

The mat on the facing page may date as early as
1920. It is hooked entirely with cotton. As the use
of rayon and silk became more common from
1928 onward, the mat-hookers were able to blend
colours and achieve a very sophisticated shading,
like that seen in the mat above.

99

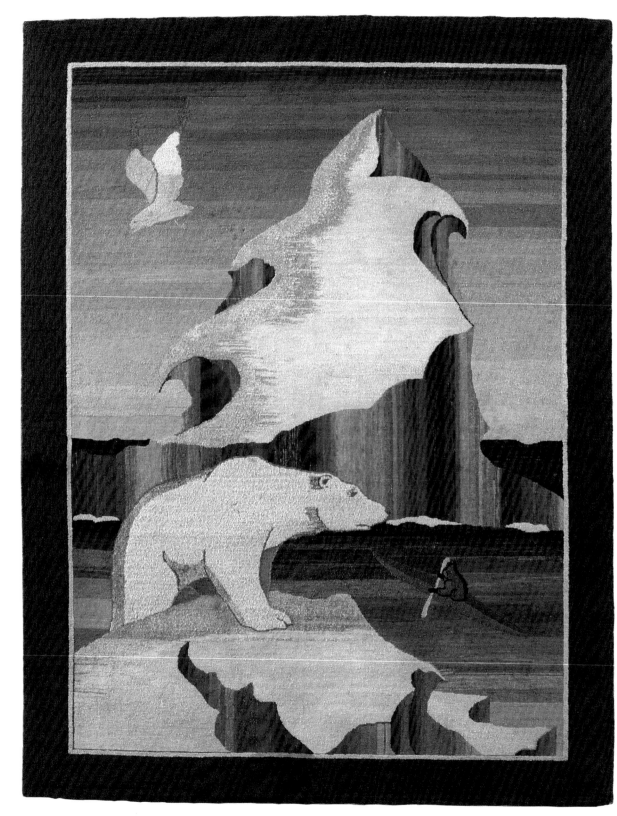

Special Bear

Silk, rayon, cotton, and velvet, dyed
Design attributed to Rudolph Freund, c. 1937
53 x 40 inches

Grenfell mats are distinctive for hooking in which every hole in the brin is filled, a technique that may result in as many as 200 stitches per square inch. The mat shown here is exceptionally finely hooked. The edge of the iceberg is hooked in pure silk, lending it a shimmering icy tone. The teal colour in the towering berg is hooked on the vertical, increasing the sense of its magnitude. Directions on the original paper pattern note that the iceberg should be hooked in this manner. On the reverse of the pattern "Special Bear, 40 x 53" is written in pencil. Careful scrutiny of this mat reveals a small mistake: blue water floods the kayak just in front of the paddler on the right.

Two horizontal drawings of the design are in the collection of the Grenfell Historical Society in St Anthony, both signed by Rudolph Freund. One is dated "January 6 '37"; the other, "March 2, '37." The design immediately brings to mind the work of Lawren Harris (1885–1970) of the Group of Seven and the American artist Rockwell Kent (1882–1971). Both are noted for their stark northern landscapes, simplicity of form, and bold use of colour.

In a 1936 letter to Rhoda Dawson, Harriet Curtis wrote: "Lady G has wished upon us a young man, just graduated from the School of Industrial Arts in Philadelphia ... he may be fine ... but we wish that we had been consulted, so that we might have had a say ... However, it's settled and he is on his way, so we can only hope for the best. As he is a designer, as well as a craftsman, he should be very valuable if he is the right sort."[40] Rudolph Freund is no doubt the young man to whom this correspondence refers.

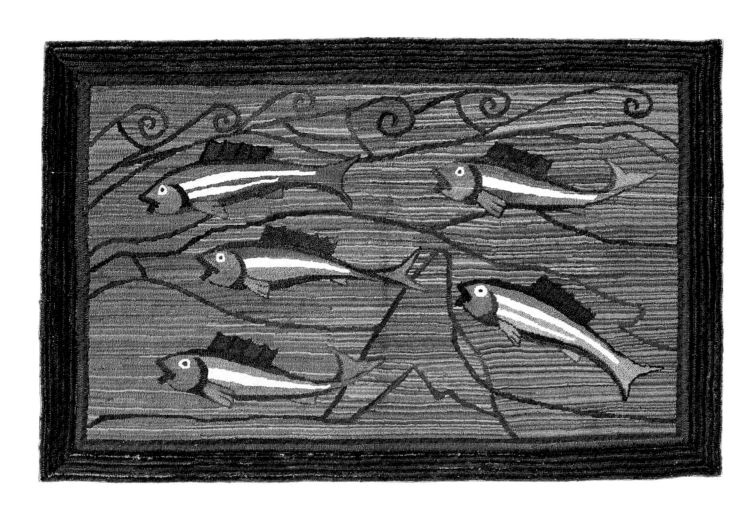

Capelin

Silk and rayon, dyed
Design attributed to Dora Mesher Ricks; in production by 1936
27 x 40 inches

Dora Mesher was a local woman with consider-
able artistic talent who was working at the
Industrial as an assistant to M.A. Pressley-Smith
when Rhoda Dawson arrived in 1930. Dawson
wrote, "She was gentle, loving, kind but efficient.
She did without murmur the hack work we all
had to do, drawing out the mats, putting in the
rag, silk stockings … weighing, writing the
instructions. She also did the dyeing, quite a pro-
fessional job. But more than that, Dora was a true
artist. She had been sent out to … an art school
in the States and her taste was impeccable –
far too good for the tourist trade on which the
Mission depended."[41] Mesher married Bobby
Ricks, who was in charge of the Industrial's
workshop and was an accomplished woodcarver.
Invoices specify "Dora Ricks' fish mats" as stock
number 125, selling for a base price of $5.68 for
silk and $6.22 for cotton.[42]

Capelin are small pelagic fish living in large
schools. They are vital to the food chain of the
northwest Atlantic as a main food source for a
myriad of species including humpback, minke,
and finback whales, cod, and harp seals. Their
movement inshore is followed by the cod and
whales. Capelin are also important to the fishing
industry, being sold for use in garden fertilizers
and dog food.

Nursery Mat

Silk and rayon, dyed
Design in production by 1936
27.5 x 20 inches

Among the Deep Sea Fishers noted in a 1943 issue
that this mat was designed by a Labrador woman
– note the skin boots, which were not worn by
women in Newfoundland – and reproduced as
an engagement calendar. It was intended for a
child's room, to acquaint the child with the typi-
cal scenes of northern life. The Nursery design
was stock number 23 and sold for a base price
of $3.32 for cotton and $2.83 for silk in 1937.
Interestingly, invoices show the same mat selling
at a small increase, $3.88 for cotton, by 1946.[43]
This was a favourite pattern, and many such
mats were hooked. In a variation of the design,
the woman wears a flared skirt.

The image on this page shows the reverse
side of the mat pictured opposite. The backs of
Grenfell mats are as pleasing as the fronts, and
show the technical precision and expertise of the
mat-hooker. Any fading becomes apparent when
the two sides are compared. This is an example of
earlier mats, which were hooked through the hem
rather than with the raw edge turned under.
Using this technique made the mat reversible.

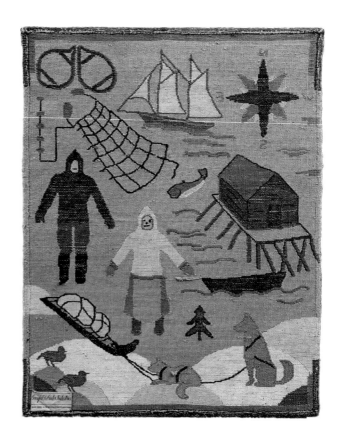

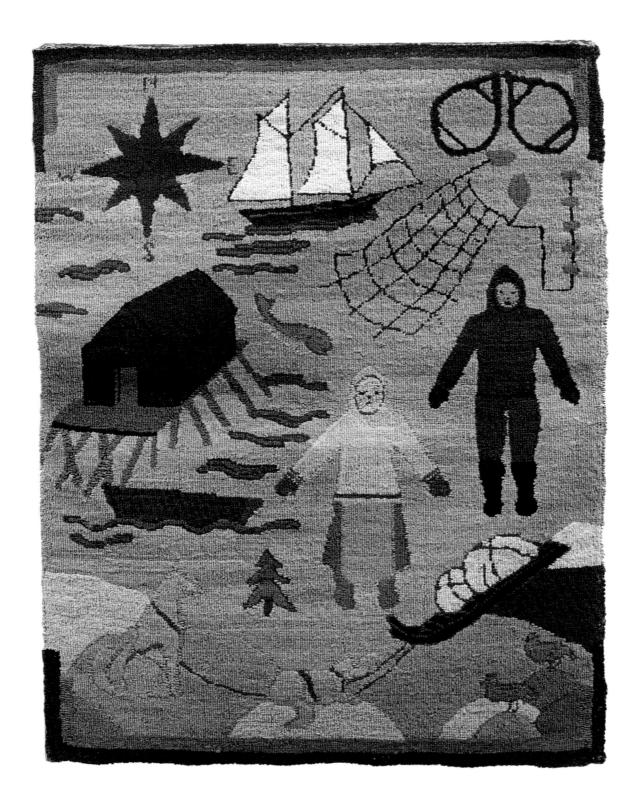

Trap Boat

Silk and rayon, dyed
Design in production by c. 1935–40
18.25 x 22.5 inches

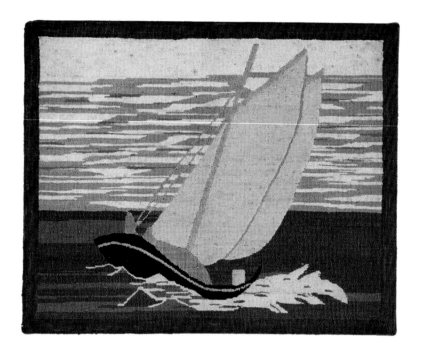

The wonderful sense of motion in this mat is reminiscent of the designs of Dora Mesher, a local girl whom the Mission sent to Philadelphia and Kentucky to study art. On her return to St Anthony, she worked at the Industrial as an assistant to M.A. Pressley-Smith and as a designer. She and Rhoda Dawson were close friends. In a 1930 Christmas card to her father, Dawson wrote, "There is a woman who works with us of Indian descent … She designs the most beautiful rugs. Pressley is so naughty and makes me do fearful commonplace ones [mats] for stock and then these magnificent things of Dora's roll in and I writhe."[+]

A trap boat is a large undecked fishing boat propelled by oar, small sail, or engine. They were used in the fishery for setting and hauling traps, especially cod traps.

Inuit and Penguins

Silk and rayon material, dyed with appliquéd whitecoat sealskin
11.5 x 16 inches

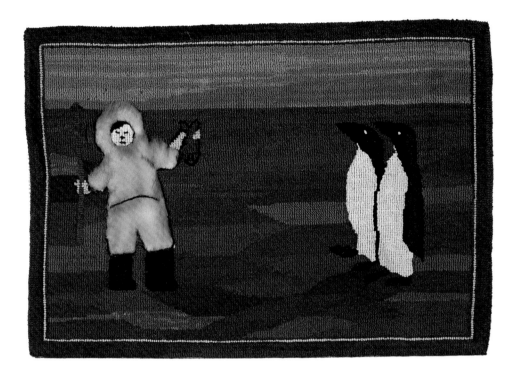

The designer of this pattern looked beyond the usual scenes for inspiration. Penguin images are unusual, as penguins are not found in the north. However, the 1939 New York World's Fair featured Admiral Byrd's Penguin Island, a celebration of Bryd's journey to Antarctica, and the buying public developed an insatiable desire for images of penguins. Thereafter, penguins appeared frequently on Grenfell Mission Christmas cards capitalizing on the penguin's new popularity. The Inuit figure comes directly from a Christmas card designed in 1939 for the American market, shown at right.

Eileen Wedd, an Industrial supervisor at Harrington Harbour, had introduced the use of animal fur, usually whitecoat seal, as a textural element in hooked mats by 1943.

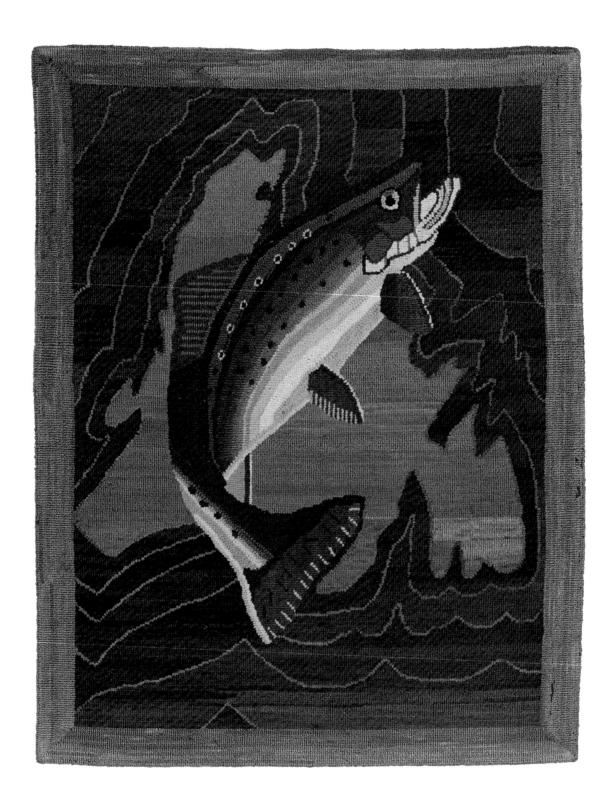

Salmon

Silk and rayon, dyed
Design in production c. 1940s
26.5 x 20.5 inches

While the fish in this design is unmistakably a
trout, all the mat-hookers I interviewed remem-
bered this as the Salmon mat. In a striking design,
the fish is superimposed over the island of
Newfoundland and the surrounding waters,
which are indicated by "waves" in the hooking.
The pattern is in the collection of the Grenfell
Historical Society; its title is given as "Trout Mat."

Drawing for Bear Mat

Signed R. Freund
Dated Nov. 3, '36
Coloured pencil on paper
8.5 x 6.5 inches

Bear Mat

Cotton, silk, and rayon, dyed
Designed by Rudolph Freund; in production in 1936
8.5 x 6.5 inches

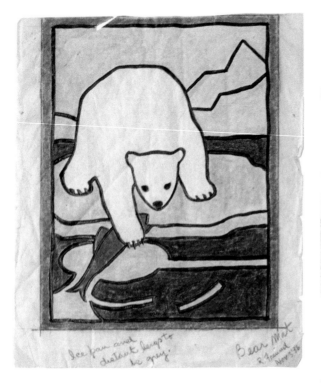

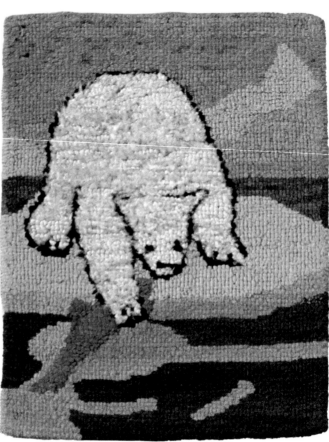

Rudolph Freund had a wonderful graphic style that translated easily into hooked mat designs. Here the bear is hooked in a soft, raised, randomly clipped cotton, creating a lifelike image. Only four signed mat drawings exist at the Grenfell Historical Society; all are by Freund. Written in pencil on the drawing are the instructions "Ice pan and distant bergs to be grey." The date and signature are in the lower right corner.

Starfish & Sea Urchin

Silk, rayon, and brin, dyed
Design attributed to Rhoda Dawson; in production by 1937
26 x 20 inches

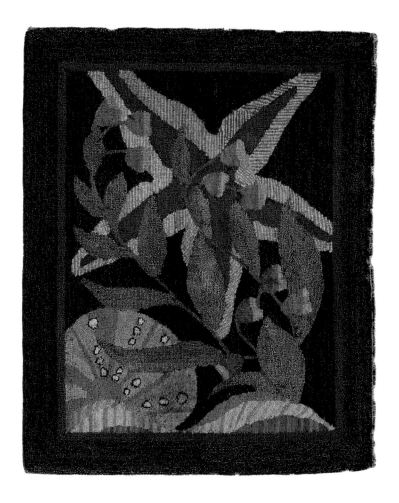

This exceptional mat is most often seen hooked as a circular chair mat (16 inches in diameter) or a much smaller (6 inch diameter) table coaster. (See page 133.) The pattern, stock number 88d, sold for a base price of $3.38 in cotton and $2.28 in silk in 1937.[45]

In general, mats were standardized in three size categories: standard (26 x 40 inches), half standard (20 x 26 inches), and ABC (20 x 32 inches). Larger (up to 65 x 40 inches) and smaller mats were produced, but the bulk of Grenfell mats fall into one of the three main sizes. The mat shown here is a half standard.

Bill Anderson's Cove, Harrington Harbour

Silk and rayon, dyed
Designed by Alice Cox; in production by 1952
14.5 x 18.5 inches

Anglican Church, Harrington Harbour

Silk and rayon, dyed
Design in production by 1952
13.75 x 18 inches

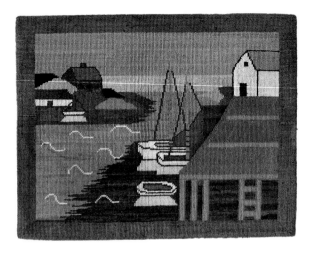

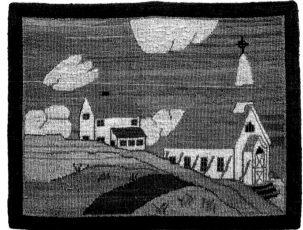

Bill Anderson's store and stage, at right, and Charles Bobbitt's store on the left are identifiable landmarks. Bill Anderson and Charles Bobbitt were local Harrington men who "fished the cod trap" all their lives. Bobbitt died in the 1980s, Anderson in the late 1990s. Younger family members, unable to fish because of the closed fishery, have turned to crabbing and experimental fishing that tests the ocean waters to determine whether the fish are returning in any numbers.

The Mission hospital in Harrington Harbour was funded entirely by the Toronto, Montreal, and Ottawa branches of the Grenfell Association.

Harrington Harbour's Anglican Church and parsonage are beautifully depicted in this mat. The island's women were noted for their exceptionally fine hooking. The dark brown pathway represents the wooden walkways that serve as roads for all-terrain vehicles on this rocky outcropping in the Gulf of St Lawrence.

Igloo

Silk and rayon, dyed
Design in production by 1935
33 inches in diameter

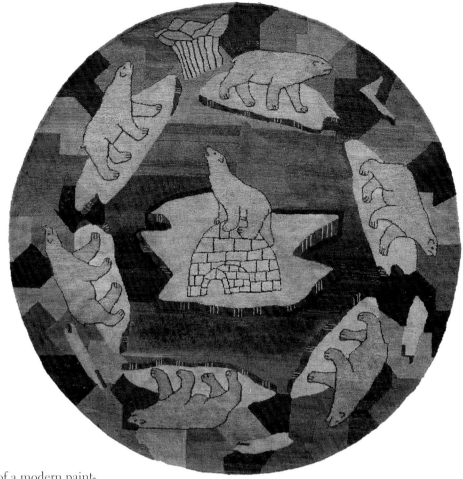

This mat has the visual impact of a modern paint-
ing. The linear abstract forms behind the bears
create a sense of depth and movement. A storm
cloud hovers overhead. The choice of colours –
cool blues, soft greys, and sea green teals – adds to
the sense of the stark northern landscape. Each of
the three known mats of this pattern is distinctive
in its interpretation of the design.

A circular mat of the same design and similar
size and referred to as Igloo is included on a
requisition list of 9 January 1936.[46]

Sweet Pea (Beach Pea)

Brin, silk, rayon, and velvet, dyed
Designed by Rhoda Dawson; in production by 1935
21.5 x 25.75 inches

The manager of the Philadelphia Grenfell shop wrote Dawson a letter in October 1935 praising the work at Harrington: "[T]he pièce de resistance was the Harrington hooking ... each piece is a work of art. We want to congratulate you on the results of your winter at Harrington. The colors are very artistic. We shall not have it in stock very long at the rate it is being bought. We do hope you can make some more floral designs such as the little round gentian mat. We should like to have a set of Labrador flowers. We have the Twinflower, Crackerberry and Sweet Pea but not in the small mats ... This letter is just to tell you we are all delighted with your work and thank you for it."[47]

This mat is most often seen as a smaller round chair or table mat.

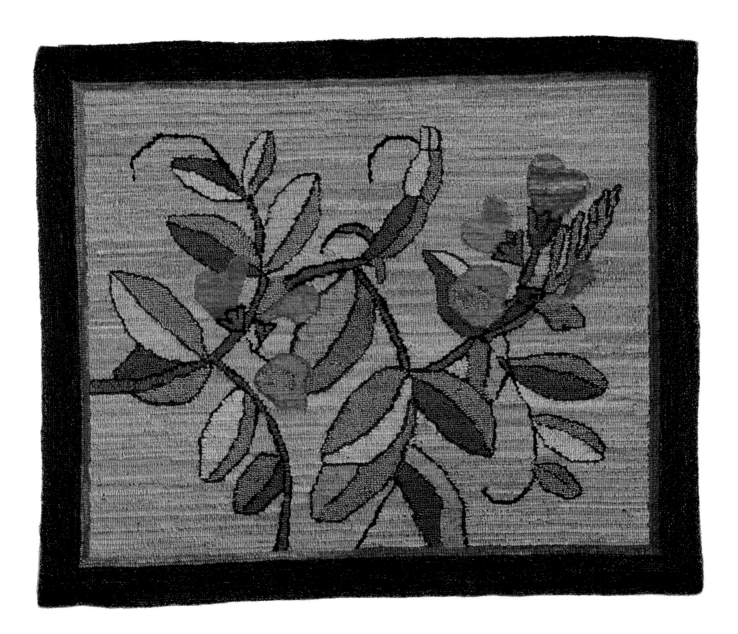

Battle Harbour, Labrador

Silk and rayon, dyed
Design in production c. 1935
22 x 26.75 inches

Battle Harbour, a small, rugged island located at the mouth of St Lewis Inlet at the northeast end of the Strait of Belle Isle, was the site of the first Grenfell Mission hospital, established in 1893. The port was an important stopover for the hundreds of vessels that fished the Labrador coast. In 1909, Battle Harbour received international attention when Admiral Robert E. Peary used the island as the site of his press conference detailing his successful (now disputed) attempt to reach the North Pole. Today it is a restored and revitalized historic area that chronicles Newfoundland and Labrador's rich inshore fishery.

The red roofs on the buildings in Battle Harbour resulted from waterproofing the wooden shingles with rendered seal oil and ochre. Although no firm evidence attributes this mat design to Rhoda Dawson, she did spend time here in 1935 making up mats.

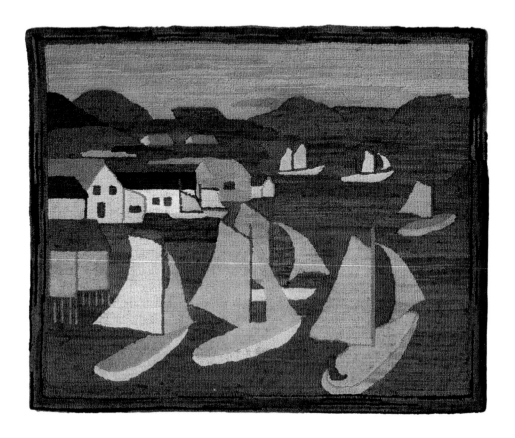

Mother Bear and Cubs / Three Bears

Brin, cotton, and wool
Design copyrighted in 1920
26.75 x 39.5 inches

An early IGA catalog from Boston (c. 1925), *Hooked Picture Mats*, showed a picture of this mat titled "Mother Bear and Cubs." Two years later, a pamphlet from the Grenfell Association of Great Britain and Ireland pictured it under the name "Three Bears." It was stock pattern number 12, and was usually ordered in the half standard size at a base price of $3.32 for cotton and $2.83 for silk.[48]

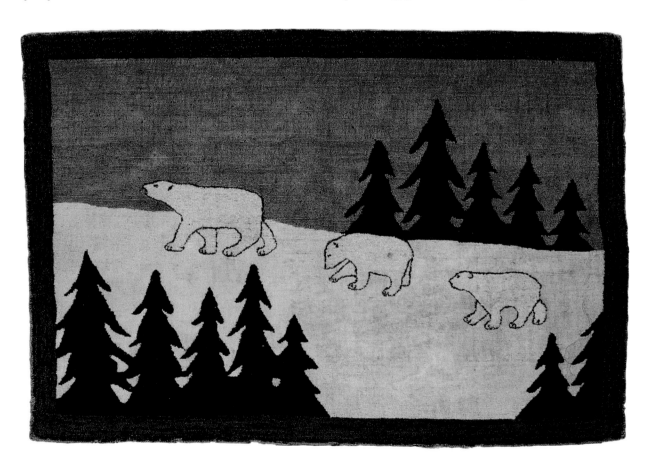

Budgell's Wharf, St Anthony

Silk, rayon, and cotton, dyed
Design in production c. 1945
34 x 45.75 inches

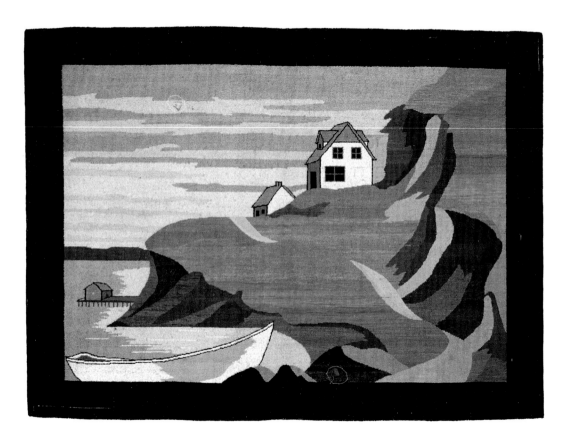

This mat was used as a sample for the mat-hookers. The small swatches on the lower brown rock and in the light grey area in the sky served as a guide indicating the appropriate colour to use. An assistant supervisor at the Industrial would often hook the first mat of a new design as a sample. In this mat, the boat is hooked incorrectly, with seawater flowing through the dory; also, pencil marks indicate the position for another window on the side of the house. Standards of acceptance were strict, and this mat would have been used only as a sample or sold at a reduced price at a staff sale. The location shown on the mat, along the road to Fishing Point in St Anthony, still looks much the same today.

Goose Marsh

Cotton, dyed
Design copyrighted in 1920
26 x 38 inches

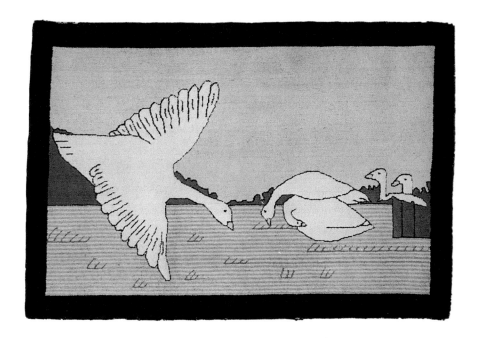

The earlier mats were hooked using all cotton, a technique that slowly died out in the 1930s as silk and rayon became the preferred hooking fabrics. However, because of prohibitively high customs duties, cotton mats continued to be hooked for the British market into the 1940s. Rhoda Dawson wrote a letter to Katie Spaulding in the British office: "I was sorry to hear about the mats. You know, I cannot remember the wording of your cable … asking for extra mats, but I remember the pleasure with which I received it. I also remember wondering as I looked them over whether silk ones would pass Customs. In fact I believe I mentioned it to Curtis, but we neither one of us had any idea. Now I'm sure that of the two of us reading that cable, one would have seen the words "no silk" – our heads, of course, were full of the U.S.A. order which was all silk. And I knew in my inside that there had been a duty on silk mats to England because I had to pay it."[49]

A photograph of a mat of this pattern appeared in the October 1920 issue of *Among the Deep Sea Fishers*, with a copyright date of 1920 clearly visible in the lower left border. Grenfell mats were protected by international copyright for many years. This mat was stock pattern number M14.

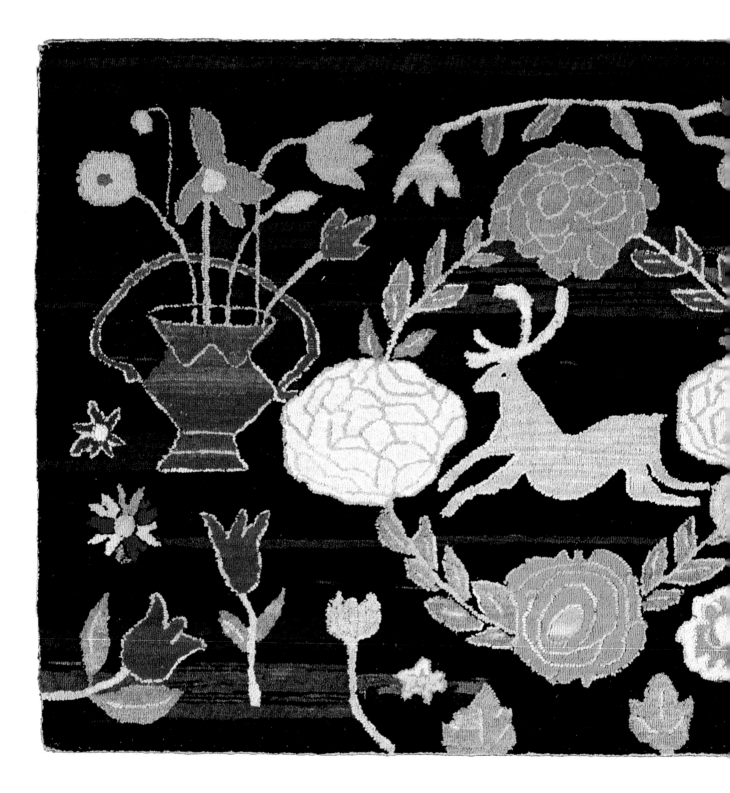

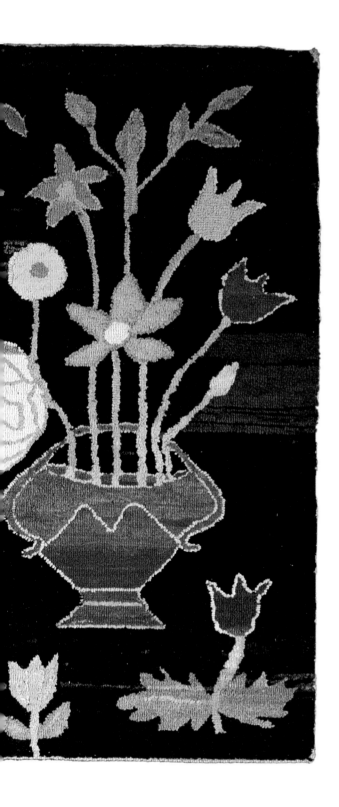

Leaping Stag

Silk and rayon, dyed
Design in production c. 1930–35
26 x 39.5 inches

This superb mat retains its original sales tag, which indicates that it was pattern number 101 and had a retail price of $7.50. The design is reminiscent of quilt patterns, particularly the early style known as the Baltimore album quilt. Mats such as this were designed to satisfy the colonial nostalgia sweeping the United States and Canada in the late 1920s.

Walrus

Cotton, dyed
Design copyrighted in 1920
26 x 38 inches

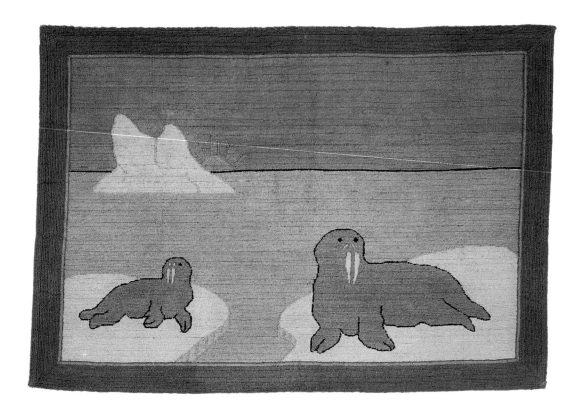

A photograph of a mat of this pattern first
appeared in the October 1920 issue of *Among the
Deep Sea Fishers*. Early Industrial records list the
mat as stock pattern number M15, and handwrit-
ten on this one's label is the number 15. The
design is similar to Polar Bears on Ice Floes.
Using different animals in the same scene saved
time and labour while creating a variety
of designs.

Spouting Whales and Walrus

Cotton, silk, and rayon, dyed
Design in production by 1931
27 x 40 inches

This mat has a delightfully whimsical quality that
fits nicely with the Industrial's advertising claim
that the "mats are really very quaint, attractive,
durable, and useful especially in halls, bathrooms,
or nurseries."[50] It is masterfully shaded, with
colours suggestive of an early morning at sea.

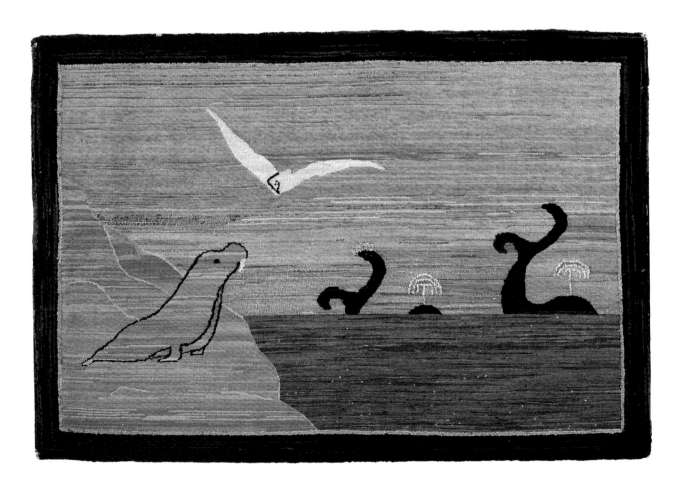

People Working Series

Silk and rayon, dyed
Designed by Ned Hancock; in production c. 1938

In 1910, Jessie Luther's journal contained this entry: "I have just resumed a new kind of responsibility … that of godmother for the eighth child of the Hancock family. It is a boy, to be named Edwin Nicholas. The men of the family tell me I am expected to give the family a barrel of flour and provide for the child if stranded."[51] Ned Hancock grew up to be one of the students sent by the Mission to the United States for schooling. He lived with Jessie Luther in Providence, Rhode Island, and graduated from the Rhode Island School of Design in 1934 with a speciality in jewelry, sculpture, and silversmithing. On his return to St Anthony around 1935–40, Grenfell offered to pay him one year's salary at the Industrial in the hope that Hancock might establish a jewelry initiative using labradorite. His work at the Industrial focused on designing and carving ivory and wooden objects. Hancock designed these place mats as a series, entitled *People Working*. A 22 x 15 inch dog team mat for the centre of the table completed the set. Despite the belief of some that he was one of the Industrial's best workers, he was fired for "moral turpitude."[52] He moved back to the United States, where he became a naturalized citizen.

Top row, left:
Spreading Fish on Flake
11.5 x 15 inches
Women were used to dropping everything if a fog bank appeared to threaten the drying cod. This woman is typically dressed for the time in an apron and bandana.

Top row, right:
Sealer
11 x 15.25 inches

Middle row, left:
Ice Fisherman
11 x 15.75 inches

Middle row, right:
Woodsman
11.25 x 15 inches

Bottom row, left:
Mending the Nets
11.25 x 15.25 inches

Bottom row, right:
Coloured drawing for Mat Hooking design
10.25 x 15.25 inches

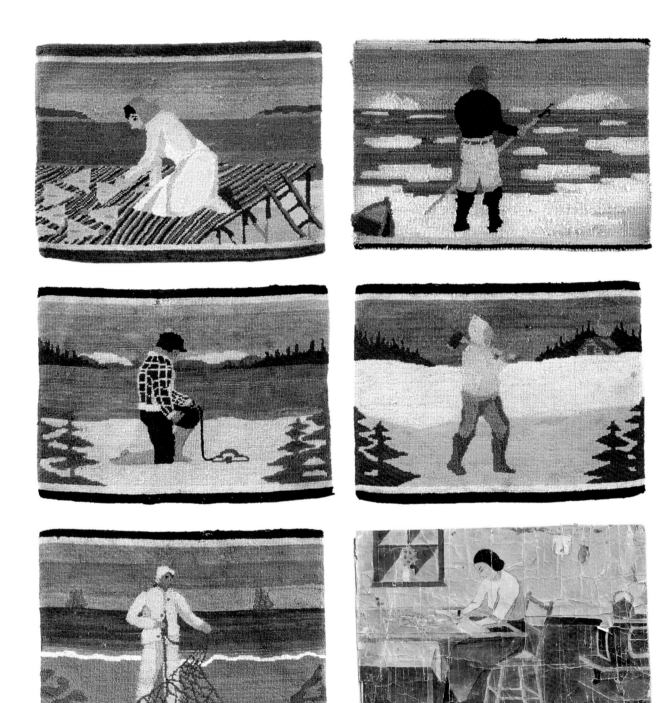

The Road to Fishing Point, St Anthony

Silk and rayon, dyed
Design in production by 1929
25 x 38.5 inches

This landscape looks much the same today, although the United Church at the left is no longer standing. In 1906, Jessie Luther wrote in her journal, "The little church stands on a hill overlooking the harbour, with a lovely view of the sea. It is pretty and well-built – quite a surprise for I did not expect to see coloured glass in the pointed windows or a red woolen carpet on the platform."[53] She further noted, "It is good news that a much needed lighthouse is soon to be built at the entrance to St Anthony harbour, the only one on this part of the coast, which is poorly charted."[54]

An article in a Toronto newspaper of 1929 said of this or a similar mat: "One of the hooked rugs was in itself a vivid scene of dark brown cliffs against a blue sea, making a background for a white frame church and a fishermen's cottage."[55] In some mats of this design the mat-hooker has dotted the foreground with flowers.

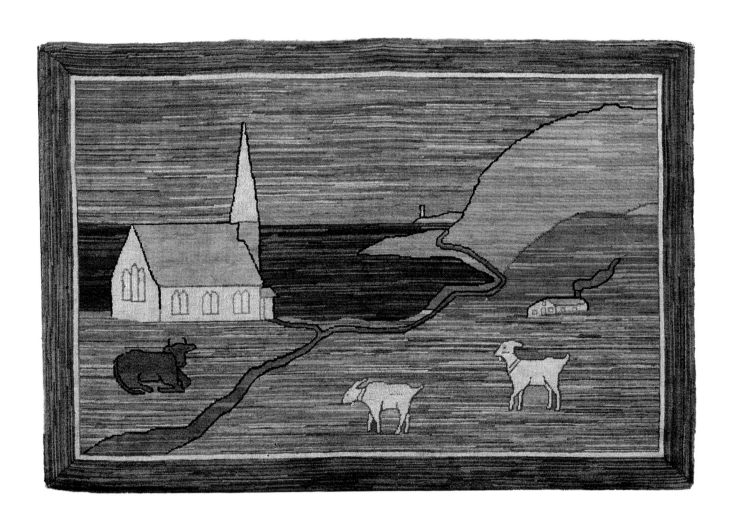

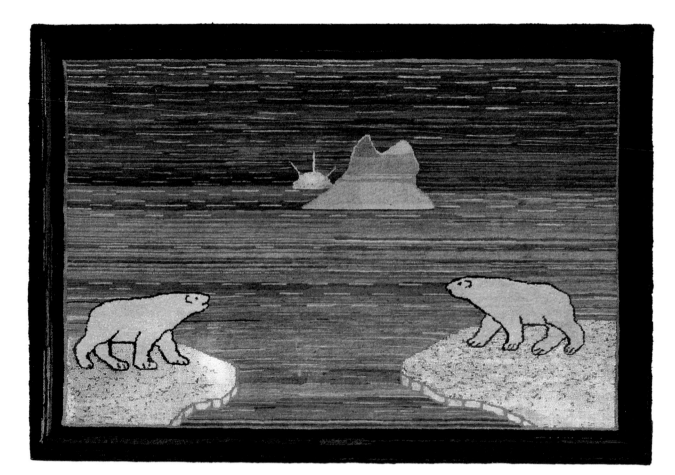

Polar Bears on Ice Floes

Cotton, wool, silk, and rayon, dyed
Designed by Wilfred Grenfell; in production by 1916
28 x 39 inches

The bears in this mat are hooked in wool, giving them a raised, nicely realistic texture. The ice pans are hooked with silk. This mat was stock pattern number 5 and sold for a base price of $5.68 in 1938.[56] The report from a sale in Boston on 2 November 1916 observed, "It is a far cry from the bleak homes of Labrador to The Hotel Brunswick, Boston ... but the women of the North, through a sale of their handiwork made themselves known to many Boston women. This one of the polar bears [was] one of the favorite mats sold ... We have taken many orders for this mat – price being $6.00."[57]

Dog Team

Silk, rayon, and brin, dyed
Design in production by 1930
15.25 x 49.25 inches

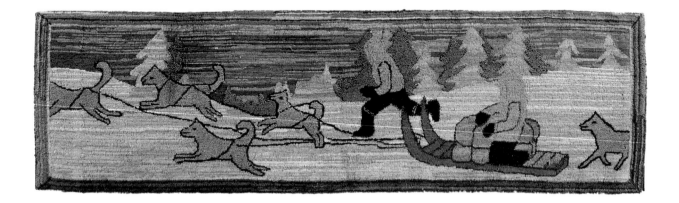

Often, when a dog team was pulling a heavy load
or running uphill, one man would run alongside
to lighten the dogs' burden. The absence of a red
cross on the bundle indicates that the team is
involved in normal daily activity, not rushing to
a medical emergency. This mat, like the one on
the facing page, was intended for use as a long
footstool cover.

Dog Team with Northern Lights

Brin and cotton, dyed
Design in production by 1930
15.25 x 49 inches

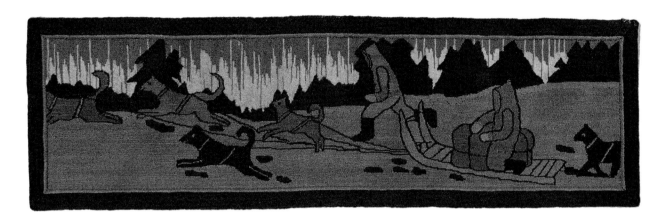

In 1907, Jessie Luther wrote, "It is difficult to describe the beauty of winter in this place … the sky at sunset is a curious green near the horizon and the pinks, blues and purples on the snow and ice are beyond description."[58] This mat conveys something of the scene so aptly described by Luther. Like the previous design, it was to be used as a long footstool cover.

Table Mats

Silk and rayon, dyed
Design in production c. 1935–45

Small table mats like these were sold as trivets, pot holders, or coasters; they were also included with mat bundles as samples for the mat-hookers to follow for colour directions. Pressley wrote to Rhoda Dawson in December 1935, while she was in Great Britain, that Rhoda's "potholders" were selling like anything, and that another 500 of them had just been shipped off to the States. In 1939, Janet Stewart introduced small mats (5 x 6 inches) to interest the younger generation – girls of nine to fourteen years of age – in the craft so that they might carry on the tradition as they grew up. "I think they need praise and encouragement. We pay for the better work while others get material to try and interest and encourage them."[59] These items were referred to as "midget mats" and carried the stock pattern numbers 126, a, b, c, and d. They sold for a base price of 25 cents.[60]

Top row, left:
Sailboat (5.75 inches in diameter)

Top row, right:
Outport (6 inches in diameter)

Middle row, left:
Polar Bear (8 inches in diameter)

Middle row, centre:
Cabin (8 inches in diameter)

Middle row, right:
Cod with Anchor (8.25 inches in diameter)

Bottom row, left:
Starfish, Sea Urchin (6 inches in diameter)

Bottom row, right:
Seagulls (6.5 inches in diameter)

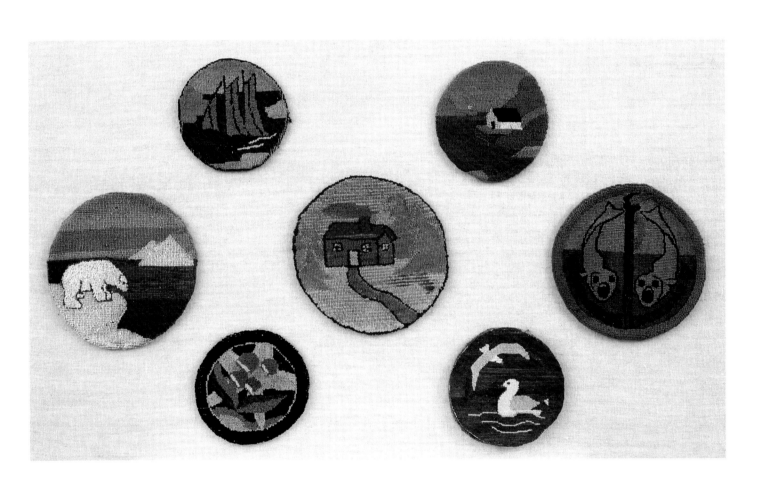

Cod and Anchor Mat

Silk and rayon, dyed
Design in production by 1936
8.25 inches in diameter

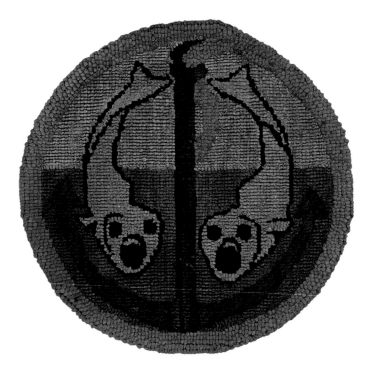

Local St Anthony fishermen identified this mat as depicting whitecoat seals because of the large eyes. However, when the drawing for the design was located, written on the bottom right was "Cod and Anchor Mat." This is another of the four known mat drawings signed and dated by Rudolph Freund.

In 1938, Freund returned to the United States, where he took a job as a cover artist for *Natural History*, the publication of the American Museum of Natural History. His covers appear on the May 1939 and March 1940 issues. Later he worked for *Life* magazine. In 1964, he received enthusiastic reviews for his exhibition of drawings and paintings at Yale University's Peabody Museum. He died of a stroke at the age of fifty-four in Collegeville, Pennsylvania.

Cod and Anchor Mat Drawing

Signed R. Freund
Dated Nov. 3 '36
Coloured pencil on paper
6.5 x 8.5 inches

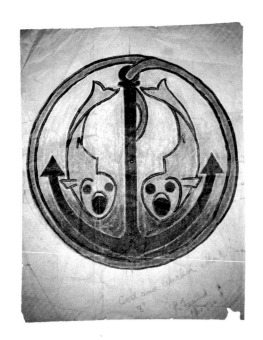

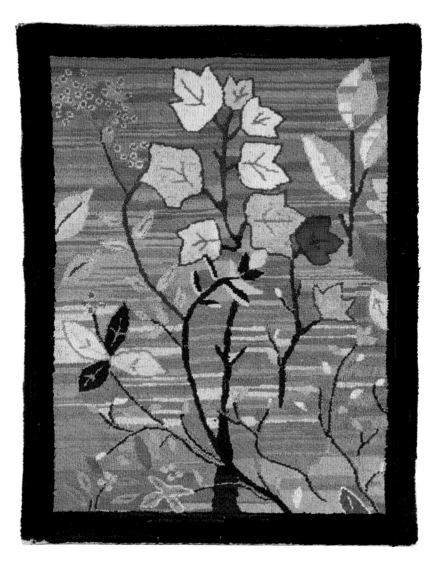

Falling Leaves

Silk and rayon, dyed
Design in production c. 1940
25.5 x 19.5 inches

One mat-hooker in the Labrador Straits enthusiastically remembered the mat shown here as one of her favourites, although she hooked only a single mat of this design. She remarked, "One year, you'd have a favourite and the next year you'd never see it again."[61] In the early years, except for the most popular polar bears, dog teams, and ducks, patterns were always being dropped and new ones added. The constant change was essential for both keeping repeat customers coming

back and interesting new buyers. Janet Stewart wrote later, "I try my best to add new articles in all departments but when one brain and one person has to move all departments I find it a dreadful task."[62] She also noted that she had improved on some of the old designs but had not added any new ones.

The leaves hooked on this mat are those of a squashberry bush. It was common for mat-hookers to trace real leaves when designing their own mats.

Howling Dog

Silk and rayon, dyed
Designed by Phyllis Little; in production by 1939
14.75 x 10.75 inches

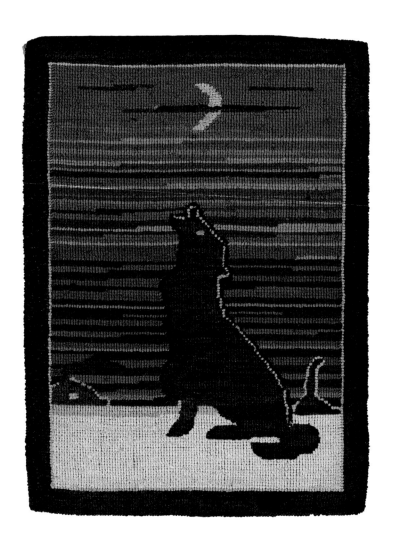

Jessie Luther recorded in her journal: "The dogs have just begun their unearthly howl, which means it is late. Each night at about quarter to twelve they begin their unearthly wail. Suddenly, one dog starts with a long drawn out note, the others follow in a piercing chorus for about five minutes, when they stop as suddenly as they began. I fancy it must be like a wolf's cry."[63]

In 1951, Phyllis Little designed a Grenfell Christmas card for the Canadian market using the same design. Eben Joy, the owner of the Dog Team Tavern in the late 1940s and 1950s, remembers calling this mat "Labrador Grand Opera." An invoice lists this "oblong" mat as stock pattern number 120a, selling for a base price of 90 cents.[64]

IGA 1931

Silk, rayon, and velvet, dyed
Designed in 1931
24 x 37.25 inches

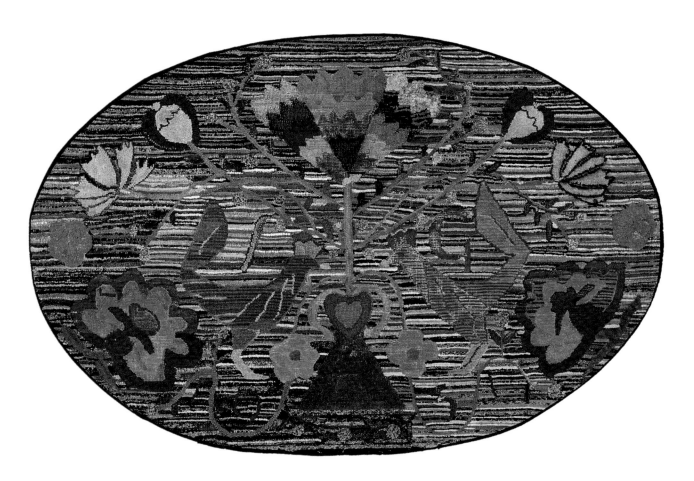

IGA stands for International Grenfell Association. This mat is very much in the style of a "local mat" and was probably made as a gift for someone associated with the Mission. The letters I and G appear above the roosters, while the letter A can be seen in the base of the floral pattern. The date, 1931, is tucked along the lower edge. Patterned fabrics are used in the hooking, something never seen in a picture mat from the Industrial. This mat, like Labrador Bouquet (page 97), is a good example of the striping technique used in the hookers' own mats. It is most likely a unique example.

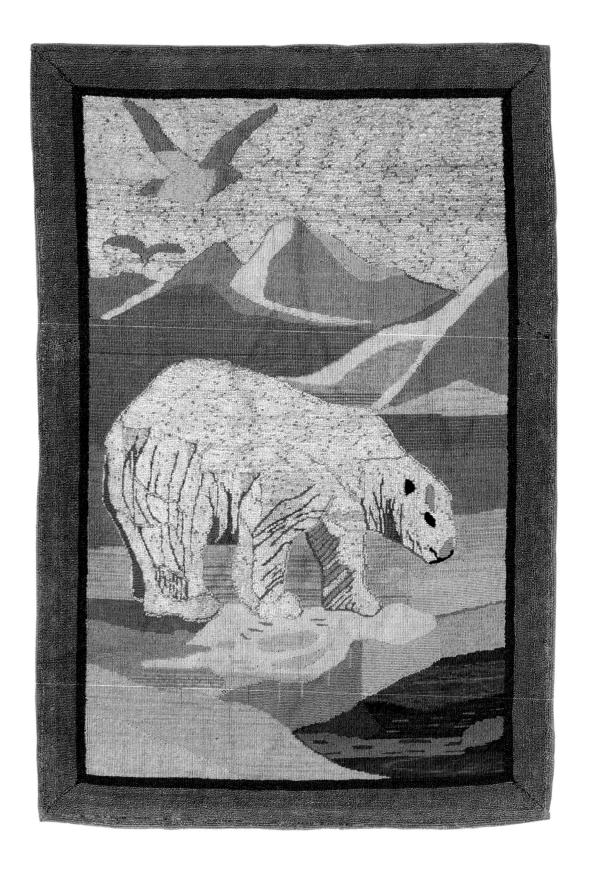

Vertical Bear

Silk and rayon, dyed
Design in production by 1939
39.5 x 26.5 inches

The use of silk for the bear and the sky gives this mat a distinctive shimmer. The original drawing for the design carefully notes the number of stockings needed for each section and refers to the design as "Vertical Bear." The design closely resembles an Audubon print and appeared as the cover of the Grenfell Mission's 1942 engagement calendar; it was still being hooked into the 1960s. Julia Yetman of Red Bay, Labrador remembered it well and has a photograph of herself as a young girl proudly holding a finished Vertical Bear. The stock pattern number was 36; the mat sold for a base price of $7.05 in 1939, which had increased to $7.81 by 1946.[65]

Coastal Schooner

Silk and rayon, dyed
Design in production c. 1940s
24 x 24.5 inches

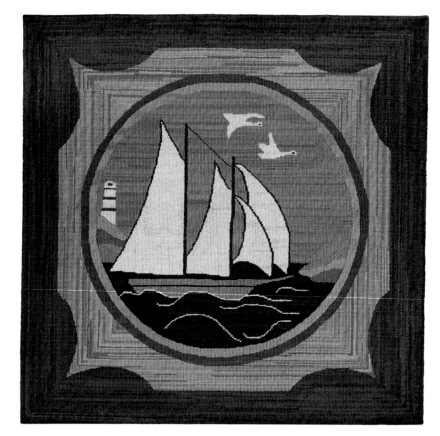

This Harrington Harbour mat carries the Grenfell Labrador Industries / Handmade in Canadian Labrador label. It is unique for its picture within a frame design.

Schooners such as the one shown were called Labrador Traders by the local community. They provided an essential link between the people of the Labrador and points south. Several well-known traders, including Captain Sam Cox of the *Silver Thread* and Captain Lou Vatcher, sailed out of Halifax; Captain Mercier of the *Labrador Trader* sailed from Quebec. Each spring and fall they set sail for Harrington to buy the season's fish catch from the merchants and deliver provisions.

Coastal schooners usually had two or three masts and ranged in length from 50 to 70 feet. Fore and aft rigging on each mast allowed them relatively easy access through the small channels or "tickles" of many of the local ports.

While the entrance into Harrington was marked by a lighthouse opened in 1931 on Entry Island – known locally as Shag Island – it was not the grand structure shown in the mat but just a small, short tower, as seen in the photo at left. Each night after fishing, the keeper, Uncle Jack Bobbitt, climbed the few steps to light the oil lantern and check the stationary reflector. The Canadian Coast Guard burned the lighthouse down c. 1973.

Polar Bear on Growler

Silk and rayon, dyed
Design in production c. 1928
18.5 x 30.25 inches

The shades in this mat are beautifully blended, creating a soft palette that evokes a northern winter. Polar bears were one of the most popular images and hundreds, perhaps thousands, of mats depicting them were hooked for the Industrial. Despite strict standardization, no two were ever identical.

The Latin name for the bears, *Ursus maritimus,* "sea bear," is appropriate because they spend most of their time at the edge of the ice pack, where it is easiest to find food.

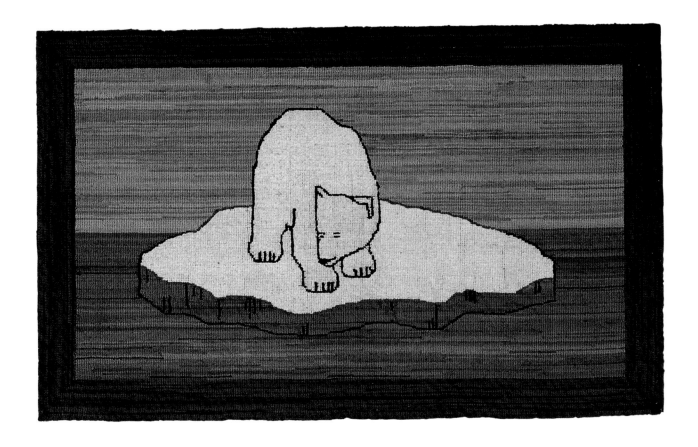

Single Polar Bear on Ice Pan

Silk or rayon, brin, and cotton, dyed
Design in producion c. 1930
26.5 x 40.5 inches

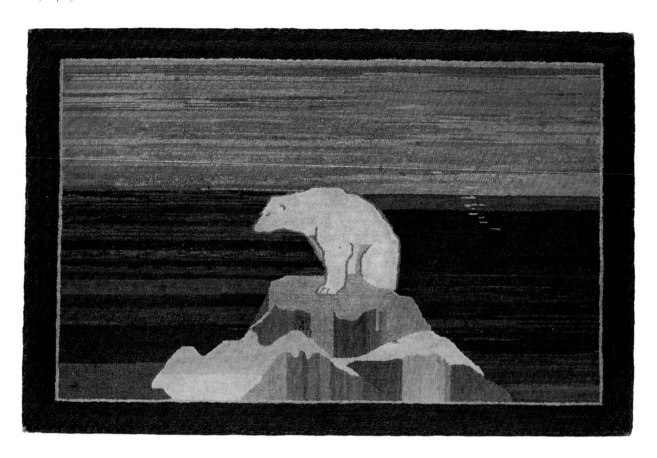

Polar bears were a popular image among both mat-hookers and customers. The bears travel south from the Arctic on the ice packs borne by the Labrador current. Eventually the large ice packs break into smaller ice pans (floes) or bergs, called "growlers," on which the bears are usually pictured.

Early requests for various colours of cotton hooking materials often specified white, which was important for depicting both snow scenes and the many animals that are white during the winter. This pattern was stock number 3 and sold for a base price of $5.68 in 1938.[66]

Lone Canada Goose Stool Cover

Brin, dyed
12.25 x 18 inches

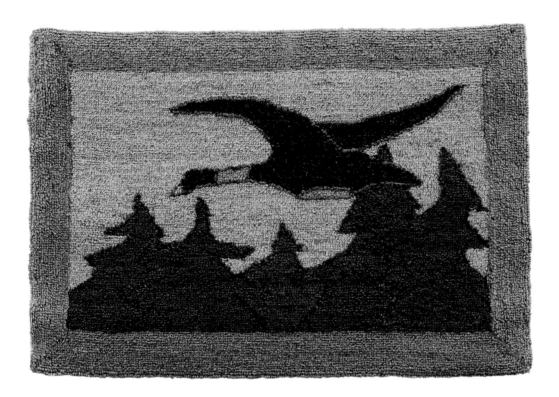

This design is nearly always hooked in brin – an indication of its intended use as a stool cover. A drawing for this mat at the Grenfell Historical Society is signed "J.D.P.", the initials of Julia Patey (now Martens). Patey, who presently lives in British Columbia, worked for the Industrial as a young girl in 1956–57 drawing stencils and preparing mat bundles. She remembered drawing the design but was certain it was not her original; rather, she copied it from a stencil too worn for further use. She also recalled many old patterns being discarded.[67]

This popular pattern was sold as a chair or stool cover. A wide margin of brin was left unhooked around the edges for turning under a cushion.

Crackerberry

Silk, rayon, and brin, dyed
Designed by Rhoda Dawson; in production by 1935
16 inches in diameter

This is the Crackerberry design to which the
letter cited earlier from the manager of the
Industrial shop in Philadelphia to Rhoda
Dawson referred, together with the Sweet
Pea mat (shown on page 115). The pattern
for this mat is in the holdings of the
Grenfell Historical Society, where it is
catalogued as the Bunchberry design.
However, the local vernacular for the
flower is "crackerberry."

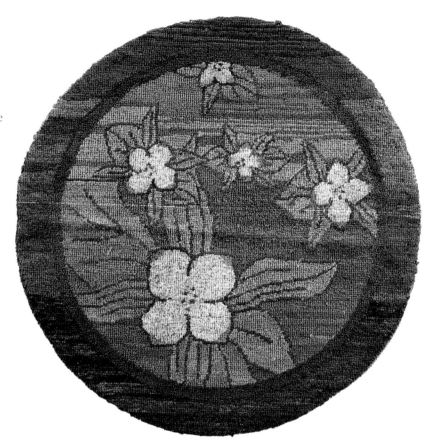

Dog Team Seat Cover

Brin, dyed
Design in production c. 1928
17.5 x 21 inches

It was important for the Industrial to introduce
new designs and uses for hooked mats in order
to retain a vibrant customer base. Seat, chair, or
footstool covers were popular adaptations. The
unhooked border shows the fineness of the brin
base used in Grenfell mats. A mat-hooker would
hook material through every hole in the
brin, making a tight, durable product.

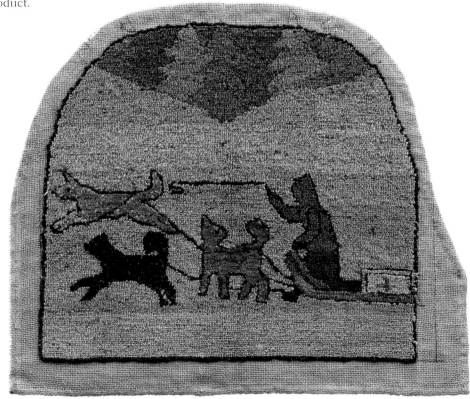

Saucer Geometric

Silk and rayon, dyed
Design in production by 1944
39.25 x 27.5 inches

The mat shown here was hooked in Harrington Harbour. Hookers called this the Flatiron or Saucer pattern, making the circular shapes by tracing around their iron or a small plate. The design is typical of mats hooked all over eastern Canada and the northeastern United States. In her *How to Make Hooked Rugs*, Mary Perkins gives directions for a mat of this type.[68] Industrial supervisors were quick to adapt patterns from other sources and label them "Grenfell."

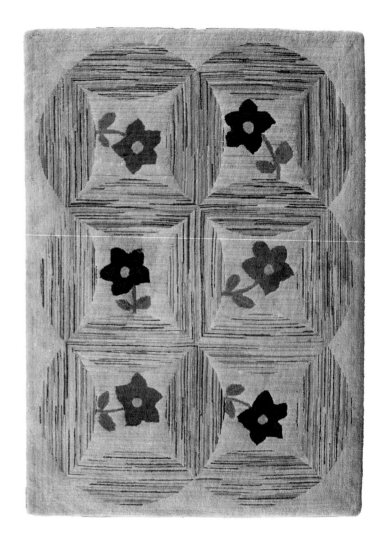

Fox

Silk and rayon, dyed
Designed by Rhoda Dawson; in production c. 1934
12 x 10 inches

A letter to Rhoda Dawson from Martha Harding in Harrington Harbour reported, "Mrs Albert Rowsell is well and still at the mats. She has hooked some of your fox pattern mats." Harding also mentioned her own hooking: "I am still hooking. I cannot remember how many I have hooked in number. Miss Thompson[69] has paid me $19.00 + 17. More mats not paid for, quite a help is it not. So you see I have done a lot of hooking."[70]

True to her typical style, Dawson captured a sense of motion and urgency in the fox's pose.

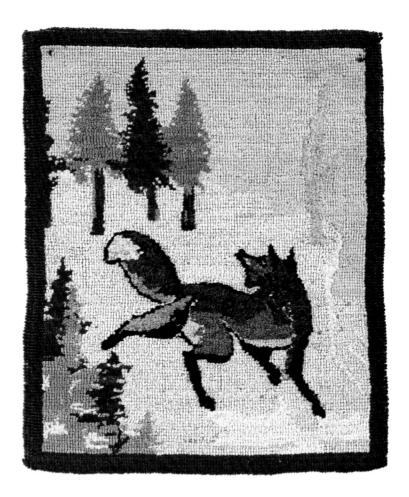

Log Cabin Floor Mat

Silk and rayon, dyed
20.25 x 32.25 inches

This is another example of a mat design commonly found throughout eastern Canada and the northeastern United States. It is based on a variant of the Log Cabin quilt pattern; quilts were a readily available design source. A mat of the same design is pictured in *Collecting Hooked Rugs* by Elizabeth Waugh and Edith Foley.[71] The Industrial used this geometric as one of their regular patterns. Mats were marketed as picture mats, floor mats, table mats, or chair mats. The example shown here is typical of a floor mat.

Ships Sailing North

Brin, dyed
Designed by Rhoda Dawson; in production c. 1930–35
15 x 48.75 inches

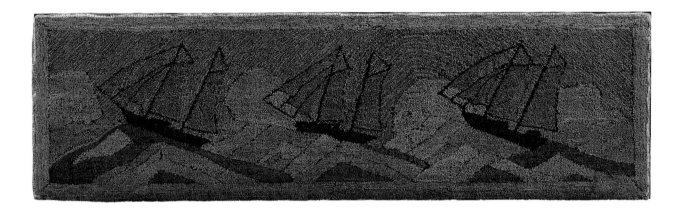

Grenfell hooked mats are known for their nearly
universal use of straight-line hooking. This is one
of the few patterns to break tradition and to
encourage hooking that conveys a sense of motion
approaching seasickness. Mats of this size were
meant to serve as long footstool covers.

Atlantic Puffin

Silk and rayon, dyed
Design in production c. 1940
12.5 x 10 inches

Rhoda Dawson noted in her unpublished manuscript: "There were several designs of puffins, picturesque birds, native to the sub-Arctic, which were supposed to satisfy the tourist's insatiable demands for penguins, which are, of course, native to Antarctica."[72] These small, colourful birds with bright orange feet and a massive orange, yellow, and blue striped bill were sometimes referred to as "Labrador Peacocks." The rocky coast and countless islands of Newfoundland and Labrador provide an ideal breeding ground for puffins, the most spectacular member of the alcid seabird family. Today, heavy predation from gulls has caused a sharp decline in the puffin populations.

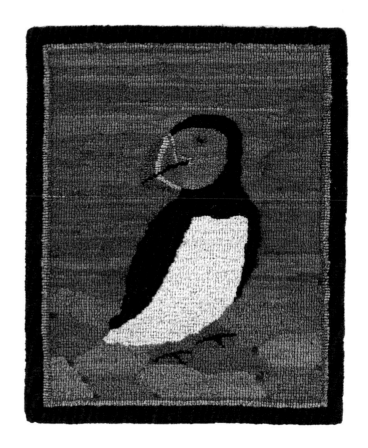

Pond Ducks or Seagulls Feeding

Silk and rayon, dyed
Designed by Rhoda Dawson; in production c. 1934
14.5 x 14.25 inches

Dawson wrote an article in *Among the Deep Sea Fishers* in July 1938, "The Folk Art of the Labrador," in which she identified this mat as her design. Dawson's flair for the unusual but true-to-life is expressed delightfully in this scene of ducks feeding hind end up.

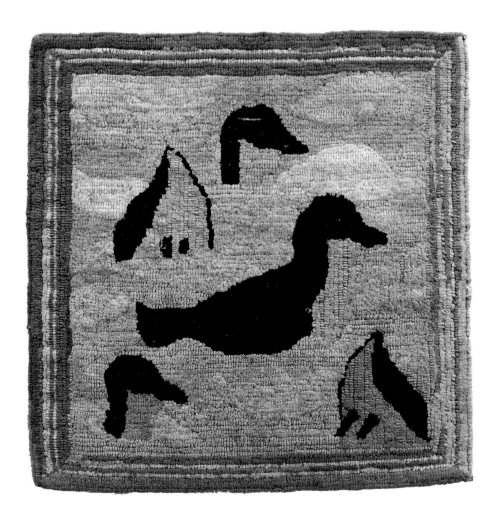

Twinflowers

Silk and rayon, dyed; velvet
Designed by Rhoda Dawson; in production by 1930–35
21 x 27.5 inches

The letter written by the manager of the Industrial shop in Philadelphia to Dawson in 1935 also referred to this mat, along with the Sweet Pea and Crackerberry designs (see pages 115 and 144 respectively).

Dawson's versatility as an artist shines in this abstract floral. A twinflower (*Linnaea borealis*) is a small plant with a pink bell on either side of a fine stalk above a pair of evergreen leaves. It is a fragrant perennial, common in the cool woods and bogs of North America.

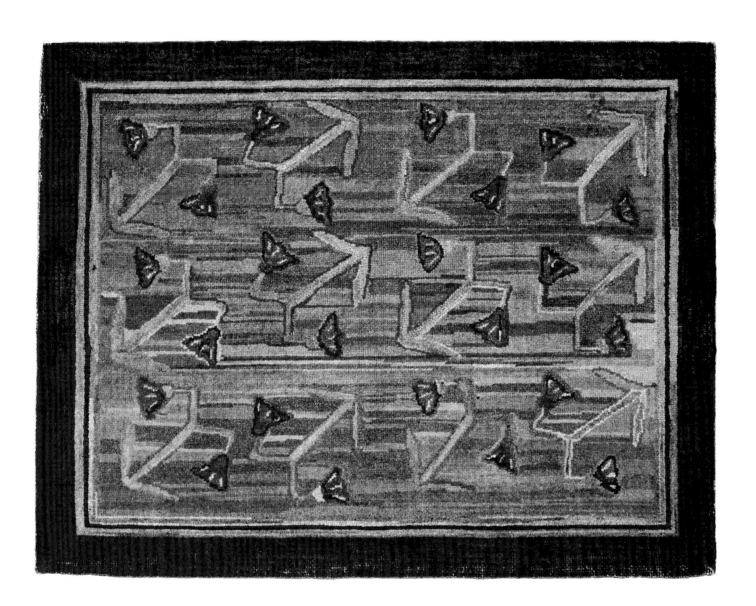

Two Bear Bag

Silk, rayon, chenille, and Grenfell cloth, dyed
Designed by Betty Fyfe; in production by 1935
12 x 10 inches

The pattern for the Two Bear Bag is in the collection of the Grenfell Historical Society. On it is noted: "Don't have pointed noses on bears." Handbags, evening purses, and knitting or tote bags proved a popular item. A letter from Janet Stewart to "Dear Seaweed" (Betty Seabrook) asked, "[D]o you think you could get 1 doz Betty Fyfe knitting bags for us to show. I am certain we could sell them. Everyone always wants to buy mine."[73] This request is accompanied by a hand-drawn sketch of a bag having the shape of the Two Bear Bag. Both designs shown on this page were also hooked as picture mats.

Small squares of "Grenfell cloth" cover the points where the ends of the handle are sewn to the bag. Grenfell cloth was the first lightweight, firmly woven material that was waterproof and windproof. It was produced by Haythornethwaite Bros. in Lancashire, England from the 1920s until fairly recently. Dr Grenfell frequently noted that the cloth was made to his specifications.

Puffin Bag

Cotton and rayon, dyed; patterned silk lining
Design in production c. 1945
9 x 14 inches

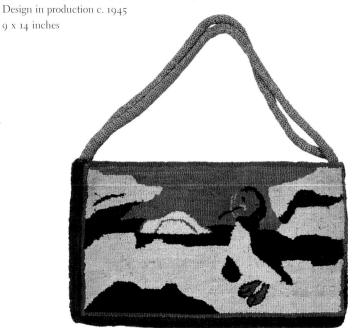

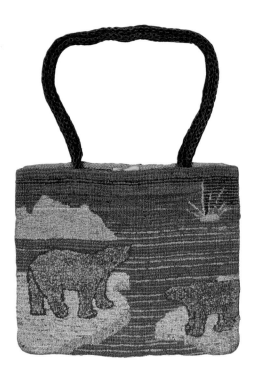

St Anthony Wharf

Silk and rayon, dyed
Design in production c. 1945–50
16.5 x 24 inches

The wharf at St Anthony, looking out toward the
lighthouse at Fishing Point, presents a strong
image in this mat. The Grenfell Historical Society
has four patterns for this design, annotated as to
colour choices.

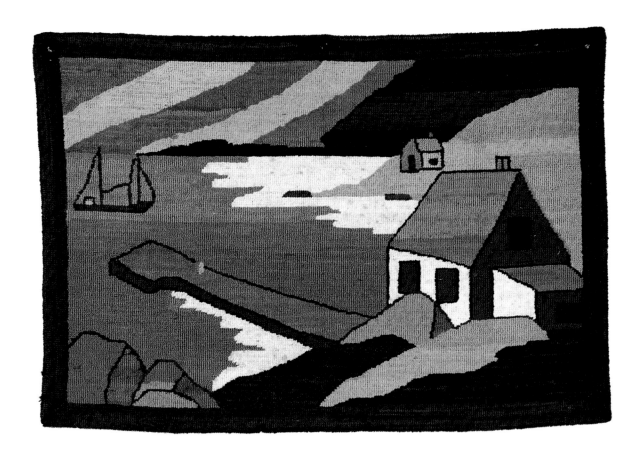

Reindeer Driving

Cotton
Designed by Wilfred Grenfell; in production by 1916
26.75 x 46 inches

Dr Grenfell introduced reindeer from Norway to the St Anthony region in 1907. He felt that one reindeer could do the work of an entire dog team and could also provide skins, meat, and milk. However, countless factors – not the least of which was a reindeer's complete lack of interest in pulling a komatik – combined to make the experiment a failure. (In 1892, U.S. government officials had tried the same experiment in Alaska and failed.) Jessie Luther wrote in her journal, "Finally the doctor … started off … attempting to drive instead of lead the deer. This did not please the deer. He walked very slowly, frequently stopped, turned, and according to Dr. Grenfell 'made faces at [him]'. He also opened his mouth and seemed to gasp after every effort."[74] Luther also related her own experience: "I discovered that the thrill of riding behind a deer is not always associated with speed. The deer ambled now and then when urged but took a lukewarm interest in traveling faster than a slow walk. This indifference gave Dr. Grenfell, accustomed to a rushing start with the dogs, a painful surprise: that an animal born into the world as a deer should so mistake his use in life … Only once did he [the deer] voluntarily quicken his pace, when he spied a patch of moss laid bare by the wind. He made a dash for it, and there we sat while he feasted."[75] Reindeer and caribou are the same species, differing only in that reindeer are domesticated and caribou are not.

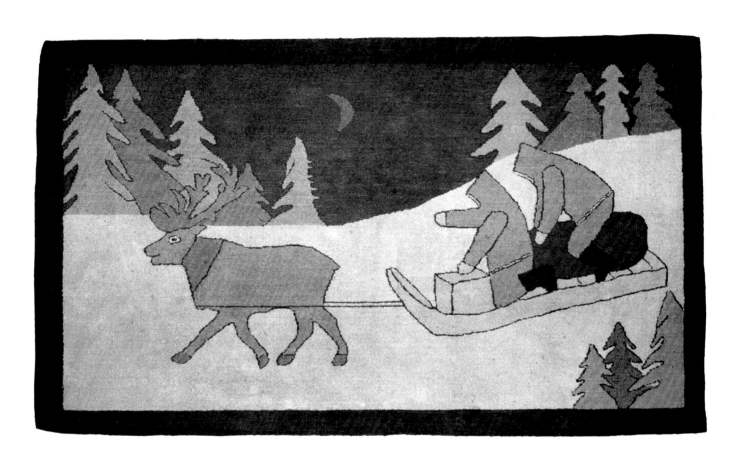

Seagull Book Cover

Silk and rayon, dyed
Design attributed to M.A. Pressley-Smith; in production by 1930
15 x 9.5 inches (flat)

Schooner Book Cover

Silk and rayon, dyed
Design attributed to M.A. Pressley-Smith; in production by 1930
14.5 x 9.5 inches (flat)

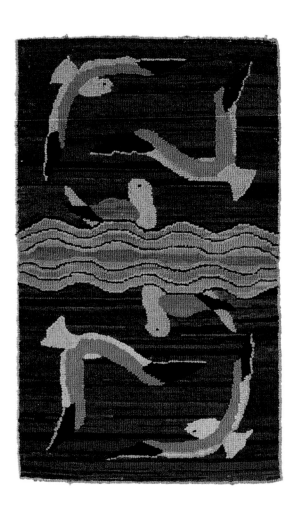

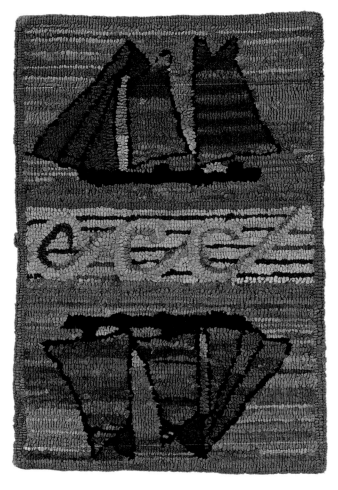

Jigging For Cod Book Cover

Brin, undyed
28.4 x 9.5 inches (flat)

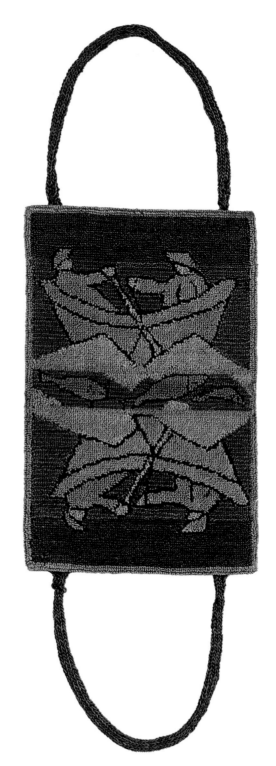

Hooked book covers – another attempt to widen the consumer base – were in production by 1930. The mats shown here were specifically designed for this purpose. The waves in the centre of the two book covers on the facing page and the cod-fish at the end of the jigging line in the example at right would cover the spine of a book.

In a letter of 15 November 1930, Pressley wrote, "By this mail we are forwarding a package containing 81 book covers – a further consign-ment of Lady Grenfell's order for 200. I shall be interested to hear what success she is having disposing of them."[76] The reply answers her spec-ulations all too clearly: "We are all dismayed to receive your last letter telling us that still more bookcovers are on their way to this office. Do please keep back any more until you hear from us. I do not know why Lady Grenfell loves these bookcovers as she does. They are so expensive that, so far, they have not sold well in England, and we are almost overwhelmed to receive the two hundred. Of course, if Lady Grenfell can dispose of them that is perfectly all right, but I have my doubts, as owing to the duty we have to pay, we had to put up the prices … We have been charged 33 1/3% on all these book covers, and it really is not worth the cost."[77]

The long straps on the Jigging for Cod book cover may have made it more of a book bag.

St Anthony Table Mat

Brin, silk, and rayon, dyed
Design in production by 1933
9 x 8.5 inches

This mat represents St Anthony from an interest-
ing and successful perspective. Hills frame the old
United Church in the centre and the buildings
on either side. A sailing dory, oversized for this
small mat, approaches or perhaps sails away from
the pier in the harbour.

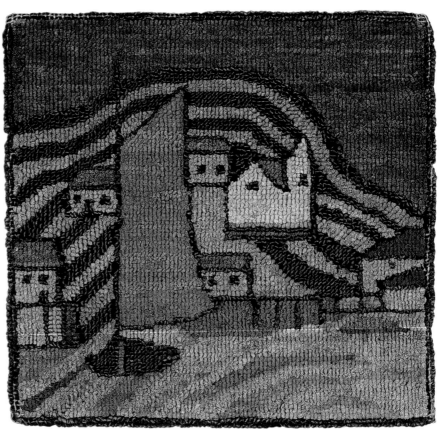

Grand Falls

Silk and rayon, dyed
27 x 32.5 inches

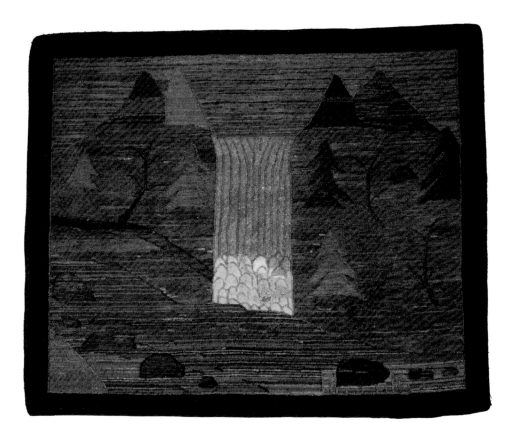

This unique mat most likely depicts Labrador's Grand Falls (now called Churchill Falls), a major waterfall nearly one and a half times higher than Niagara Falls. According to native legend, two Indian maidens were enticed to the brink of the falls by evil spirits while collecting wood and lured over the edge. It is believed that the maidens, no longer young and beautiful, can sometimes be seen through the mist with arms outstretched, waiting to catch anyone who dares venture too near. Churchill Falls powers one of the world's largest hydroelectric plants, which supplies the electricity that lights Broadway in New York City.

Double Curve Book Cover

Silk, rayon, brin, and Grenfell cloth, dyed
Design attributed to M.A. Pressley-Smith; in production c. 1927
7.25 x 19 inches (flat)

This visually strong book cover is one of the few Grenfell pieces to incorporate native imagery. The aboriginal double curve motif appears in paintings on skin garments and in beadwork and embroidery among the Naskaspi and Montagnais of Labrador. Its inspiration is believed to derive from the plant world, and it is thought to convey early native concepts of balance, spirituality, and unity of community.

After Rhoda Dawson returned home to England, she began chronicling her Newfoundland experiences. In the course of doing so, she corresponded with Pressley asking about the origins of mat patterns. In response to a query about a "mushroom" design, on 12 May 1937 Pressley wrote, "We did make mushroom mats once – if it's a very old one it might be that or one of those I did from Naskapi designs. If you are interested I have a whole book about them by Dr Speck which I'll lend you."[78] Frank G. Speck wrote a number of books about the native peoples and their imagery. One, *Symbolism in Penobscot Art*, may be the book to which Pressley was referring. It has five pages illustrating eighty-two double curve motifs, and likens the Penobscot tradition to the Naskapi. The book was published in 1927, during Pressley's tenure at the Industrial.

The label on this book cover is the first one used by the Industrial, Made in Labrador stamped in black ink onto a small strip of linen, which helps to validate its date of hooking. A similar design was hooked as a small decorative mat.

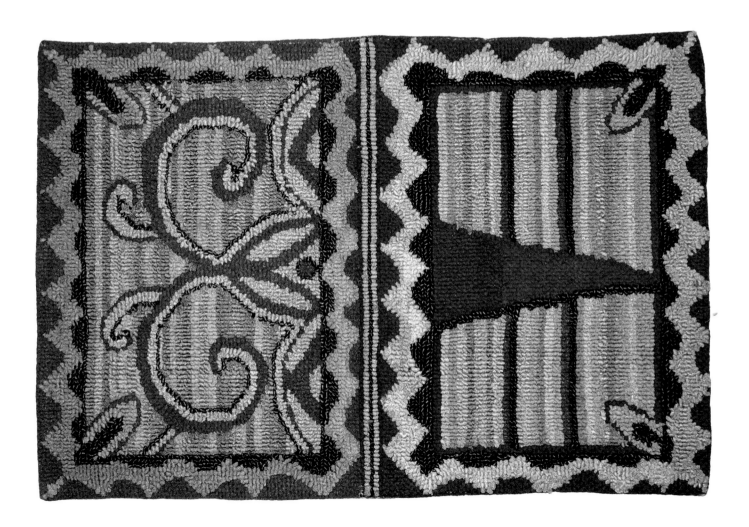

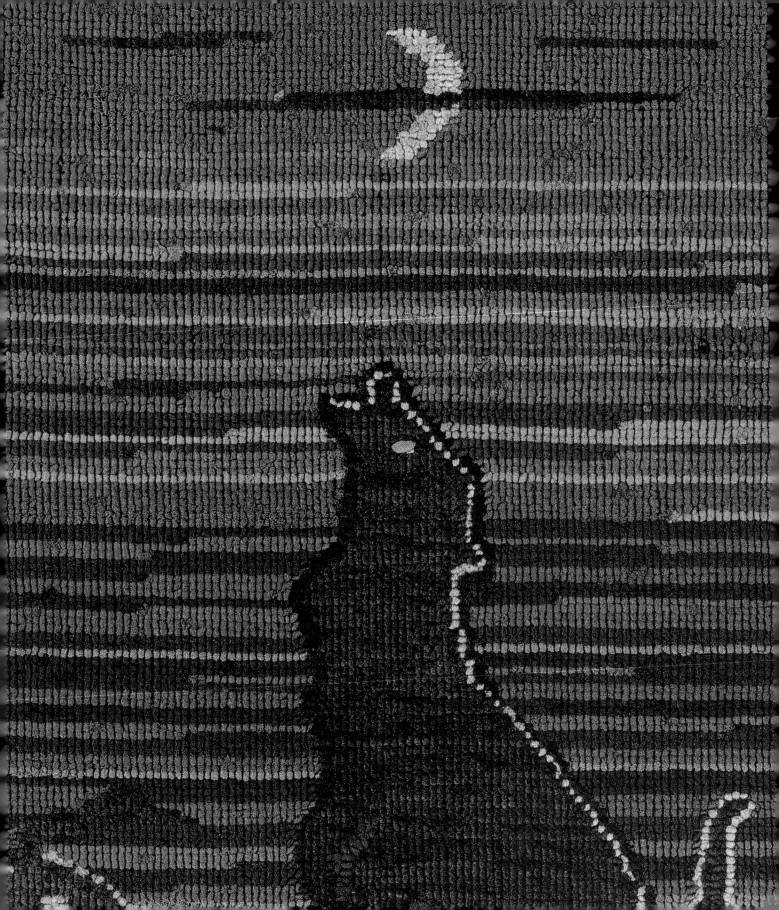

Notes

PART ONE

1 Rompkey, *Grenfell of Labrador*, 12.
2 Gray, "The Labrador Doctor," 45.
3 Confederation with Canada occurred on 31 March 1949.
4 Grenfell, ADSF, January 1917.
5 Telephone interview with Rosamond Grenfell Shaw, 14 September 1993.
6 Luther, "In Retrospect," 113.
7 John Mason Little (1875–1926) was a gifted surgeon from a wealthy Boston-area family. He was educated at the Noble and Greenough School and graduated from Harvard Medical School in 1901. He volunteered as Mission doctor in the summer of 1907 and was in charge of the St Anthony hospital until 1917.
8 Rompkey, *Jessie Luther at the Grenfell Mission*, 76.
9 Ibid., 47.
10 The Canadian Handicrafts Guild brochure, 1907.
11 Rompkey, *Jessie Luther at the Grenfell Mission*, 209.
12 Ibid., 251.
13 Interview with Una Roberts, St Anthony, Newfoundland, 15 June 1992.
14 Interview with Olive Saunders, St Anthony, Newfoundland, 16 June 1992.
15 The earliest stamped patterns were produced in the 1850s by the firm of Chambers and Leland, Lowell, Massachusetts, and were followed by patterns sold by Edward Sands Frost, a tin peddler in Biddeford, Maine from 1864 to 1876.

16 Luther, "Hooked Mats," 78.

17 Interview with Hilda Moores, Red Bay, Labrador, 17 September 2000.

18 Luther, "In Retrospect," 123.

19 Ibid.

20 Rompkey, *Jessie Luther at the Grenfell Mission*, 79.

21 Helen Albee was born and raised in Dayton, Ohio and received her artistic training at the New York Institute of Artist-Artisans. In 1898, she and her husband John retreated to the small White Mountain hamlet of Pequaket, New Hampshire to live year-round. Here she worked to promote the ideals of the Arts and Crafts movement by heeding the "Progressive Era" call of "What are you doing for your community?" In an effort to reclaim America's rural past through its lost domestic arts, Albee took it upon herself to rescue and dignify the utilitarian hooked rug from what she described as being "so needlessly ugly." Her willingness to share her ideas resulted in a small booklet published in 1901, *Abnakee Rugs*, which describes in detail her experiment and its materials and methods. It went through six printings in seventeen years.

That Jessie Luther relied on this source as a foundation for the Industrial is evident in nearly all its aspects. Certainly variations were adapted to fit the needs of the local communities, but the similarities between the two ventures are striking. Albee approached the rural women of her area who needed employment. Much like the women in northern Newfoundland and Labrador, they were suspicious and were not convinced that Albee's rugs had any value to render them either saleable or desirable: "I did not use bright colors, I wove no vines, no flowers into my rugs; no cats nor puppy dogs reposed on parti-colored foliage" (Albee, *Abnakee Rugs*, 15–16). But after a sell-out exhibition of Albee's rugs at a local meeting hall, the women reluctantly agreed that there might be merit in them after all.

Albee experimented with dyes, first making her own natural dyes but soon settling on eight shades of commercial aniline dyes, which she carefully blended into an array of soft colours. In her book she provided complete instructions on dyeing, as well the formulas for the aniline dyes. Albee's rugs used new fabrics, and she printed patterns on burlap. The Abnakee patterns were mostly geometrics, some resembling native American designs. She also detailed the proper hooking technique and mentioned that the best hook is "made of a forty penny nail" (Ibid., 29).

Workers earned a wage based on the size of the rug and the intricacy of the pattern. Albee identified the best places to sell the rugs as "small but popular summer resorts" (Ibid., 23) and organized exhibitions. Abnakee rugs carried a silk label as a guarantee of authenticity but, in a significant departure from the Industrial, which did not use labels until well after Luther's resignation, each rug-hooker worked her initials onto the under edge of her rug. Although the need for constant and conscientious supervision

was underscored in both undertakings, Luther and Albee both endeavoured to provide their workers with a keen sense of accomplishment and personal pride in a carefully standardized product.

22 Rompkey, *Jessie Luther at the Grenfell Mission*, 104.

23 Too dirty: The weather was too inclement.

24 Rompkey, *Jessie Luther at the Grenfell Mission*, 107.

25 Eleanor Storr (1873–1962) was a competent Englishwoman in charge of the Grenfell orphanage. She volunteered in St Anthony until 1914.

26 Rompkey, *Jessie Luther at the Grenfell Mission*, 113.

27 Ibid., 114.

28 Luther, "Industrial Development at St Anthony," 32.

29 Outing flannel: A general term for twilled or plain weave cotton fabric napped on one or both sides, made in white, plain colours, yarn-dyed stripes, checks, or plaids, and also printed. (*Fairchild's Dictionary of Textiles*, ed. Phyllis G. Tortora [New York: Fairchild Publications, 1996] 399.)

30 "Brin" is the local vernacular for burlap. Several definitions can be found. The *Dictionary of Newfoundland English* defines brin as "a strong, coarse-woven sacking; burlap." *The English Dialect Dictionary* (1898) defines it as a Devonshire word meaning "strong linen." *Fairchild's Dictionary of Textiles* offers quite a different definition: "a single filament of silk woven by the silkworm in making the cocoon." In this book brin is considered to have the first meaning, burlap.

Brin was used as the base for the mats. Unravelled brin (jute thread) was also used as hooking material, in addition to silk, rayon, and cotton. Thus, brin thread would be hooked onto a brin base. Hooking an entire mat in brin results in a coarser overall feel, but also gives it desirable durability.

31 Luther, "In Retrospect," 123.

32 Luther, "Industrial Development at St Anthony," 32.

33 Bark mats used a dye commonly known as "bark." Each year, before nets were placed in the water for the season, the fishermen "barked" them, as well as their sails. The process involved dipping the nets and sails into a boiling tub of water containing pieces of bark or "cutch" purchased from a local merchant. The bark dissolved in the boiling water, making a deep brown solution. When dipped into this solution the nets and sails became coated, making them resistant to rot and, in the case of the nets, more difficult to see in the water. (Fishermen say fish can see nets.)

Women frequently dipped their brin in the boiling solution; it would become a shade of brown whose intensity depended on how long the brin was left in. The strands of brin were coiled into a skein before being dipped. After the strands had dried they were hooked into a mat in the usual manner. Sometimes women took a small piece of bark and boiled it on the stove for dyeing.

34 Luther, "In Retrospect," 123.

35 Canadian Guild for Crafts Archives, Jessie Luther to Miss Peck, 3 May 1909.

36 Rompkey, *Jessie Luther at the Grenfell Mission*, 42.

37 Ibid., 287.

38 Dr Grenfell married Anne McClanahan of Lake Forest, Illinois, on 18 November 1909.

39 Grenfell, "The Hooked Mat Industry," 12.

40 Ibid.

41 Grenfell, *Toilers of the Deep*, 93–4.

42 Ibid.

43 Grenfell, "The Hooked Mat Industry," 12.

44 Wilfred Thomason Grenfell Papers, Anne Grenfell to W.R. Stirling, 6 August 1916 [1915].

45 Ibid.

46 Ibid.

47 Ibid.

48 Jessie Luther Papers, Luther to the Board of the International Grenfell Association, [1915].

49 Jessie Luther Papers, Luther to Grenfell, 17 September 1915.

50 Ibid.

51 Jessie Luther Papers, Grenfell to Luther, 1915.

52 Jessie Luther Papers, Grenfell to Luther, n.d.

53 Schwall, "Industrial Work in Northern Newfoundland and Labrador," 4.

54 Luther, "Industrial Contrasts – Early Days," 5.

55 Grenfell, "The St Anthony Mat Industry," 135.

56 Canton flannel: "A carded cotton fabric woven with a four-harness warp face twill with heavy, soft filling yarn and a medium count warp. A long nap is raised on the back. Used in night wear, underwear, interlinings and sportswear." (*Fairchild's Dictionary of Textiles*, ed. Phyllis G. Tortora [New York: Fairchild Publications, 1996], 91.) In 1912, it sold for between ten and eighteen cents per yard.

57 W.R. Stirling Papers, Anne Grenfell to Stirling, 1 September 1916.

58 Grenfell, "The St Anthony Mat Industry," 137.

59 Interview with Jessie Colburne, St Anthony, Newfoundland, 14 June 1992.

60 "The Toronto Branch Report," ADSF, October 1913.

61 Alice Appleton Blackburn of Cambridge, Massachusetts went to St Anthony as a volunteer teacher in 1911. In 1912 she assumed leadership of the Mission school. She married A.C. Blackburn, an English pastor working with the Mission, in 1914. Their baby girl Ruth, born in 1915, was the first child born to a Mission couple. The Blackburns lived in St Anthony year-round for nearly seventeen years. Alice was a much-loved volunteer wherever her services were needed. She began to assist Jessie Luther in 1914 and agreed to take charge of the Industrial over the following winter. When she needed mats stencilled or flannelette dyed she enlisted the whole staff to assist her in her kitchen. She is listed as assistant director/director 1916–18. After the resignation of Laura Young in 1920, Alice resumed the post of director until the arrival of Catherine Cleveland in 1922. The Blackburns left the Mission in 1929 and settled in England, where Alice died on 22 December 1965.

62 Laura Young of Willimantic, Connecticut worked in the educational department of the

Boston State House and was educated at the Normal School of Art before her tenure with the Grenfell Mission. Assisted by her mother, Young worked in the Industrial for two years. The Chicago branch of the Grenfell Mission and three Mission friends from Buffalo each contributed $500 toward her salary.

63 Interview with Annie Pike, Red Bay, Labrador, 17 September 2000. Minnie Pike died on 28 April 1943.

64 Rhoda Dawson Bickerdike Papers, Grenfell to Dawson, 1 November 1935.

65 Grenfell, "The Industrial Work," 106.

66 Elizabeth Page graduated from Vassar College, Poughkeepsie, New York in 1912 and received an M.A. from Columbia University in 1914. A teacher, she volunteered for the Grenfell Mission in White Bay from 1921–25. She married Herbert Harris in 1954, authored four books, and died in 1969.

67 ADSF, January 1922, 117.

68 Elizabeth Page Harris Papers, black notebook.

69 Elizabeth Page Harris Papers, to-do list in black notebook.

70 Misses Schwalls, Miss Young, Miss Pollard: Mary E. and Sarah Schwall of New Bedford, Massachusetts were travelling assistants to Jessie Luther and Alice Blackburn, 1915–17. Mary was also the housekeeper at the Mission's Guest House, and Sarah served as a teacher in the Grenfell school. Laura Young directed the Industrial in 1918–20, as already mentioned. Katherine Pollard (Stride) of Boston joined the Mission staff in

1920 as an assistant to Alice Blackburn and supervised work at the Industrial until Catherine Cleveland's arrival in 1922. Returning home to the Massachusetts North Shore in the summer of 1921, Pollard organized a ball in East Gloucester and raised $1,500 for the benefit of the Industrial. She married a Grenfell Mission chaplain, William Stride, in 1923. She died in 1962. All four women contributed to the strong foundation of the Industrial.

71 Grenfell, "Industrial Work," 121.

72 Telephone interview with Alice Jones, 14 September 1993.

73 Jean Wishart (1902–91) Papers, Wishart to her parents, summer 1925.

74 Parker, "Mission Industrial Display," 47.

75 *Boston Evening Transcript*, 2 December 1924.

76 Catherine Cleveland returned to New York, where she attended classes at Columbia University. She began working for the Cotton Textile Institute in 1932 and in 1939 became a board member of the IGA. In 1940, she went to work for the Works Progress Administration (WPA) as chief of the Sewing and Mattress Project, a United States government program that was part of President Franklin Delano Roosevelt's New Deal. The project employed trained seamstresses who made clothing and mattresses for those in need.

77 Bickerdike, "Mae Alice Pressley-Smith, M.B.E.," 17.

78 NONIA was an organization of nurses in southern Newfoundland who introduced knitting as a means for the coastal women to

augment the family income. Their territory overlapped with that of the Grenfell Mission in the White Bay area of Newfoundland. Dr Grenfell was initially opposed to their involvement in the Industrial effort, but in time a spirit of cooperation was achieved. Bad blood developed between NONIA and Pressley, however; she resigned, thinking the nurses an "extremely selfish" lot.

79 Elizabeth Page Harris Papers, 14 January 1927.

80 Grenfell, "The St Anthony Mat Industry," 137.

81 Grenfell, "Save Your Silk Stockings," 69.

82 Ibid, 133.

83 Grenfell, "The St Anthony Mat Industry," 137.

84 Letter from Grenfell to W. Biddle Tamburro, 19 July 1929. Private collection of the author.

85 Luther, "In Retrospect," 113, 123.

86 Nolan, "Grenfell Hooked Mats," 24.

87 Luther, "In Retrospect," 123.

88 Sir Wilfred Grenfell Papers, M.A. Pressley-Smith to Katie Spaulding, 18 May 1930.

89 Ibid.

90 Elizabeth Page Harris Papers, Edith Tallant to Page, Easter 1927.

91 "The Industrial Department," ADSF, April 1931, 15.

92 Interview with Gladys Mitchell Chislett, Chevery, Quebec, 5 October 1998.

93 Interview with Lavinia Mitchelmore, Green Island Cove, Newfoundland, 16 September 2000.

94 Interview with Violet Pye, Lodge Bay, Labrador, 15 September 2000.

95 Dr Grenfell was knighted by King George V in 1927.

96 Grenfell, "Lest We Forget," 59.

97 Rhoda Dawson Bickerdike Papers, "Newfoundland Memoirs," 17.

98 Neary, "Wry Comment: Rhoda Dawson's Cartoon of Newfoundland Society," 4.

99 Sir Wilfred Grenfell Papers, M.A. Pressley-Smith to Katie Spaulding, 15 November 1930.

100 Rhoda Dawson Bickerdike Papers, Dawson to Nelson Dawson, Christmas 1930.

101 Rhoda Dawson Bickerdike Papers, Dawson to Nelson Dawson, 8 March 1931.

102 Rhoda Dawson Bickerdike Papers, Dawson to Margaret (Sclanders) Fitzpatrick, 3 April 1931.

103 Sir Wilfred Grenfell Papers, M.A. Pressley-Smith to Katie Spaulding, 15 November 1930.

104 Sir Wilfred Grenfell Papers, Pressley-Smith, "Outline of the Survey," 1–3.

105 Pressley-Smith, "Industrial Distress," 3.

106 Ibid., 5.

107 "Scattered" refers to a mat requiring numerous colour changes in many areas, as opposed to one with lots of sky, water, or open space, which would not require a mat-hooker to change colours frequently.

108 Elizabeth Page Harris Papers, Mrs Gale to Page, March 1932.

109 Elizabeth Page Harris Papers, Berrie Yale to Page, 5 March 1933.

110 Elizabeth Page Harris Papers, letter to Page, 1933.

111 "Cruises to the Alluring North and the Gulf of St Lawrence," Clarke Steamship Publicity Folder, 1935.

112 Rhoda Dawson Bickerdike Papers, diary notation, April 1931.

113 Rhoda Dawson Bickerdike Papers, Dawson to Nelson Dawson, 22 June 1931.

114 Sir Wilfred Grenfell Papers, M.A. Pressley-Smith to Katie Spaulding, 3 September 1931.

115 Probably Molly Molesworth, whom Dawson called the "artist girl" in a letter of 15 October 1931 to her father, also saying that Molesworth was "fearfully popular and her painting is awful."

116 Rhoda Dawson Bickerdike Papers, Dawson to Nelson Dawson, August 1931.

117 Rhoda Dawson Bickerdike Papers, Dawson to Margaret (Sclanders) Fitzpatrick, 17 September 1931.

118 Rhoda Dawson Bickerdike Papers, Draft of unpublished book, Chapter 5 (written in 1990 referencing her trip home to Great Britain in 1933).

119 Rhoda Dawson Bickerdike Papers, Grenfell to Sir William Furse, 26 May 1933.

120 Neary, "Wry Comment: Rhoda Dawson's Cartoon of Newfoundland Society," 7.

121 Wilfred Thomason Grenfell Papers, Grenfell to Eleanor Cushman, 7 July 1938.

122 Rhoda Dawson Bickerdike Papers, M.A. Pressley-Smith to Dawson, 6 December 1933.

123 Janet Stewart, a Canadian from Ontario, toured the Labrador coast by boat supervising the handicrafts in the summer of 1934.

124 Rhoda Dawson Bickerdike Papers, M.A. Pressley-Smith to Dawson, 6 May 1934.

125 Rhoda Dawson Bickerdike Papers, Dawson to Margaret (Sclanders) Fitzpatrick, November 1934.

126 Hutchison Family Papers, Jo Carson, "Handicraft Teacher Proud of Grenfell Work," Toronto newspaper clipping, 1962.

127 Rhoda Dawson Bickerdike Papers, "Newfoundland Memoirs."

128 Rhoda Dawson Bickerdike Papers, Margaret Pierce to Dawson, 27 October 1935.

129 Rhoda Dawson Bickerdike Papers, 3 June 1935.

130 Sir Wilfred Grenfell Papers, Rhoda Dawson Bickerdike to Shirley Day, 6 February 1962.

131 Ibid.

132 Rhoda Dawson Bickerdike Papers, Laura Thompson to Dawson, 29 July 1935.

133 Rhoda Dawson Bickerdike Papers, Dawson to Margaret (Sclanders) Fitzpatrick, 11 November 1935.

134 Rhoda Dawson Bickerdike Papers, Dawson to Katie Spaulding, 13 December 1935.

135 Rhoda Dawson Bickerdike Papers, "The Soapstone Voyage," Newfoundland Memoirs.

136 Rhoda Dawson Bickerdike Papers, Newfoundland Memoirs.

137 Dawson, "The Folk Art of the Labrador," 39.

138 Sir Wilfred Grenfell Papers, Rhoda Dawson Bickerdike to Shirley Day, 6 February 1962.

139 Bickerdike, "Mae Alice Pressley-Smith, M.B.E.," 17.

140 Rhoda Dawson Bickerdike Papers, Keir to Dawson, 23 January 1936.

141 Rhoda Dawson Bickerdike Papers, Harriet Curtis to Dawson, 25 September 1936.

142 Dr Charles Curtis replaced Dr John Mason Little in 1917 as the head of the hospital in St Anthony. He, too, was a gifted surgeon

trained at Harvard University. The hospital in St Anthony was later named the Curtis Memorial Hospital in his honour.

143 Rhoda Dawson Bickerdike Papers, Harriet Curtis to Dawson, 25 September 1936.

144 ADSF, April 1937, 8.

145 ADSF, April 1936, 46.

146 Ibid.

147 Rhoda Dawson Bickerdike Papers, Effie Lee to Dawson, 15 September 1936.

148 Ibid.

149 Wilfred Thomason Grenfell Papers, Lady Grenfell to Mrs Ferguson, 2 August 1938.

150 Wilfred Thomason Grenfell Papers, Harriet Curtis to Lady Grenfell, 27 August 1938.

151 Wilfred Thomason Grenfell Papers, Harriet Curtis to Lady Grenfell, 23 July 1938.

152 NEGA Papers, Minutes of the IGA meeting, 13 April 1938.

153 Wilfred Thomason Grenfell Papers, Cecil Ashdown to Lady Grenfell, 16 November 1938.

154 NEGA Papers, Lady Grenfell to Shirley Smith, secretary, 7 July 1938.

155 Catherine Vaughn, who later married Eben Joy, rented and then purchased the Dog Team Tavern in 1946, continuing to operate it as publicity for the Grenfell Mission. The Dog Team Tavern continues in business today under Chris Hesslink, who is only its third owner. It still serves wonderful, comfortable fare and displays an interesting collection of Grenfell memorabilia.

156 Interview with Eben Joy, Ft Meyers, FL, 22 March 1996.

157 Wilfred Thomason Grenfell Papers, Minutes of the NEGA meeting, Cecil Ashdown, secretary, 11 May 1943.

158 Newly born seal pups are known as "whitecoats" from their snow-white fur, which they shed within three weeks of birth, turning grey.

159 Eileen Wedd introduced this technique by 1943. An invoice from the Ottawa branch to the Halifax branch listed "Bear – fur appliqué," for a base price of $2.00 on 21 September 1943. Eileen Wedd was from Toronto and had a background in fashion design and sketching.

160 Wilfred Thomason Grenfell Papers, Lady Grenfell to Laura Thompson, 31 August 1938.

161 Reekie, "Canada and the Canadian Labrador," 24.

162 Reekie, "A Letter from Labrador," 3.

163 Effie Lee joined the Grenfell Mission in 1935 as a book-keeper and contributed her loyalty to every phase of the Industrial's work for eleven years. She resigned with Janet Stewart.

164 Sir Wilfred Grenfell Papers, Janet Stewart to Catherine Vaughn, 14 November 1945.

165 Ibid.

166 Ibid.

167 Veronica Wood was Janet Stewart's immediate successor. She reported that, in 1947, 978 mats were hooked; in the same seven-month period in 1948, 1547 mats were hooked by the same number of mat-hookers. See ADSF, April 1949, 11.

168 Ibid.

169 Stout, *New York Times*, 1 February 1996.

170 Seabrook, "Does Change Mean Progress?", 115.

171 Sir Wilfred Grenfell Papers, Janet Stewart to Catherine Vaughn, 14 November 1945.

172 Muff, "The Muff Report Report," Veronica Hodd to Mary Andrews, 8 July 1959, Appendix 3, 1.

173 "Aunt" was and remains a familiar form of address among the people of the coast.

174 Interview with Barbara Harding, Harrington Harbour, Quebec, 7 October 1998.

175 Telephone conversation with Anne (Nan) Carney, 22 September 1993. Anne Carney directed the Harrington Industrial between June 1952 and August 1953. Esther Cox died in 1962.

176 Muff, "The Muff Report Report," Veronica Hodd to Mary Andrews, 8 July 1959, Appendix 3, 1.

177 Telephone conversation with Marilyn Dunford, 1 May 2000.

178 Grenfell Handicrafts became an independently owned and operated business in 1984.

PART TWO

1 Interview with Stella Fowler, Capstan Island, Labrador, 18 September 2000.

2 Interview with Violet Pye, Lodge Bay, Labrador, 15 September 2000.

3 Wood, "Canadian Shore Industries," 47.

4 "Brief Items," *ADSF*, July 1929, 94. A letter from Pressley-Smith dated Nov. 1930 further substantiates the figures.

5 Rhoda Dawson Bikerdike Papers, M.A. Pressley-Smith to Dawson, 15 February 1938.

6 Telephone conversation with Gladys Mitchell Chislett, Chevery, Quebec, 15 May 2000.

7 Interview with Stella Fowler, Capstan Island, Labrador, 18 September 2000.

8 Interview with Bessie Pilgrim, Main Brook, Newfoundland, 20 September 2000.

9 Interview with Una Roberts, St Anthony, Newfoundland, 18 September 2000.

10 Rhoda Dawson Bickerdike Papers, M.A. Pressley-Smith to Dawson, 15 February 1938.

11 Ibid.

12 Interview with Violet Pye, Lodge Bay, Labrador, 15 September 2000.

13 Telephone conversation with Catherine Buchanan, St Anthony, Newfoundland, 10 October 2000.

14 Interview with Eliza Yetman, Red Bay, Labrador, 17 September 2000.

15 Sir Wilfred Grenfell Papers.

16 Sir Wilfred Grenfell Papers, M.A. Pressley-Smith to Margaret Pierce, 11 February 1930.

17 Sir Wilfred Grenfell Papers, transcript of Mr Champney's telephone call regarding registration of Industrial goods, 14 February 1930.

18 Sir Wilfred Grenfell Papers, M.A. Pressley-Smith to Katie Spaulding, 1 August 1930. Cash's is a well-known British label company. At one time they had offices in Canada and the United States. They are still in business in Great Britain.

19 Correspondence and interview with Stella Hoddinott, Green Island Cove, Newfoundland, June 2001.

20 Hutchison Family Papers, Newspaper clipping from a private scrapbook, Toronto, Ontario, 1936.

21 Rhoda Dawson Bickerdike Papers, M.A. Pressley-Smith to Dawson, 26 April 1937.

22 Waugh and Foley, *Collecting Hooked Rugs*, frontispiece.

23 Rhoda Dawson Bickerdike Accession Notes, The Victoria and Albert Museum, London, England, T.462-1992.

24 Rhoda Dawson Bickerdike Papers, Dawson to Ned Dawson, 8 March 1931.

25 Rudge, "Sources of Inspiration," 36.

26 Interview with Una Roberts, St Anthony, Newfoundland, 21 September 2000.

27 Sir Wilfred Grenfell Papers, invoice from the Industrial Department of the IGA to the Grenfell Association of Great Britain and Ireland, 8 October 1937.

28 Interview with Minnie Compton, St Anthony, Newfoundland, 22 June 1992.

29 Interview with Emily Sulley, St Anthony, Newfoundland, 23 June 1992.

30 Hutchison Family Papers, newspaper clipping from a private scrapbook, Toronto, Ontario, 1951.

31 Sir Wilfred Grenfell Papers, invoice from the Industrial Department of the IGA to the Grenfell Association of Great Britain and Ireland, 6 June 1939.

32 Rhoda Dawson Bickerdike Papers, Dawson to Shirley Day, 2 August 1980.

33 Kent, *Hooked Rug Design*, Plate 99a.

34 Sir Wilfred Grenfell Papers, invoice from the Industrial Department of the IGA to the Grenfell Association of Great Britain and Ireland, 6 June 1939.

35 Stephen Hamilton, Letter to author, 4 November 1991.

36 Cleveland, "Reports of Mission Activities," 175.

37 Hutchison Family Papers, newspaper clipping from a private scrapbook, Toronto, Ontario, 1932.

38 Cleveland, "Reports of Mission Activities," 174.

39 For pictures of similar mats, see Kent, *The Hooked Rug*, 3, 145.

40 Rhoda Dawson Bickerdike Papers, Harriet Curtis to Dawson, 25 September 1936.

41 Rhoda Dawson Bickerdike Papers, "Dora Mesher."

42 Sir Wilfred Grenfell Papers, invoices from the Industrial Department of the IGA to the Grenfell Association of Great Britain and Ireland, 17 September 1937, 8 October 1937; Scottish Branch, 1937, 27 June 1938, 3 December 1938, and 6 June 1939.

43 Ibid., 23 October 1936, 8 October 1937, 27 June 1938, 3 December 1938, 6 June 1939, and 29 November 1946.

44 Rhoda Dawson Bickerdike Papers, Dawson to Ned Dawson, Christmas 1930.

45 Sir Wilfred Grenfell Papers, invoices from the Industrial Department of the IGA to the Grenfell Association of Great Britain and Ireland, 17 September 1937, 8 October 1937, and 27 June 1938.

46 Ibid., 9 January 1936.

47 Rhoda Dawson Bickerdike Papers, Margaret Pierce to Dawson, 27 October 1935.

48 Sir Wilfred Grenfell Papers, invoices from

the Industrial Department of the IGA to the Grenfell Association of Great Britain and Ireland, 17 September 1937 (price $3.06), 8 October 1937, 27 June 1938, 3 December 1938, and 6 June 1939.

49 Sir Wilfred Grenfell Papers, Rhoda Dawson to Katie Spaulding, 13 December 1935.

50 Grenfell, "The St Anthony Mat Industry," 137.

51 Rompkey, *Jessie Luther at the Grenfell Mission*, 247.

52 Rhoda Dawson Bickerdike Papers, Kier to Dawson, 23 January [1936].

53 Rompkey, *Jessie Luther at the Grenfell Mission*, 25. The church was built in 1899–1901, principally by John Moore.

54 Ibid., 41.

55 Hutchison Family Papers, newspaper clipping from a private scrapbook, "Labrador Rugs sold by by Mission," Toronto, Ontario, 1929.

56 Sir Wilfred Grenfell Papers, invoices from the Industrial Department of the IGA to the Grenfell Association of Great Britain and Ireland, 27 June 1938 and 6 June 1939.

57 White, "New England Grenfell Items," 159.

58 Rompkey, *Jessie Luther at the Grenfell Mission*, 77.

59 Sir Wilfred Grenfell Papers, Janet Stewart to Betty Seabrook, 2 June 1939.

60 Sir Wilfred Grenfell Papers, invoice from the Industrial Department of the IGA to the Grenfell Association of Great Britain and Ireland, 6 June 1939.

61 Interview with Rosie Linstead, L'Anse au Loup, Labrador, 19 September 2000.

62 Sir Wilfred Grenfell Papers, Janet Stewart to Betty Seabrook, 16 January 1939.

63 Rompkey, *Jessie Luther at the Grenfell Mission*, 27.

64 Sir Wilfred Grenfell Papers, invoice from the Industrial Department of the IGA to the Grenfell Association of Great Britain and Ireland, 6 June 1939.

65 Ibid., 6 June 1939 and 29 November 1946.

66 Ibid., 27 June 1938 and 3 December 1938.

67 Telephone interview with Julia Patey Martens, 16 February 2001.

68 Taylor, *How to Make Hooked Rugs*, 48.

69 Laura Thompson was the nurse in charge at Harrington Harbour in 1936. She also supervised the Industrial work.

70 Rhoda Dawson Bickerdike Papers, Martha Harding to Dawson, 2 April 1936.

71 Waugh and Foley, *Collecting Hooked Rugs*, 84.

72 Rhoda Dawson Bickerdike Papers, "Newfoundland Memoir."

73 Sir Wilfred Grenfell Papers, Janet Stewart to Betty Seabrook, 3 May 1939.

74 Rompkey, *Jessie Luther at the Grenfell Mission*, 100–1.

75 Ibid., 119–20.

76 Sir Wilfred Grenfell Papers, M.A. Pressley-Smith to Katie Spaulding, 15 November 1930.

77 Sir Wilfred Grenfell Papers, Katie Spaulding to M.A. Pressley-Smith, 9 December 1930.

78 Rhoda Dawson Bickerdike Papers, Pressley-Smith to Dawson, 12 May 1937.

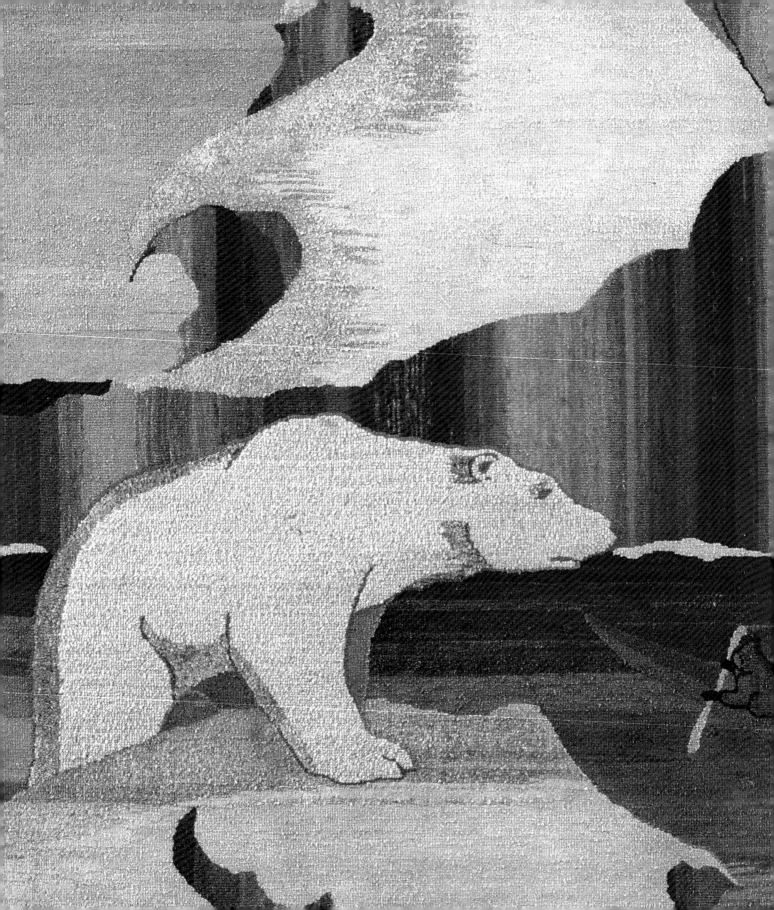

Collections

Most museums do not have Grenfell mats on permanent display; please call ahead.

Canadian Museum of Civilization, Hull, Ontario
McCord Museum, 690 rue Sherbrooke Ouest,
 Montreal, Quebec
Newfoundland Museum, St John's, Newfoundland
Nova Scotia Museum, 1747 Summer Street,
 Halifax, Nova Scotia
Textile Museum of Canada, 55 Centre Avenue,
 Toronto, Ontario
Sir Wilfred Thomason Grenfell Historical Society,
 St Anthony, Newfoundland
Dog Team Tavern, Middlebury, Vermont
Peary-MacMillan Arctic Museum, Bowdoin
 College, Brunswick, Maine
Shelburne Museum, Shelburne, Vermont
Society for the Preservation of New England
 Antiquities, Johnathan Sayward House, York,
 Maine
Stamford Historical Society, Stamford, Connecticut
Wadsworth Atheneum, Hartford, Connecticut
Victoria and Albert Museum, South Kensington,
 London, England

Mats shown in the book were in the following
private collections at the time of publication:
Susan Alain; Mary Bert and Alvin P. Gutman;
Mrs George P. Bissell, Jr; Linda Brady; Michael
Braun; Carmichael Engineering Limited,
Montreal; Judith Bennett Carty; Suzanne
Courcier amd Robert Wilkins; Robin Fernsell;
Gilman Paper Company; Arthur and Susan
Goldstone; Mary Hayden; Chris Hesslink; Marion
Hood; Peter and Annie Hornett; Norman Hotham;
Eben Joy; Evelyn Jubber; William and Paula
Laverty; Margaret Light; Freda MacDonnell;
Robert and Barbara Meltzer; Patricia Lynch
Smith and Sanford Smith; Albert Steidel; Murray
Waddington; Susan and Michael Zak.

Photographs of the mats are by Judith Angel,
Ken Burris, and Carlo Catenazzi.

Bibliography

ABBREVIATIONS

ADSF *Among the Deep Sea Fishers*
IGA International Grenfell Association
NEGA New England Grenfell Association
NONIA Newfoundland Outport Nursing
and Industrial Association
NSARM Nova Scotia Archives and Records
Management
PANL Provincial Archives of Newfoundland
and Labrador
RNMDSF Royal National Mission to the
Deep Sea Fishermen
WPA Works Progress Administration
WTGHS Sir Wilfred Thomason Grenfell
Historical Society

PUBLICATIONS

Abbott, Louise. *The Coast Way*. Montreal:
McGill-Queen's University Press, 1988.
Albee, Helen R. *Abnakee Rugs: A Manual
Describing the Abnakee Industry, the Methods
Used, with Instructions for Dyeing*. 2nd ed.
Cambridge, MA: Riverside Press, 1903.
– "Developing a Home Industry: How the
Abnakee Rug Grew Out of the Old Fashioned
Hooked Mat of our Grandmothers," *The
Craftsman* (November 1908): 236–41.
– "How Abnakee Rugs are Made: A Full
Description of the Exact Method of Working,"
The Craftsman (December 1908): 353–7.
– "Making Successful Rugs in Country Homes,"
Country Life in America (August 1905): 411–13.

– "A New England Village Industry," *The Craftsman* (September 1902): 291.

Allen, Max. *Canadian Hooked Rugs, 1860–1960.* Montreal: The McCord Museum, 1977.

Allen, Max and Simon Waegemaekers. *Hooked Rugs: A Canadian Tradition.* Ottawa: Ottawa Public Library, July 1975.

Among the Deep Sea Fishers. Toronto and Boston: International Grenfell Association, Vols 1–78. 1903–81.

Anonymous. "The Bursting of the Industrial Department," ADSF (October 1930): 133–4.

– *The Canadian Handicrafts Guild Bulletin,* Montreal, 1907.

– *The Canadian Handicrafts Guild,* Recettes Choisies pour Teindre Les Tissus, 1916.

– "Does Change Mean Progress?" ADSF (January 1952): 115.

– "Going the Winter Rounds," ADSF (April 1928): 35–6.

– "Hooked Rugs in Newfoundland," *Journal of American Folklore,* vol. 92, 1979.

– "Labrador Mission," *Life,* 19 September 1949, 115–24.

– "A Letter from Labrador," *The Maritime Co-Operator,* 1 April 1944, 3.

– "NONIA," *The Work and Aims of the Newfoundland Outport Nursing and Industrial Association,* November 1924.

– *Our Time – Our Story,* Battle Harbour Literacy Council, 1999.

– "The Story of the Labrador Doctor," pamphlet distributed by the British Grenfell Association, n.d.

Armstrong, Bess. "Summer Resort Industrial Sales," ADSF (October 1930): 135–6.

Ashdown, Cecil S. "Changing Fields," ADSF (October 1943): 68–9.

– "Changes in the Organization of Grenfell Labrador Industries, Inc.," ADSF (October 1938): 113.

– "Dogteam Tavern, Vermont," ADSF (April 1946): 29.

– "Industrial Work," ADSF (April 1943): 7.

Avery, Evelyn C. "The roads converge on the Connecticut Dog Team Tea House," ADSF (October 1934): 113–14.

Barbeau, Marius. "The Origin of the Hooked Rug," *Antiques* (August 1947): 110–13.

Belbin, Louise. *Traditional Newfoundland Mats.* The Art Gallery, Memorial University of Newfoundland, April 1978.

Benson, Gerald, ed. *Out of Our Hearts, Churches of Newfoundland and Labrador.* St John's, Newfoundland: Good Tidings Press, 1992.

Benson, Harriet L. "Clothing Store Do's and Don'ts," ADSF (July 1950).

Beriau, O.A. "Craft Revival in Quebec." Province of Quebec, Department of Agriculture, Quebec City, 1942.

Bierwagen, Ottmar. "St. Anthony's Survival Instincts," *Canadian Living* (January 1994): 82–5.

Bickerdike, Rhoda Dawson. "Mae Alice Pressley-Smith, M.B.E.," ADSF (April 1972): 17.

Blackburn, Alice. "The Industrial Department – St. Anthony and Griguet Branches – October 1914, to October 1915," ADSF (January 1916): 166.

– "The Industrial Department," ADSF (October 1923): 102–3.

Bowles, Ella Shannon. *Handmade Rugs.* Boston, MA: Little, Brown & Co., 1927.

Boyd, Cynthia. "Hooked Mats of Canada's Atlantic Provinces – Newfoundland and Labrador," *Piecework Magazine* (January/February 1998): 50–1.

Brown, Rachel M. and Horace McNeill. *Inasmuch*. Private Printing, 1992.

Burbank, Leonard F. "More About Hooked Rugs," *Antiques* (November 1922): 213–18.

Carney, Anne E. *Harrington Harbour … Back Then …* Montreal: Price-Patterson Ltd, 1991.

Cleveland, Catherine. "An Imaginary Trip Through the Industrial Department at St Anthony," ADSF (January 1925): 144–9.

– "Industrial Department," ADSF (January 1926): 174–5.

– "Industrial Department Report," ADSF (July 1925): 85

– "Industrial Work on the Labrador," ADSF (January 1920): 115–17.

– "Report of the Work of the Industrial Department, 1923–1924," ADSF (January 1925): 151–2.

– "Reports of Mission Activities – Industrial Department 1924–1925," ADSF (January 1926): 175.

Cox, Leo. "The Golden North," *Canadian Geographic Journal* (April 1938): 203–8.

Craig, Lebe. "Mostly Industrial," ADSF (April 1932): 18–21.

Cull, Freeman B. *When Bells Toll in the North*. St John's, Newfoundland: Breakwater Books, 1994.

Curtis, Charles, MD. "Minnie Pike, A Friend," ADSF (October 1943): 76.

– "The Year on the Coast," ADSF (April 1941): 6–7.

Curtis, Harriet. "Valedictories," ADSF (October 1946): 84–5.

Dana, Ethel C. "Occupational Therapy in Labrador," ADSF (July 1929): 67–8.

Dawson, Rhoda. "The Folk Art of the Labrador," ADSF (July 1938): 39–49.

– "The Wharves of St. John's, Newfoundland," *Canadian Parliamentary Review* (Summer 1992): 2–5.

Dunford, Marilyn. "Grenfell Handicrafts," ADSF (July 1970): 35–40.

Earhart, Margaret. "Better Health for Capstan Island," ADSF (October 1922): 132–4.

Earle, Mike. *Battle Harbour Labrador Guided Tour Info*, n.d.

Eaton, Allen H. *Handicrafts of New England*. New York: Bonanza Books, 1949.

Fallier, Jeanne. "Grenfell, Hooked on Helping," *Atha* (Newsletter of the Association of Traditional Hooking Artists) (April/May 1985): 1–4.

Farrell, Jeremy. *Socks & Stockings*. London: B.T. Batsford Limited, 1992.

Foote, Evelyn A. "A Short Summary of the Winter's Work," ADSF (July 1926): 83.

Frost, Edward Sands. *Hooked Rug Patterns*. Dearborn, MI: Greenfield Village and Henry Ford Museum, 1970.

Gray, George W. "The Labrador Doctor," *The American Magazine* (April 1928): 44–7, 102–10.

Grenfell, Lady Anne. "The Industrial Effort," ADSF (October 1930): 99–105.

Grenfell, Wilfred T. *Forty Years for Labrador*. Boston and New York: Houghton Mifflin, 1932.

– "The Hooked Mat Industry," ADSF (January 1914): 12.

– "The Industrial Work," ADSF (October 1920): 104–6.

– "Industrial Work," ADSF (April 1923): 8–11.

– "Industrial Work," ADSF (October 1924): 121.

– "Industrial Work and Clothing," ADSF (October 1930): 128–32.

– "Labrador's Lesson in Humanity," *Rotarian* (December 1938): 22–5.

– "Lest We Forget," ADSF (July 1930): 5.

– "The Mat Industry," *Toilers of the Deep* 30 (1915): 90–4.

– "Need of Industrial Work," ADSF (July 1926): 83.

– "The New Tea Houses," ADSF (January 1936): 143–5.

– "The St Anthony Mat Industry," ADSF (October 1916): 134–7.

– "Save Your Silk Stockings," ADSF (July 1928): 69.

– "Silk Stockings Needed in Unlimited Quantity," ADSF (October 1929): 133.

– "To the North Lies Labrador," *Rotarian* (November 1938): 15–17.

– "Work and Progress at St Anthony," *Toilers of the Deep* 28 (1913): 237–9.

Hall, H.J., M.D. "Work as a Remedy for Nervous Exhaustion," *Good Housekeeping* (October 1905): 351–5.

Hicks, Amy Mali. *The Craft of Hand-Made Rugs*. New York: Empire State Book Company, 1936.

Hodd, Donald G. "Veronica Wood," ADSF (January 1943): 114.

Huber, Mary. "My Labrador Rug," *Chatelaine* (June 1938): 19.

Junek, Oscar Waldemar. *Isolated Communities: A Study of a Labrador Village*. New York: American Book Company, 1937.

Kent, William Winthrop. *The Hooked Rug*. New York: Tudor Publishing, 1937.

– *Hooked Rug Design*. Springfield, MA: The Pond-Ekberg Company, 1949.

Kivimaki, Anna. "Nursing with the Grenfell Mission," *The American Journal of Nursing* (June 1937): 593–8.

Kopp, Joel and Kate. *American Hooked and Sewn Rugs: Folk Art Underfoot*. 2nd ed. New York: E.P. Dutton, 1985.

Kurlansky, Mark. *Cod, A Biography of the Fish that Changed the World*. New York: Walker and Company, 1997.

Lacey, Amy. "Labrador, Home of the Iceberg," *Travel Magazine* (May 1916): 24–7, 52.

Laine, Betty. "Hooking with Hosiery," *Rug Hooking* (January/February 1995): 40–3.

Laverty, Paula. "The Hooked Mats of the Grenfell Mission," *Grenfell Mats*. New York: Hudson River Press, 1994.

– "Hooked Mats of the Grenfell Mission," *Piecework Magazine* (November/December 1996): 56–9.

– "Save Your Old Silk Stockings: The Hooked Mats of the Grenfell Mission," *Folk Art* (Winter 1993/94): 52–9.

Law, Margaret Lathrop. "The Hooked Rugs of Nova Scotia," *House Beautiful* (July 1928): 58–9, 86–8.

Leach, MacEdward. *Folk Ballads and Songs of the Lower Labrador Coast*, Bulletin no. 21, Anthropological Series no. 68. Ottawa: National Museum of Canada, 1965.

Leitch, Adelaide. "The Hooked Rugs of Harrington," from a Toronto newspaper, in a private scrapbook, 1956.

– "Pictures on Brin – The Grenfell Hooked Mats," *Canadian Geographic Journal* (February 1958): 76–7.

Limouze, Dorothy Francis. "The Loom," ADSF (October 1938): 96–100.

Linsley, Leslie. *Hooked Rugs: An American Folk Art*. New York: Clarkson Potter, 1992: 74–81.

Luther, Jessie. "Development of the Industrial Work in Dr. Grenfell's Mission at St Anthony," ADSF (January 1907): 11–14.

– "Hooked Mats," *The House Beautiful* (July 1916): 78–9, 106.

– "Industrial Contrasts – Early Days," ADSF (April 1942): 4–5.

– "Industrial Development at St Anthony," ADSF (April 1909): 27–33.

– "Industrial Work," ADSF (October 1913): 21–7.

– "The Industrial Work," ADSF (April 1915): 3–11.

– "In Retrospect," ADSF (October 1930): 112–24.

– "Landing of the Reindeer," ADSF (January 1954): 126–8.

– "Landing of the Reindeer, continued," ADSF (April 1954): 29–31.

– "Mission to Labrador," unpublished manuscript, private collection of Martha Gendron.

Lynch, Colleen. *Helping Ourselves: Crafts of the Grenfell Mission.* St John's, Newfoundland: Newfoundland Museum, 1985.

Lynch, Colleen and Patricia Gratton. *The Fabric of Their Lives; Hooked and Poked Mats of Newfoundland and Labrador.* St John's, Newfoundland: The Art Gallery, Memorial University, 1980.

Lynett, Steve. "Newfoundland's Miracle Medical Mission," *Imperial Oil Review*, Number 3 (1974): 8–15.

McDonald, Sharon. "As the Locusts in Egypt Gathered Crops: Hooked Mat Mania and Cross-Border Shopping in the Early Twentieth Century," *Material History Review* (Fall 2001): 58–70.

Merrick, Elliott. *Northern Nurse.* New York: Charles Scribner's Sons, 1942.

Moshimer, Joan. "Rugs of the Grenfell Mission," *Rug Hooker – news and views* (July/August 1982): 140–58.

Muff, Mary Eileen. "The Muff Report Report on a Survey of the Department of Grenfell Handicrafts August 1st to September 15th, 1962." Appendix 3, Provincial Archives of Newfoundland and Labrador, St John's, Newfoundland.

Neary, Peter. "Wry Comment": Rhoda Dawson's Cartoon of Newfoundland Society," *Newfoundland Studies* 8, 1, 1992.

Nolan, Sally. "Grenfell Hooked Mats," *America at Home.* New York: Fall Antiques Show Catalog (1982): 22–4.

O'Brien, Mary Margaret. *Traditional Newfoundland Mats.* St John's, Newfoundland: The Art Gallery, Memorial University of Newfoundland, May 1978.

O'Brien, Patricia, ed. *The Grenfell Obsession, An Anthology.* St John's, Newfoundland: Creative Publishers, 1992.

Page, Elizabeth. "The New Director of the Industrial Department," ADSF (January 1925): 150.

Parker, Grace Hamilton. "Industrial Department Sales Plans," ADSF (October 1927): 130.

– "Mission Industrial Display at the British Empire Exhibition," ADSF (July 1924): 47.

Perkins, Libby. "Rhoda Nelson Bickerdike (nee Dawson) 1897–1992," *The Friend, A Quarterly Weekly*, Vol. 150, No. 24, 12 June 1992.

Phillips, Anna M. Laise. *Hooked Rugs and How to Make Them.* New York: MacMillan, 1925.

Pierce, Margaret. "Industrial Department Notes," ADSF (October 1937): 128.

Pilgrim, Earl B. *The Price Paid for Charley.* White Bay, Newfoundland: Tromso Enterprise Ltd, 1990.

Pocius, Gerald. "Textile Traditions of Eastern Newfoundland." Ottawa: National Museum of Man Mercury Series, No. 29, 1979.

– "Hooked Rugs in Newfoundland – The Representation of Social Structure in Design," *Journal of American Folklore* 92 (1979). 273–84.

Pressley-Smith, M.A. "Brief Items," ADSF (July 1929): 94.

– "Industrial Distress," ADSF (April 1932): 3–5.

– "Outline of the Survey," St John's, Newfoundland: Provincial Archives of Newfoundland and Labrador, 1930.

– "Work As Medicine," ADSF (October 1930): 110–12.

Pye, Pearl. "Rug Hooking," *Them Days*. Happy Valley/Goose Bay, Labrador, Vol. 4 (no. 4) (1979): 39–40.

Reekie, Isabella. "Canada and the Canadian Labrador," ADSF (April 1938): 24.

– "A Letter from Labrador," *The Maritime Co-Operator* (1 April 1944): 3.

Richardson, Cynthia Watkins. "A Profitable Philanthropy: The Abnakee Rug Industry of Helen Albee of Tamworth," *Historical New Hampshire* (Fall/Winter 2001): 86–103.

Robson, Scott. "Hooked Mats of Canada's Atlantic Provinces – Nova Scotia," *Piecework Magazine* (January/February 1998): 48–9.

Rogers, Ruthanne C. "The Folk Craft and The Era – Hooked Mats of Eastern Canada – Grenfell and Beyond," *Atlantic Roots, Quebec-Labrador Foundation* (Winter 1965): 16–21.

Rompkey, Ronald. *Grenfell of Labrador*. Toronto: University of Toronto Press, 1991.

– "Jessie Luther: New England Craftswoman and Pioneer Occupational Therapist," *Antiques Journal* (September 1999): 10.

– ed. *Jessie Luther at the Grenfell Mission*. Montreal: McGill-Queen's University Press, 2001.

– ed. *Labrador Odyssey*. Montreal: McGill-Queen's University Press, 1996.

Rudge, Geraldine. "Rhoda Dawson, A Missionary zeal for rag rugs and Ruskin," Obituary, *The Guardian* (31 March 1992).

– "Sources of Inspiration," *Crafts* (September/October 1991): 34–7.

Ryan, Nanette and Doreen Wright. *Garretts and the Bluenose Rugs of Nova Scotia*. Mahone Bay, NS: Spruce Top Rug Hooking Studio, 1995.

Sanderson, Edith Clothier. "The Industrial Shops – Philadelphia," ADSF (October 1930): 137–9.

Sayre, Francis B. "Be you a Real Doctor?" *The New York Times Magazine* (2 August 1942): 12, 26.

Schwall, Mary E. "Industrial Work in Northern Newfoundland and Labrador," ADSF (April 1916): 3–4.

Seabrook, Betty. "Grenfell Association of Great Britain and Ireland," ADSF (July 1952): 59.

– "Grenfell's Labrador, The Record of Heroic Efforts For a Suffering Land," *The Countrywoman* (November 1936): 8–9.

Sims, Dr Stanley. "OT Pioneer in the Forgotten Colony," *Therapy Weekly* (1 July 1993): 4.

Skipwith, Peyton. "Rhoda Dawson," *Independent* (2 April 1992).

Sloan, Edith S. "New York Annual Sale," ADSF (April 1925): 30.

Speck, F.G. *Decorative Arts of the Indian Tribes of Connecticut*. Ottawa: Canadian Dept of Mines, 1915.

– *Nascapi Savage Hunters of the Labrador Peninsula*. Norman, OK: University of Oklahoma Press, 1935.

– *Symbolism in Penobscot Art*. The American Museum of Natural History, Vol. XXIX, Part II, 1927, 32–5.

Stewart, Janet. "A District Industrial Supervisor," ADSF (October 1937): 102–4.

– "Letters – The Condition of the Industrial Building," ADSF (October 1930): 140–1.

– "Reflections," ADSF (April 1940): 9.

Stout, David. "Julian W. Hill, Nylon's Discoverer, Dies at 91," Obituary, *New York Times* (1 February 1996): B7.

Szala, Meneok and Kara McIntosh. "Craft Development and Development Through Crafts: Adaptive Strategies of the Labrador Women in a Changing Fishery," *Anthropologies XXXVIII* (1996): 249–70.

Tallant, Edith. "The Industrial Department and the People," ADSF (October 1929): 125–8.

– "An Itinerant Industrial Worker," ADSF (October 1930): 124–8.

Taylor, Mary Perkins. *How to Make Hooked Rugs.* Philadelphia: David McKay Company, 1930: 48–9.

Thomas, Gordon W. *From Sled to Satellite.* Toronto: Irwin Publishing, 1987.

Threlkeld-Edwards, H. "The Industrial Shops – New York," ADSF (October 1930): 137.

Titford, Bill and June. *A Traveler's Guide to Wild Flowers of Newfoundland Canada.* St John's, Newfoundland: Flora Frames, 1995.

Tortora, Phyllis G., ed. *Fairchild's Dictionary of Textiles*, 7th ed. New York: Fairchild Publications, 1996: 91, 399.

Traquair, Ramsey. "Hooked Rugs in Canada," *Canadian Geographic Journal* (May 1943): 240–54.

Turbayne, Jessie A. *Hooked Rugs, History and the Continuing Tradition.* Atglen, PA: Schiffer Publishing, 1991: 106–127.

– *Hooked Rug Treasury.* Atglen, PA: Schiffer Publishing, 1997.

Underhill, Vera Brisbee and Arthur Burks.

Creating Hooked Rugs. New York: Coward McCann, 1951.

Varick, Elizabeth. *New Ideas for Hooked Rugs.* New York: Home Institute, 1940.

Vaughn, Catherine. "Dogteam Tavern Tales," ADSF (July 1941): 53.

– "Grenfell Labrador Industries: Peaceful Days in Vermont," ADSF (July 1942): 58–9.

– "Industrial Notes," ADSF (January 1942): 124–5.

– "Station Wagon," ADSF (October 1940): 95.

Wallace, Dillon. *The Lure of the Labrador Wild.* New York: Fleming H. Revell, 1905.

Waugh, Elizabeth and Edith Foley. *Collecting Hooked Rugs.* New York: The Century Company, 1927.

Whalen, David. *Just one Interloper after Another, An Unabridged, Unofficial, Unauthorized History of the Labrador Straits.* Forteau, Labrador: The Labrador Straits Historical Development Corporation, 1990.

Wheeler, Candace. *How to Make Hooked Rugs.* New York: Doubleday, Page and Company, 1908.

White, E.E., ed. "New England Grenfell Items," ADSF (January 1917): 159.

Wood, Veronica. "Canadian Shore Industries," ADSF (July 1940): 46–7.

– "The Industrial – New Quarters," ADSF (April 1949): 10–11.

Young, Laura. "Industrial Department August 1st, 1918 to May 1st, 1919," ADSF (July 1919): 64–5.

– "The Industrial Department of Yesterday and Today," ADSF (July 1920): 85–7.

ARCHIVAL MATERIAL

Bickerdike, Rhoda Dawson. Accession Papers. The Victoria and Albert Museum, London, England.

Bickerdike, Rhoda Dawson. Papers. Coll. 198, Centre for Newfoundland Studies Archives, Memorial University, St John's, Newfoundland.

Canadian Handicraft Guild Archives, Montreal, Quebec.

Freund, Rudolph. Papers. American Museum of Natural History Special Collections, New York, New York.

Grenfell Association of Great Britain and Ireland. Papers. MG 63, Provincial Archives of Newfoundland and Labrador, St John's, Newfoundland.

Grenfell Mission Halifax Branch (1939–1981). Papers. MG 20, Vols 1591–94. NSARM.

Grenfell, Sir Wilfred. Labrador Papers. MG 327, Provincial Archives of Newfoundland and Labrador, St John's, Newfoundland.

Grenfell, Wilfred T. Papers. MSS # 254, Sterling Memorial Library, Manuscripts and Archives, Yale University, New Haven, Connecticut.

Harris, Elizabeth Page. Papers. MSS # 771, Sterling Memorial Library, Manuscripts and Archives, Yale University, New Haven, Connecticut.

Hutchinson Family. Papers. Private Collection, Toronto, Ontario.

International Grenfell Association. Business Office Papers. MG 63, Provincial Archives of Newfoundland and Labrador, St John's, Newfoundland.

International Grenfell Association. Labrador Medical Mission Papers. MG 63, Provincial Archives of Newfoundland and Labrador, St John's, Newfoundland.

International Grenfell Association. Miscellaneous Material Papers. MG 63, Provincial Archives of Newfoundland and Labrador, St John's, Newfoundland.

Lake Mohonk House Archives, Mohonk Lake, New York.

Luther, Jessie. Papers. Private Collection of Martha Gendron, Swansea, Massachusetts.

New England Grenfell Association. Papers. MSS # 1200, Sterling Memorial Library, Manuscript and Archives, Yale University, New Haven, Connecticut.

Wishart, Jean. Papers. Private Collection of Carol Wishart, Toronto, Ontario.

INTERNET AND SOFTWARE SOURCES

Abbott, Louise and Kent Benson. *Visions of the Lower North Shore of Quebec: An Annotated Inventory of Archival Stills and Motion-Picture Footage.* CD-ROM Tomifobia, Quebec: Abbott and Benson, 1997.

Encyclopedia of Newfoundland and Labrador: www.enl.cuff.com

Grenfell Hooked Mats: www.grenfellhookedmats.com

Labrador Straits History: www.labradorstraits.nf.ca

Newfoundland Heritage: www.heritage.nf.ca/arts/silkmats

Acknowledgments

When I began research on the subject of Grenfell hooked mats nearly twenty years ago I never remotely imagined the truly incredible journey they had in store for me. An incalculable number of people helped me along my way. To each I wish to express my heartfelt thanks.

Deepest gratitude to all the mat-hookers who shared their stories and became my friends: Gladys Mitchell Chislett, who was my beginning, middle, and end; Maggie Mitchell Anderson, Olive Blake, Edna Bobbitt, Minnie Bobbitt, Kit Buchanan, Peggy Yetman Butt, Jessie Colburne, Minnie Compton, Vi Decker, Pearl Fowler, Stella Fowler, Linda Gibbons, Agnes Hancock, Barbara Harding, Stella Hoddinott, Alice Jones, Bessie Jones, Edna Jones, Rosie Linstead, Mosa Mans, Julia Patey Martens, Jessie Michelin, Augustina Mitchelmore, Lavinia Mitchelmore, Hilda Moores, Martha Moores, Mary Patey, Agnes Pike, Annie Pike, Bessie Pilgrim, Ruth Pilgrim, Violet Pye, Una Roberts, Myrtle Rowsell, Olive Saunders, Rita Stevens, Lottie Styles, Emily Sulley, Dorothy Tucker, Nina Walker, Eliza Yetman, Julia Yetman, Ruby Yetman.

Sincere appreciation for their invaluable assistance: Judith Schiff at the Sterling Memorial Library, Manuscripts and Archives, Yale University, New Haven, Connecticut; Linda White at the Centre for Newfoundland Studies Archives, Memorial University, St John's, Newfoundland; Greg Walsh and Sandra Ronayne at the Provincial Archives of Newfoundland and Labrador, St John's, Newfoundland; Clare W. Browne at

the Victoria and Albert Museum, London, England; Gill Hillyard at the Sir Wilfred Thomason Grenfell Historical Society, St Anthony, Newfoundland; Susan White, Agnes Patey, and Janet Patey at Grenfell Regional Health Services, St Anthony, Newfoundland; Jane Smiley at Lake Mohonk House Archives, New Paltz, New York; and Huw Jones at Herbert Art Gallery and Museum, Coventry, England.

Countless thanks to the lenders to my three Grenfell mat exhibitions, whose willingness to contribute has helped enormously: the late Patricia Lynch Smith and Sanford Smith, who gently pushed me into this project so many years ago; Susan Alain, Mrs. George P. Bissell, Jr., Linda Brady, Michael Braun, Judith Carty, Virginia Cave, Sallie Chislett, Suzanne Courcier and Robert Wilkins, John Fernsell, Martha Gendron, Mary Gordon, Mark Hayden, Chris Hesslink, Marion Hood, Maggie Hutchison, Eben and Eileen Joy, Evelyn Jubber, Kate and Joel Kopp, the late Arlene La Fave, Barbara Lohnes, Freda MacDonnell, Robert and Barbara Meltzer, Robin Moore, Linda Plotkin, Ralph Ridolfino, Betty Robertson, Wally Rogers, Nancy Ruth, Diane Scharf, Iris Simpson, J. Lynnwood Smith, Warren Steadman, Albert Steidel, Carol Telfer, Jessie Turbayne, Murray Waddington, Carol Wishart.

I am indebted in special ways to many friends: Judie Fletcher and Miller Carmichael for their continual and tremendous support; Annie and Peter Hornett for helping me scale mountains; Conrad Graham and Cynthia Gordon for supplying many laughs, which kept me going; Helen Meredith for her irrepressible good humour and for knowing everyone; Colleen Lynch for her

pioneering research on this topic; Francis Nuelle, whose thoughtful and careful editing gave the manuscript its initial form; Sarah and Richard Holland for their generous hospitality; Rachel Brown for her early encouragement; Link and Julie Brown for always wanting to listen to me; the late Stephen Hamilton for sharing his memories; the late Rosamond Grenfell Shaw for her friendship and knowledge; Cindy Gibbons for leading me to so many mat-hookers and for luring me to Battle Harbour; Al and Penny Hadfield for lending me their copies of *Among the Deep Sea Fishers*; Gerard Wertkin, Liz Warren, and Stacy Hollander of the American Folk Art Museum for nurturing the first exhibition; Celia Oliver and Eloise Beal for the second exhibition, at the Shelburne Museum; Sarah Holland, Sarah Quinton, Margaret Ballantyne, Marijke Kerkhoven, and Roxane Shaughnessy at the Textile Museum of Canada for supporting the third. Also to Ronald Rompkey, Peter Neary, and James Hiller for always-good advice; Penny Houlden, Susan and John Maunder, and Ann Devlin for the opportunity to catalog the Newfoundland Museum's Grenfell collection; Meryl Roberts and Betty Learning in North West River, Labrador for their kindness; the late Ivan Curson and Norman Pindar for their extensive efforts on my behalf; Sharon McDonald for all the amazing information she shared; Louise Abbott for her knowledge of the Lower North Shore; Linda Lloyd and Sharon Chubb-Ransom for their sleuthing on Shay island; Phyllis Oxley for her information on the final days of the Toronto Grenfell branch; Cynthia Richardson for sharing her comprehensive scholarship on

Helen Albee; Marilyn Dunford, whose Grenfell
Industrial experience helped me understand the
end of the story; the photographers Judith Angel,
Ken Burris, and Carlo Castenazzi for their
patience and skill; Joan McGilvray of McGill-
Queen's University Press for her perseverance
in bringing the manuscript to publication and
for patiently, with humour, guiding me the
whole way; Olga Domján for keeping me on
track with her dedication, curiosity, and always
intelligent editing.

I also gratefully acknowledge the financial
support I received from the International Grenfell
Association and the Pasold Research Fund.

Index

Photographs are indicated in bold type.